2708881990| 6947694

N
7433915

D1208749

DATE DUE

12/8/11			

Demco

DISCARDED

THE ART OF PARTICIPATION

THE AR
PARTICI

'1950 TO

T OF

PATION

NOW

San Francisco Museum of Modern Art

Thames & Hudson

RUDOLF FRIELING

BORIS GROYS

ROBERT ATKINS

LEV MANOVICH

MANDALE COMMUNITY COLLEGE
LIBRARY
9700 FRANCE AVENUE SOUTH
BLOOMINGTON, MN 55431-4399

SEP 2 3 2008

This catalogue is published by the San Francisco Museum of Modern Art in association with Thames &
Hudson, New York and London, on the occasion of the exhibition *The Art of Participation: 1950 to Now*,
organized by Rudolf Frieling for the San Francisco Museum of Modern Art and on view November 8, 2008,
through February 8, 2009.

The exhibition is generously funded by The James Irvine Foundation and SFMOMA's Collectors Forum.
Additional support is provided by Goethe-Institut San Francisco.

the James Irvine
foundation

Director of Publications: Chad Coerver
Managing Editor: Karen A. Levine
Publications Assistant: Laura Heyenga
Index: Frances Bowles
Design: Volume Inc.
Color separations: Echelon

Copyright © 2008 by the San Francisco Museum of Modern Art, 151 Third Street,
San Francisco, California, 94103.

All Rights Reserved. No part of this publication may be reproduced or
transmitted in any form or by any means, electronic or mechanical, including
photocopy, recording or any other information storage and retrieval system,
without prior permission in writing from the publisher.

First published in 2008 in hardcover in the United States of America by Thames
& Hudson Inc., 500 Fifth Avenue, New York, New York 10110.

thamesandhudsonusa.com

First published in the United Kingdom in 2008 by Thames & Hudson Ltd,
181A High Holborn, London WC1V 7QX.

thamesandhudson.com

Library of Congress Catalog Card Number: 2008901217

British Library Cataloguing-in-Publication Data
A catalogue record for this book is available from the British Library

ISBN 978-0-500-23858-5

Cover:
Kit Galloway and Sherrie Rabinowitz *Hole-in-Space*, 1980 (see pls. 90–91)

Front endsheets:
Wolf Vostell *9 Decollagen*, 1963 / Happening in Wuppertal, Germany, 1963 / Archiv Sohm, Staatsgalerie
Stuttgart, Germany
Erwin Wurm *One Minute Sculptures*, 1997 (see pls. 141–42)

Frontispieces:
Pages 2–3: **Tom Marioni** *The Act of Drinking Beer with Friends Is the Highest Form of Art*, 1970–2008 (see pl. 82)
Pages 4–5: **Matthias Gommel** *Delayed*, 2002 (see pl. 157)
Pages 6–7: **Lygia Clark** *Rede de elástico* (Elastic Net), 1973 (see pl. 37)

Back endsheets:
Felix Gonzalez-Torres *"Untitled,"* 1992/1993 (see pl. 119)
Jochen Gerz *The Gift*, 2000 (see pl. 147)

A note on the captions: throughout this catalogue, measurements (in inches) are provided for paintings,
sculptures, and other object-based artworks unless dimensions are variable or were not confirmed in time for
publication. No media or dimensions are listed for performances, happenings, or other ephemeral projects.

Photography credits appear on page 212.

Printed and bound in Germany by Cantz.

CONTENTS

Director's Foreword
Neal Benezra

The San Francisco Museum of Modern Art has long been considered a leader in exploring how new technologies transform contemporary art. As one of the first museums to establish a media arts department (in 1987), and through innovative exhibitions such as *010101: Art in Technological Times* (2001), SFMOMA has also addressed the impact of technological culture on how a museum carries out its responsibilities to the public. Our Media Arts team is once again breaking new ground in presenting one of the first exhibitions to examine the rich field of participatory art. The practices addressed in *The Art of Participation: 1950 to Now* are, in many ways, related to the Web 2.0 zeitgeist: the collective generation and free sharing of content epitomized by online communities such as Wikipedia, Flickr, Facebook, and YouTube. It is by now generally accepted that these social networking sites have begun to radically transform the ways in which we relate to each other—not only online, but also as a society. Perhaps less well known, however, is that artists of the past half-century pioneered (often in analog form) many of the collaborative strategies adopted and technologized by the 2.0 movement. A full understanding of our current moment is impossible without an awareness of this vital prehistory in the cultural arena.

Conceived by Rudolf Frieling, SFMOMA's curator of media arts, *The Art of Participation* looks back nearly sixty years to contextualize what the critic Umberto Eco has called "open works"—situations created by artists that involve members of the audience as participants or even partners in the art-making process. In a more general sense, this timely project also considers works that address the social systems within which the public engages with art. I would like to acknowledge Rudolf for his innovative conception of the exhibition as a profoundly engaging experience for visitors as well as a richly informative (if necessarily selective) overview of participatory art. Rudolf was aided in his efforts by assistant curator Tanya Zimbardo and curatorial assistant Melissa Pellico, who not only rose to the challenge of coordinating this logistically complicated show, but also contributed insightful text entries to the catalogue. Tammy Fortin provided crucial administrative support during the development of the project.

Ruth Berson, deputy director of exhibitions and collections, administered the many complexities of mounting this presentation, with the able assistance of exhibitions coordinator Emily Lewis. The demanding installation was expertly carried out by Kent Roberts, Greg Wilson, Al Cheves, Steve Dye, and Noah Landis, with significant contributions from registrar Erika Abad and conservators Michelle Barger and Barbara Schertel. Blair Winn and his Development staff, particularly Andrea Morgan, Misty Youmans, and Martina Bill, obtained the funding that underwrote the exhibition and made it possible. The marketing and communications efforts of Nancy Price, Libby Garrison, Caitlin Moneypenny-

Johnston, and Robyn Wise were crucial to building an audience and encouraging public participation in the overall project. Rick Peterson, Simon Blint, and the Visitor Services team paved the way for a satisfying experience in the galleries and other museum spaces. Layna White and Ann Gonzalez in the Collections division must also be thanked for their contributions to the project.

Under the guidance of director of publications Chad Coerver, this remarkable volume was shaped by managing editor Karen Levine into something more than a mere exhibition catalogue. With the enthusiastic partnership of Thames & Hudson, it has grown into a focused survey of participatory practices since the 1950s, incorporating a range of artworks and ideas that could not be accommodated within the scope of the exhibition. The diversity and quality of the reproductions are due in large part to the painstaking, perseverant research of publications assistant Laura Heyenga. The Publications team joins me in thanking authors Boris Groys, Robert Atkins, and Lev Manovich for their contributions to the catalogue. We would also like to acknowledge Adam Brodsley, Eric Heiman, and Iran Narges of Volume Inc., the San Francisco studio behind the book's thoughtful and innovative graphic design. SFMOMA's head of graphic design, Jennifer Sonderby, together with senior designer Terril Neely, effectively translated Volume's idea to the gallery context, while imaging coordinator Susan Backman helped arrange photography of a number of works in the museum's collection.

The Art of Participation is at the heart of a multiyear initiative, supported by the James Irvine Foundation, that will extend the project's spirit of openness and active engagement. Combining exhibition and education programming with other forms of outreach, the effort comprises a kind of laboratory, testing ways in which the three-way relationship between the museum, artists, and the public can be reinvented. That the initiative exists is in large part due to the vision of Dominic Willsdon, Leanne and George Roberts Curator of Education and Public Programs. For their work on *The Art of Participation*, as well as the larger slate of programming that it has inspired, we thank SFMOMA's entire Education Department, particularly Peter Samis, Frank Smigiel, Stephanie Pau, and Suzanne Stein.

All of us at SFMOMA are grateful to the Irvine Foundation, the museum's Collectors Forum auxiliary, and the Goethe-Institut San Francisco for generously funding the presentation. Without their support of the exhibition, and without the efforts of our truly dedicated staff, we would never have had this outstanding opportunity to develop new ways to engage museum audiences, both now and in the future.

Introduction
Rudolf Frieling

Why participate in the first place? Why not just appreciate what others have made? There are as many motivations to engage in participatory art as there are reasons to refuse. At the same time, we have no choice whether or not to participate in the larger context of society (truly escapist notions aside). We are already embedded members of families, communities, associations, schools, and possibly also museums. Yet the etymology of participation—from the Latin *participare* (to participate), derived from *pars* (part) and the root of *capere* (to take)—stresses the transitive verb.[1] We actively become part of a larger whole without necessarily knowing what this might constitute. We trust that we will find out by participating. But is there an art of participation?

1 See http://www.etymonline.com/index.php?term=participation (accessed July 13, 2008).

Though many exhibitions have included works of a collaborative or participatory nature, this project represents one of the first sustained explorations of the genealogy of participation in a museum context. What has become a relatively common practice at alternative spaces, in public places, or at community centers is now the focus of a museum exhibition. Is this a contradiction that compromises the anti-institutional stance of many artists? Is there an inherent conflict between the museum as an institution and a truly participatory practice? Or does the San Francisco Museum of Modern Art's staging of such a show indicate a paradigm shift within the traditional art context? These questions need to be addressed, though we should be wary of jumping to immediate conclusions.

Tellingly, during its early preparatory stages *The Art of Participation* was called *MyMuseum,* a nod to the rise of online social platforms such as MySpace and Facebook. It has gradually evolved, however, into an exploration of the myriad ways in which a museum can address the public, interact with its audiences, and invite the active involvement of its visitors. The prominence of what has become known as Web 2.0, as well as our museum's proximity to technological culture in the San Francisco Bay Area, has inspired SFMOMA to question its role in a world that has fully embraced the new tools of social networking. In this respect, *The Art of Participation* is an urgent response to a radically changing environment. But far from being positivistic about this development, I propose instead that we look at ways in which artists have addressed and continue to address these issues in their specific (and often entirely subjective) ways. When artists are doing it, the museum must do it as well. It is as easy as that—and yet things are complicated.

One of the inherent and unsolvable problems of participatory art is that an exhibition addressing the genre can never fully achieve its promise. On the one hand, truly participatory art—that which goes beyond symbolic gestures—is a utopian ideal rather than an artistic or political reality. On the other, the inclusiveness of a curated show is inevitably compromised by limited space and funding. By referencing artists and artworks

outside the scope of the gallery presentation, this catalogue aims to expand the context historically, politically, and technologically (see, respectively, the essays by Boris Groys, Robert Atkins, and Lev Manovich). In the plate section, exemplary works by artists in the exhibition are juxtaposed with projects by other significant practitioners, providing, we hope, the material for an informed discussion of participation in art—or rather, as the title of my essay suggests, a discussion that moves us toward a better grasp of the concept. The essay title is an homage to the Fluxus artist George Brecht, who in 1959 named his first solo exhibition *Toward Events*. Suggesting a direction rather than a goal, a process rather than a finished object, it was the first of Brecht's projects to announce his interest in performative concepts. In the same vein, *The Art of Participation* gestures toward an understanding rather than asserting a definitive statement. More than fifty years after John Cage's groundbreaking composition *4'33"*, the starting point of this exhibition, we have yet to come to terms with the radical implications of participatory art.

Not all of the works in the show are participatory in the strict sense of the word. Some are documents of past performances or events; others are merely concepts. There are also projects that address the limitations of audience engagement. The resistance to or critique of participation is a necessary part of the argument. It is a beautiful and sometimes irritating moment when we come to understand that a participatory event cannot "fail" in the traditional sense. Participatory art is an open invitation: the viewers' refusal to participate, or the participation of only a small number of people, counts as much as total physical engagement. Watching others participate—what is called "lurking" in the online context—is an inherent part of the experience.

A number of recent exhibitions have included live elements that might previously have been considered nonartistic or too performative to be included in a permanent installation. Some artists, meanwhile, have specifically addressed the functions of gallery spaces, often drawing freely from architecture and design in order to explore a site's functionality and social use (consider, for example, the lounges, bars, and social spaces created by figures such as Gerwald Rockenschaub and Rirkrit Tiravanija). Reflecting on these developments, SFMOMA has commissioned the Brooklyn-based architectural group Freecell to transform the museum's Koret Visitor Education Center into a space for live events, screenings, conversations, meetings, workshops, and more. Clearly referencing the do-it-yourself tradition, Freecell's *Stack to Fold* concept (fig. 1) is a modular cardboard environment with various perforated shapes that visitors may remove and reconfigure as benches, tables, desks, pedestals, and other objects. What starts as a two-dimensional instruction kit becomes, over time, a dynamic three-dimensional landscape for inhabitation and use. Both functional and playful, the project is entirely in the spirit of the Fluxus works that are highlighted in the exhibition.

The gallery presentation of *The Art of Participation* brings together historical and contemporary concepts of participation, tracing a lineage of artistic approaches that include

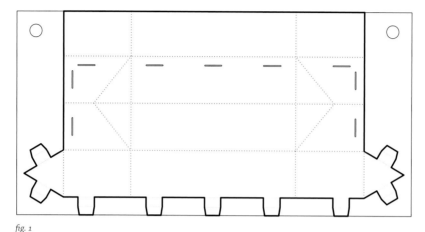

fig. 1

fig. 1
Freecell
Stack to Fold, 2008
Flat pattern diagram
of project for the Koret
Visitor Education Center,
San Francisco Museum
of Modern Art, 2008 /
Corrugated cardboard /
Courtesy the artists

communication art, institutional critique, relational aesthetics, and social practice. It thus reveals the diverse ways in which artists and viewers have critically engaged art institutions, examined modes of cultural consumption, and challenged not only the traditional model of authorship, but also utopian notions of political participation. It does so, however, by also exhibiting the gap between conceptual gestures and actual processes.

It is a rare opportunity for a curator to be able to take a critical as well as a productive stance in addressing institutional issues. During my research for this project, I was often struck by the fact that museums have approached concepts related to process and participation before, though never in such a comprehensive way. Between 1968 and 1972 there was an especially fruitful period of groundbreaking exhibitions, including the late Harald Szeemann's *Live in Your Head: When Attitudes Become Form* (1969) and *Documenta 5* (1972) as well as the New York shows *Information* and *Software* (both 1970). We are only beginning to understand the full impact of their legacy. One reason is surely the inherent difficulty of dealing with process-based works in an institutional context. SFMOMA exhibited Tom Marioni's salon *The Act of Drinking Beer with Friends Is the Highest Form of Art* in 1979, for example, yet it still arouses many concerns thirty years later (one of them being that too many people might take up the artist's offer of free beer!).

What has changed since the 1960s and 1970s—as was made clear in 1997 by Geert Lovink and Pit Schultz's *Hybrid Workspace* project at *Documenta 10*—is the fact that our contemporary media society has developed a global network of real-time communication that would once have been impossible to imagine.[2] Some museums have reacted to this shift by accommodating the demands of individual artists who wish to present participatory projects. Others have become champions of multimedia, particularly in their educational initiatives, while at the same time keeping the institutional implications of public engagement at bay. This is understandable as a structural condition. But what is at stake now is an entire generation of museumgoers—those who were "born digital." How do such

2 A few pioneers were moving in this direction as early as the 1950s, however. One was Stan VanDerBeek, who started working on films for his "Movie-Drome" in 1957; construction on this community theater in Stony Point, New York, was begun in 1963 and never completed. For an excerpt from VanDerBeek's "Culture Intercom, a Proposal and Manifesto," see http://www.mediaartnet.org/source-text/12/. Another example was Nam June Paik, who was among the first to envision the "Electronic Superhighway" in "Media Planning for the Postindustrial Society: The 21st Century Is Now Only 26 Years Away" (1974), first published in German in *Nam June Paik: Werke 1946–1976; Musik, Fluxus, Video* (Cologne: Kölnischer Kunstverein, 1976). See http://www.mediaartnet.org/source-text/33/.

audiences respond to the offerings of a museum? How do new modes of communicating and distributing information change a museum's policies and attitudes? Artists were the first to ask these questions, and it is now up to us to revisit their legacy, up to and including their resistance to illusions of full equality, communication, and participation. Politically speaking, the process of mutual exchange between visitors, users, artists, curators, and collectors is essential.

To paraphrase a truism on art coined by the late German comedian Karl Valentin, participation is beautiful, but it's a lot of work. During the development of this project, numerous institutions and individuals kindly provided information and loans or collaborated on parts of the exhibition. I would like to express particular thanks to Jeff Aldrich, Susan Allen, Paule Anglim, Carlos Basualdo, Henrik Bennetsen, MacKenzie Bennett, Laura Blereau, Natalie Bouchard, Maria del Carmen Carrión, Rob Ceballos, Diane Choplin, Alessandra, Álvaro, Eduardo, and Elisabeth Clark, Brian Conley, Daniell Cornell, Karina Daskalov, Susan Davidson, Hugh M. Davies, Steve Dietz, Glynn Edwards, Michelle Elligott, Ulrich Everding, Sabine Folie, Peter Frei, Ed Gilbert, Marian Goodman, Ken Hakuta, John Hanhardt, Jon Hendricks, Stephen Henry, Wulf Herzogenrath, Donald Hess, Antonio Homem, Bellatrix Hubert, Jon Huffman, Brooke Kellaway, Pamela and Richard Kramlich, Irwin Kremen, Laura Kuhn, Sooyoung Lee, Youngchul Lee, Doris Leutgeb, Henry Lowood, Ilona Lütken, Gideon May, Dare and Themistocles Michos, Virginia Mokslaveskas, Christophe Musitelli, Anna Mustonen, Sandra Percival, Paul Rauschelbach, Marcia Reed, Steven Sacks, Doniece Sandoval, Felipe Scovino, Christopher Seguine, Steve Seid, Michael Shanks, Susan Sherrick, Myrtha Steiner, Matthew Tiews, Susan Toland, Roberto Trujillo, and Queenie Wong. Students of the San Francisco Art Institute and the Academy of Art University, San Francisco, helpfully staffed the photo studio for Jochen Gerz's *The Gift*. Thanks also to all of the artists who so generously shared their works and ideas with the entire SFMOMA team. This experience of productive collaboration is always the most stimulating and engaging part of organizing any exhibition.

In closing, I must express deep gratitude to SFMOMA director Neal Benezra for embracing the idea behind this exhibition as well as to all of my colleagues who have supported the project from its inception. Though this has been a truly collective effort, I especially thank assistant curator Tanya Zimbardo and curatorial assistant Melissa Pellico, who not only contributed significantly to shaping the presentation, but also took care of thousands of details in the most reliable and good-humored way. I am also fortunate to have the support of Sybille Weber and our children, who so generously reorganized their lives during our move from Germany to San Francisco. Thanks to all of you.

ESSAYS

BORIS GROYS

A GENEALOGY OF PARTICIPATORY ART

A tendency toward collaborative, participatory practice is undeniably one of the main characteristics of contemporary art. Emerging throughout the world are numerous artists' groups that pointedly stipulate collective, even anonymous, authorship of their artistic activities. What we are concerned with here are events, projects, political interventions, social analyses, or independent educational institutions that are initiated, in many cases, by individual artists, but that can ultimately be realized only by the involvement of many. Moreover, collaborative practices of this type are geared toward the goal of motivating the public to join in, to activate the social milieu in which these practices unfold.[1] In short, we are dealing with numerous attempts to question and transform the fundamental condition of how modern art functions—namely, the radical separation of artists and their public.

Admittedly, these attempts are not new; indeed, they have their own well-established genealogy. One might contend that this genealogy dates as far back as modern art itself. In the early Romantic era, at the end of the eighteenth and beginning of the nineteenth centuries, poets and artists started to form groups that bemoaned the separation of art from its audience. At first glance such complaints may seem a bit surprising, for the separation of the artist from his or her audience was a result of the secularization of art—its liberation from clerical paternalism and censorship. However, the period in which art was able to enjoy its newfound freedom lasted only a short time. Many artists did not

consider the modern division of labor, which had conferred a new social status upon art, to be particularly advantageous.

The modern state of affairs can be described easily enough: the artist produces and exhibits art, and the public views and evaluates what is exhibited. This arrangement would seem primarily to benefit the artist, who shows himself to be an active individual in opposition to a passive, anonymous mass audience. The artist has the power to popularize his name, whereas the identities of the viewers remain unknown despite the fact that their validation has facilitated the artist's success. Modern art can thus easily be misconstrued as an apparatus for manufacturing artistic celebrity at the expense of the public. However, what is often overlooked is the fact that under the aegis of modernity, the artist is but an impotent agent at the mercy of the public's good opinion. If an artwork does not find favor with the public, then it is de facto devoid of value. This is modern art's main pitfall: the artwork has no "inner" value of its own. It has no merit other than the recognition the viewing public bestows upon it, for unlike science or technology it has no compelling function independent of the whims and preferences of its audience.

The statues in ancient temples were regarded as embodiments of the gods: they were revered, one kneeled down before them in prayer and supplication, one expected help from them and feared their wrath and concomitant threat of punishment. Similarly, the veneration of icons also exists as a tradition within Christianity—even if God is deemed to be invisible. The artwork has a completely different significance here than it does in secularized modernity. Of course, it was always possible to differentiate between good and bad art. Aesthetic disapproval, however, was insufficient reason to reject an artwork. Poorly made idols and badly painted icons were nevertheless part of the sacred order. Throwing them out would have been sacrilegious. In the context of religious ritual, artworks considered to be aesthetically pleasing and those considered to be aesthetically displeasing can be used with equal legitimacy and to similar effect. Within a specific religious tradition, artworks therefore have their own individual, "inner" value, which is autonomous because it is independent of the public's aesthetic judgment. This value derives from the participation of the artist and his public in communal religious practice, in their mutual membership in the same religious community—an affiliation that relativizes the gulf between the artist and his public.

By contrast, the secularization of art entails its radical devaluation. That is why Hegel asserted early on that art was a thing of the past for the modern world.[2] No modern artist could expect anyone to kneel before his work in prayer, expect practical assistance from it, or use it to avert danger. The most one is prepared to do nowadays is find an artwork interesting— and of course ask how much it costs. Price immunizes the artwork from public taste to a certain degree. A good deal of the art held in museums today would have ended up in the trash a long time ago had the

1 See Claire Bishop, ed., *Participation* (London: Whitechapel; Cambridge, MA: MIT Press, 2006), and Nina Möntmann, *Kunst als sozialer Raum* (Cologne: Walter König, 2002). 2 See Georg Wilhelm Friedrich Hegel, *Introductory Lectures on Aesthetics*, ed. Michael Inwood, trans. Bernard Bosanquet (London: Penguin, 1993), 12–13.

immediate effect of public taste not been limited by economic considerations. Communal economic participation weakens the radical separation between the artist and his audience, and concomitantly forces the public to respect an artwork because of its elevated price, even if it is not particularly liked. However, there is a big difference between the religious and financial values of an artwork. The price of an artwork is nothing other than the quantifiable result of aesthetic value that others have discerned in it. But public taste is not binding for the individual in the same way that common religion is. The respect paid to an artwork because of its price is by no means automatically translatable into appreciation per se. The binding value of art can thus be sought only in noncommercial— if not directly anticommercial and simultaneously collaborative—practice.

For this reason many modern artists have tried to regain common ground with their audiences by enticing viewers out of their passive roles, bridging the comfortable aesthetic distance that allows uninvolved viewers to judge an artwork impartially from a secure, external perspective. The majority of these attempts have involved political or ideological engagement of one sort or another. Religious community is thus replaced by a political movement in which artists and their audiences both participate. That said, the practices that are relevant to the genealogy of participatory art are chiefly those that not only subscribed thematically to a sociopolitical goal, but also collectivized their core structures and means of production. When the viewer is involved in artistic practice from the outset, every piece of criticism he utters is self-criticism. The decision on the part of the artist to relinquish his exclusive authorship would seem primarily to empower the viewer. This sacrifice ultimately benefits the artist, however, for it frees him from the power that the cold eye of the uninvolved viewer exerts over the resulting artwork.

The Gesamtkunstwerk: The Self-Sacrifice of the Artist

The strategy Richard Wagner set forth in his seminal essay "The Art-work of the Future" (1849–50) is still central to any discourse on participatory art, and it is thus worth recapitulating the main points of his text. Wagner wrote "The Art-work of the Future" shortly after the failure of the 1848 Revolution; it represents an attempt to achieve the political aims of that uprising through aesthetic means. At the beginning of the treatise Wagner states that the typical artist of his time is an egoist who is completely isolated from the life of the people and practices his art for the luxury of the rich; in so doing he exclusively follows the dictates of fashion. By contrast, the artwork of the future must realize the need for "the passing over of Egoism into Communism."[3] In order to reach this goal

3 Richard Wagner, *The Art-work of the Future,* trans. W. Ashton Ellis (Lincoln: University of Nebraska Press, 1993), 78. all artists should abandon their social isolation in two regards. First, they must overcome the distinctions between various artistic genres—or, as we might call them today, different artistic media. Overcoming boundaries between the respective media would require artists to form fellowships, in which creative individuals with expertise in different media would participate. Second, these artists' fellowships

must forgo the inclination to adopt themes or positions that are merely arbitrary or subjective; their talents should be used to express the artistic desire (*Kunstwollen*) of the people. Artists must recognize that the people, as an entity, are the only true artist: "Not ye wise men, therefore, are the true inventors, but the Folk; for Want it was, that drove it to invention. All great inventions are the People's deed; whereas the devisings of the intellect are but the exploitations, the derivatives, nay, the splinterings and disfigurements of the great inventions of the Folk."[4] Wagner views himself as a consistent materialist; he sees not the spirit but rather matter—substance, life, nature—as the source of truth. Wagner understands the people to be the substance of social life, and that is why he calls upon the artist to forgo his subjective, active, willful spirit and become one with the stuff, the very material, of life.

The unification of all creative genres to create the gesamtkunstwerk, or total artwork, demanded by Wagner (and put into practice in his own work) is by no means to be understood in purely formal terms. It is not a multimedia spectacle designed to captivate the imagination of the viewer. The synthesis of artistic genres is for Wagner more a means to an end: the unity of individual human beings, the unity of artists among themselves, and the unity of artists and the people. Wagner's understanding of the people is thoroughly materialistic—he views them primarily as bodies. In his estimation individual artistic genres are merely formalized, technicalized, mechanized bodily functions separated from the whole of the human body. People sing, dance, write poetry, or paint because these practices derive from the natural constitution of their bodies. The isolation and professionalization of these activities represent a kind of theft perpetrated by the wealthy classes upon the people. This theft must be redressed, and the individual reunited in order to re-create the inner unity of each person as well as the unity of the people. For Wagner the gesamtkunstwerk is primarily a social, even political project: "The great United Art-work, which must gather up each branch of art to use it as a mean, and in some sense to undo it for the common aim of *all*, for the unconditioned, absolute portrayal of perfected human nature,—this great United Art-work [the artist] cannot picture depending on the arbitrary purpose of some human unit, but can only conceive it as the instinctive and associate product of the Manhood of the Future."[5]

4 Ibid., 80. 5 Ibid., 88.

Wagner's reference to the future is by no means coincidental. He does not want to create his gesamtkunstwerk for his contemporaries, a people divided—in unholy fashion, as he describes it—between an elite and the hoi polloi. By contrast, the community of the future will derive from the realization of the gesamtkunstwerk, a dramatic synthesis that will unite every person participating in it. This drama represents nothing other than the staged demise of the individual, for only such a staging can symbolically

overcome the isolation of the artist and establish the unity of the people. Notes Wagner: "The last, completest renunciation (*Entäußerung*) of his personal egoism, the demonstration of his full ascent into universalism, a man can only show us by his *Death*; and that not by his accidental, but by his *necessary* death, the logical sequel to his actions, the last fulfilment of his being. *The celebration of such a death is the noblest thing that men can enter on.*"[6] The individual must die in order to promote the establishment of a participatory—or, as Wagner puts it, a communist—society. Admittedly, there remains a difference between the hero who sacrifices himself and the performer who makes this sacrifice onstage. Nonetheless, Wagner insists that this difference is suspended within the gesamtkunstwerk, for the performer "not merely *represents* in the artwork the action of the fêted hero, but *repeats* its moral lesson; insomuch as he proves by this surrender of his personality that he also, in his artistic action, is obeying a dictate of Necessity which consumes the whole individuality of his being."[7] The performer must surrender his own specific purpose in order to be able to represent the hero's sacrifice or, as Wagner puts it, "to use up, to destroy the means of art." In this way he is on even footing with the hero. For Wagner, the performer is not just an actor but also a poet and an artist—the author of the gesamtkunstwerk who has become a performer insofar as he is publicly enacting the surrender of his artistic egoism, his isolation, his supposed authorial autonomy.[8]

6 Ibid., 199.
7 Ibid., 201.
8 See ibid., 196ff.

This passage is undoubtedly of central importance for Wagner's essay. The author of the gesamtkunstwerk forgoes his subjective authorial power by reducing his own creative role, reenacting the sacrificial rituals of ancient religions, the sacred feasts of antiquity, the hero's death in the name of the common good. As far as Wagner is concerned, the author is not dead, as argued later by French poststructuralist theoreticians such as Roland Barthes, Michel Foucault, and Jacques Derrida. Were the author truly dead, it would be impossible to differentiate between participatory and nonparticipatory art, because this can only occur through the celebrated surrender of authorship by the artist. The general delight surrounding the idea of the death of the author should not belie the fact that the author must always preordain this demise. One might also claim that the enactment of this self-abdication, this dissolution of the self into the masses, grants the author the possibility of controlling the audience—whereby the viewer forfeits his secure external position, his aesthetic distance from the artwork, and thus becomes not just a participant but also an integral part of the artwork. In this way participatory art can be understood not only as a reduction, but also as an extension, of authorial power.

Wagner is fully aware of this dialectic within the participatory gesamtkunstwerk. Thus he speaks of the necessary dictatorship of the poet-performer, even if he emphasizes that this authority should be predicated upon the basis of common enthusiasm—through the

readiness of the other artists to participate. Wagner states that "The *might of individuality* will never assert itself more positively than in the free artistic fellowship."[9] This fellowship forms with the express goal of setting the stage for the poet-performer so that he can ceremonially forego his status as author and be absorbed into the people. All other members of the group achieve their own artistic significance solely through participation in this ritual of surrender and self-sacrifice. Wagner's analysis of comedy is especially interesting in this regard, for it demonstrates that only the main performer is granted the right to fall ceremoniously and tragically. Any attempt by other participants to stage their own authorship also results in the demise of that authorship. In this case, however, the demise of authorship does not look tragic but rather comical. Wagner comments in a footnote:

> The hero of the Comedy will be the obverse of the hero of the Tragedy. Just as the one instinctively directed all his actions to his surroundings and his foils—as a Communist, *i.e.* as a unit who of his inner, free Necessity, and by his force of character, ascends into the Generality—so the other in his rôle of Egoist, of foe to the principle of Generality...will be withstood...hard pressed by it, and finally subdued. The Egoist will be *compelled* to ascend into *Community*...and, without further breathing-space for his self-seeking, he sees at last his only rescue in the unconditional acknowledgment of its necessity. The artistic Fellowship, as the representative of Generality, will therefore have in Comedy an even directer share in the framing of the poem itself, than in Tragedy.[10]

For Wagner, the artist's renunciation of his authorial status with the express aim of establishing a communal artistic fellowship thus remains ambivalent. The merging of the artist with the people takes place onstage, so the public can only identify with the demise of the hero symbolically. Moreover, Wagner's artistic language remains alien to the broad mass of the people. In his essay "What Is Art?" Leo Tolstoy describes in brilliantly ironic fashion the disconcerting impression that Wagner's operas have on a "normal" member of the audience, who is neither able nor willing to penetrate its coded, symbolic meanings.[11] Furthermore, modern art has attempted both to deprofessionalize itself and to involve the audience more radically and immediately than Wagnerian opera was ever able to do.

Excess, Scandal, Carnival

Many radical avant-garde movements at the beginning of the twentieth century did indeed choose the path designed by Wagner in his "Art-work of the Future." The Italian Futurists and Zurich Dadaists were representative of groups that pursued the dissolution of artistic individuality, authority, and authorship on many levels of their respective practices. At the same time, they were more direct when it came to activating their audiences, deliberately scandalizing the public or attacking audience members physically. The Italian Futurists grouped around Filippo Tommaso Marinetti repeatedly provoked public scandals—often resulting in common brawls—in order to wrest the audience out

fig. 2
Unknown Artist
A futurist serata in Perugia, 1914
Ink on paper / 8¼ × 11⅛ in. / Courtesy Archivi Gerardo Dottori, Perugia

9 Ibid., 200. **10** Ibid., 201. **11** See Leo Tolstoy, *What Is Art?*, trans. Richard Pevear and Laura Volokhonsky (London: Penguin, 1995).

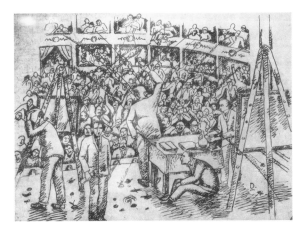

fig. 2

of its purely contemplative, passive attitude (see fig. 2). In this way the Futurists created a new synthesis between politics and art: they understood both as a kind of event design—as strategies of conquering public space by means of provocation, which served as a catalyst to activate and expose the concealed energies of the masses. In her book on Margherita Sarfatti, who played an important role as a mediator between the Futurists and Fascism, Karin Wieland states that the Futurists' motto was "War on a nightly basis":

> Marinetti introduced a new tone into politics. He exposed a new socio-psychological dimension with his rebellion against tradition and the law, which neither the liberals nor the socialists had anticipated. He incorporated the methods of a political electoral campaign into art: newspapers, manifestos, public appearances, and scandals.[12]

The Futurists' strategy, aimed less at creating individual art objects and more toward events and collective experiences (see fig. 3), was duly borrowed by the Zurich Dadaists (though admittedly the Dadaists did not subscribe to Futurism's bellicose nationalistic ideology). The majority of Dada artists, who had gathered in Switzerland during World War I on account of its neutrality, were pacifists and internationalists, a fact that is made all the more interesting when one realizes that their artistic practice owed a lot to Italian Futurism. Participants in Dada events at the Cabaret Voltaire in Zurich, which were chiefly inspired and arranged by Hugo Ball, provoked the audience and allowed the spectacle to result in general tumult. Incidentally, Ball conceived the Cabaret Voltaire as a kind of gesamtkunstwerk from the outset.[13] One might contend that his cabaret was a parodic as well as absolutely serious-minded renaissance of the Wagnerian project. In public performances of simultaneous poetry, during which multiple speakers concurrently recited poems in different languages onstage, the meaning of any individual text and the sound of any individual voice were drowned within the indecipherable, anonymous tonal material. The disappearance of the individual voice amid the collective, resonant whole was the actual aim of the event. Ball writes that "the *poème simultan* deals with the value of the *vox humana*. The human organ loses the soul, the individuality.... The poem exemplifies how man is swallowed up by the mechanical process."[14] In his most well-known performance, on June 25, 1917, Ball appeared wearing quasiepiscopal robes and reciting a poem that consisted of sound combinations having no meaning in any known language (see fig. 4). The sound poem provoked a tumultuous response from the audience. Ball recalls that in order to psychologically

12 Karin Wieland, *Die Geliebte des Duce: Das Leben der Margherita Sarfatti und die Erfindung des Faschismus* (Munich: Carl Hanser Verlag, 2004), 93–94. **13** According to Hans Richter, this was due to Wassily Kandinsky's influence. See Richter, *Dada, Art and Anti-Art*, trans. David Britt (London: Thames & Hudson, 1997), 35. **14** Ibid., 28.

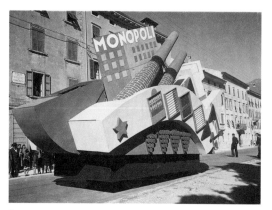

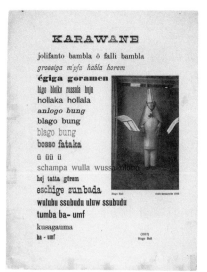

fig. 3

fig. 4

fig. 3
Fortunato Depero's
futurist float for the
Festival of Grapes parade
in Rovereto, Italy, 1936

fig. 4
Hugo Ball
Karawane, 1919
Proof sheet for the
projected anthology
Dadaco showing a 1916
photograph of the artist
in costume at the Cabaret
Voltaire / 12½ × 14¼ in. /
The Israel Museum,
Jerusalem, the Vera and
Arturo Schwarz Collection
of Dada and Surrealist Art

fig. 5
Vladimir Tatlin's
*Monument to the Third
International* (1920) being
paraded through the
streets of Moscow, ca. 1927

withstand the abuse from the audience he modeled his vocal delivery upon a church sermon, even if the words remained meaningless combinations of sounds manifesting only the sonic material of language. A new paradoxical religion of materialism was being celebrated here—a transvaluation of nonsense into the highest degree of sense.[15] The same strategy may be observed in the later activities of the Surrealists surrounding André Breton, who collectively forsook conscious control over the production of art in favor of the spontaneous effect of the subconscious, but at the same time were politically engaged and continually provoked public scandal. Various Russian avant-garde groups during the second and third decades of the twentieth century also tried to instigate the demise of the solitary creative artist in order to include the broader masses in artistic practice—and thus transform an entire nation still vibrant from the victory of communism into a gesamtkunstwerk in which all things individual were absorbed into and by the collective (see fig. 5).

The argument against such practices has often been that they are repetitive and, with the passage of time, forfeit their power to shock or provoke. The repetition of authorial surrender seems to diminish the value of this sacrifice, if not to nullify it entirely. However, we know from literature on the subject that the efficacy of sacrificial ritual is primarily a result of its repetitive character. Thus Georges Bataille describes Aztec sacrificial rituals as practices that renewed the vital strength of the society precisely through their constant repetition.[16] In his book *Man and the Sacred* Roger Caillois describes the collapse of public order that wrests the people from their customary passivity and unites them whenever a monarch dies or such a death is ritually enacted.[17] It is important not to forget at this juncture that religious sacrificial rituals always featured a central protagonist who represented a king or a god and who was publicly venerated and subsequently sacrificed. Admittedly, the modern artist is allowed to survive, but he does not escape completely unscathed. The artist's actual sacrifice resides in his self-subjugation to the repetition of the sacrificial ritual and in his renunciation of the uniqueness of his artistic individuality—a kind of second-degree sacrifice, so to speak. And this second-degree sacrifice is

15 See ibid., 40ff. **16** See Georges Bataille, *The Accursed Share,* vol. 1, trans. Robert Hurley (New York: Zone Books, 1991), 46ff. **17** See Roger Caillois, *Man and the Sacred,* trans. Meyer Barash (Urbana: University of Illinois Press, 2001).

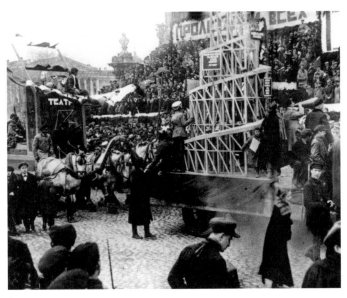

fig. 5

unique each time it occurs; although the ritual remains the same, the artistic individuality being sacrificed is invariably different.

In this sense it is also interesting to note that if Bataille and Caillois, both of whom were close to Surrealism, describe sacrificial ritual in a tragic tone, Mikhail Bakhtin places the same ritual in the context of carnival: the entertainment and merriment of the people. "In such a system the king is the clown," Bakhtin writes. "He is elected by all the people and is mocked by all the people.... Abuse is death, it is former youth transformed into old age, the living body turned into a corpse. It is the 'mirror of comedy' reflecting that which must die a historic death."[18] Bakhtin developed his theory of the carnival during the 1930s and 1940s in the Soviet Union, which perceived itself to be an actual communist society. In such a society, individualism—to use the Wagnerian expression—was short of breath: an egoist was automatically an enemy of the people. It is not by chance that Bakhtin describes the demise of the individual, his dissolution into generality, in terms of comedy, not tragedy. This demise elicits only laughter from the people—a happy, carnivalesque laughter that, according to Bakhtin, constitutes and supports the festival in which the entire populace can participate. Accordingly, Bakhtin sees carnival, rather than tragedy, as a model for a participatory—or, as he calls it, a carnivalized—artwork of the future. Far removed from Wagnerian tragedy or gloom, such artwork propagates an exuberant atmosphere of joie de vivre by staging and celebrating the victory of the collective body over individual spirit.

During the 1960s artists' collectives as well as happenings, performances, and similar events were famously reborn on a worldwide scale. Among their number, to name but a few examples, were Fluxus, Guy Debord's Situationist International, and Andy Warhol's Factory (see fig. 6). In all of these cases the twofold aim was both the collaboration of different artists and the synthesis of all artistic media. However, central to these activities was the readiness of artists to forego their isolated, elevated, privileged position in relation to the audience. Fluxus practitioners played at being entertainers and event managers; Warhol propagated art as business and business as art. Whether the

18 Mikhail Bakhtin, *Rabelais and His World,* trans. Hélène Iswolsky (Bloomington: Indiana University Press, 1984), 197–98.

fig. 6
Andy Warhol and
Gerard Malanga at work
in Warhol's Factory,
New York, ca. 1966

fig. 6

respective artists presented themselves as propagandists, provocateurs, or businessmen
is less important than the fact that they tried in equal measure to devalue the symbolic
value of art and to surrender their personal individuality and authorship to commonality.
All of this was conducted in an atmosphere that was more humorous or carnivalesque
than tragic. The Wagnerian ideal of the tragic fall was only realized in a few and thus
notable exceptions. For example, Debord's attempt to dissolve his artistic individuality
in the collective practice of the Situationist International collapsed and resulted in (self-
imposed) isolation. Debord's fate is paradigmatic of the kind of problems confronting
anyone wanting to stage and control his authorial demise. The insoluble nature of such
problems is nevertheless no argument against the gesamtkunstwerk project, but rather
the reverse: the formal, logical guarantee of its realization. For it is the paradox of the
consciously staged, self-orchestrated fall that causes the author of the gesamtkunstwerk
to fail—thus simultaneously realizing the very gesamtkunstwerk itself, which is nothing
other than the public performance of artistic failure.

Despite the aforementioned groups' historical, ideological, aesthetic, and other dif-
ferences, there is something that unites their attempts to stage the gesamtkunstwerk:
they all presuppose the material, corporeal presence of the artist and the audience in
the same (real) room. Be it a Wagnerian opera, a futurist scandal, a Fluxus happening,
or a situationist event, each has the same goal: to unite the artist and the audience at a
particular location. What, then, of the virtual spaces and interactions that increasingly
determine cultural practice, particularly in our own time? One is often inclined to think
of contemporary digital media as interactive or participatory per se. And so it seems less
imperative today to gather people together physically in one place in order to promote
a sense of participation in a social event. It seems possible to create this feeling equally
well using virtual means, for example through participation in interactive digital mass
media via the internet.

Is the Internet Cool?

The relationship between "actual" bodily participation and virtual participation seems particularly relevant to discussions of net art exhibitions and other practices that try to usher internet users into exhibition spaces, making the act of using computers a public event rather than an act performed by the user in the privacy of his or her own home. The socialization and display of computer usage may at first appear to be superfluous if one presupposes that it was already public, interactive, and participatory (albeit virtual). In the case of virtual communication and participation, however, the body of the person using the computer is of no consequence—apart, say, from the physical manifestations of fatigue that are inevitable after a few hours in front of the screen. The experience of bodily presence, for which modern art has continually striven, is absent in virtual communication. As a computer user, one is engrossed in solitary communication with the medium; one falls into a state of self-oblivion, of unawareness of one's own body, that is analogous to the experience of reading a book.

Indeed, the virtual space of the internet is not so different from the traditional space of literature as one might imagine. The internet does not replace printing, it merely makes it more quickly and cheaply accessible—but also more discerning and demanding for the user. The user is obliged to print out her texts herself, to illustrate and design them instead of simply handing them over to a printer. Thus, when one asks oneself whether the internet is participatory, the answer is yes—but typically in the same way as literary space. Everything that ends up in virtual literary spaces is acknowledged by other participants and provokes a reaction, which in turn provokes further reactions. Literary space is fragmentary, but its protagonists do indeed participate in the competition for recognition. The internet is also a medium for competition—tallies are kept of how many hits a particular site receives, how many mentions there are of this or that user, and so forth. This kind of participation would appear to have little to do with Wagner's vision of the individual seamlessly merging with the masses. The goal of participatory art within the tradition of the Wagnerian gesamtkunstwerk does not reside in waiting for technical and social progress (which, as is generally known, can never be concluded), but rather in creating universally accessible art events, here and now, beyond education, professionalization, and specialization. An effective use of the internet, however, requires a good deal of specialized knowledge. The technology is subject to constant modification and updates, differentiating users from one another intellectually as well as economically.

The analogy between traditional literary space and the internet is often overlooked, for we generally perceive electronic media such as the web to be fundamentally different from the older analog media. This view is doubtlessly rooted in Marshall McLuhan's 1964 book *Understanding Media,* which elucidates the difference between so-called hot mechanical media—the best example being print—and cool electric media such as television. In McLuhan's view hot media lead to the fragmentation of society. Cool media

conversely create global, participatory, interactive spaces and practices that overcome the isolation of the individual author, so "it is no longer possible to adopt the aloof and dissociated role of the literate Westerner."[19] McLuhan continues: "Electric speed mingles the cultures of prehistory with the dregs of industrial marketeers, the nonliterate with the semiliterate and the postliterate."[20] Under these new medial conditions, the Wagnerian program of the gesamtkunstwerk, which is intent upon uniting the entire populace irrespective of varying levels of education, can be realized automatically through technical progress.

Indeed, McLuhan's understanding of the media shares many similarities with Wagner's vision. Both interpret the individual media as extensions of the corresponding capabilities of the human body. For both the human being is the original medium; all other media are derived from this source. It is not by chance that McLuhan's book bears the subtitle *The Extensions of Man.* However, unlike Wagner, McLuhan does not call for a return to the source medium (to mankind, the people) in order to overcome the isolation of the individual (codetermined by the separation of the media) and bring about the participation of all. McLuhan attributes the modern isolation of the individual—and, above all, that of the intellectual and the artist—not to the differentiation of the respective media, but rather to the specific constitution of the traditional hot mechanical media that dominated the modern period. McLuhan hopes, therefore, that the new cool electric media will enable transition to a new era of collectivity, simultaneity, and openness.

Nonetheless, McLuhan does not view this transition as a return to the source medium, the human body, but as a complete anaesthetization—a "numbing" of man, as he calls it.[21] He believes that every extension of the human body entails its simultaneous "auto-amputation"; the human organism that has received a medial extension is anesthetized, as it were. According to McLuhan, because electronic media effectuate the extension of the human nervous system, which in turn defines the human being as a whole, their generation entails the ultimate numbing of humanity. Writing is a hot medium because it mobilizes people's attention by demanding a high degree of concentration. On the contrary, electric media are cold because they create a passive communicative situation that demands less attention. "There is a basic principle that distinguishes a hot medium like radio from a cool one like the telephone, or a hot medium like the movie from a cool one like TV," states McLuhan. "A hot medium is one that extends one single sense in 'high definition.' High definition is the state of being well filled with data."[22] One can reformulate it thus: a cold medium does not differentiate between nonspecialists and specialists, the trained or the untrained—it does not demand the faculty of concentration and specialized knowledge. According to McLuhan, it is precisely this removal of concentrated observation that allows the viewer to extend his or her field of concentration, to improve his or her perception of the environment and of other viewers who might enter this environment. In this

19 Marshall McLuhan, *Understanding Media: The Extensions of Man* (London and New York: Routledge, 2001), 5. 20 Ibid., 17. 21 Ibid., 46ff. 22 Ibid., 24.

sense television is indeed participatory: turning on the TV does not require specialized knowledge. The television medium is in fact cool; it transmits information in a relatively nonsequential manner so that the viewer can relax, eschewing the need for concentration. On the other hand, work on the computer—particularly the internet—demands a degree of concentration that quite possibly even exceeds the focus required to read a book. The internet is thus a hot medium in comparison to TV.

The purpose served by an exhibition that offers visitors an opportunity to use computers and the internet publicly now becomes apparent—namely the cooling down of the internet medium. Such an exhibition extends the attention and focus of the viewer. One no longer concentrates upon a solitary screen but wanders from one screen to the next, from one computer installation to another. The itinerary performed by the viewer within the exhibition space undermines the traditional isolation of the internet user. At the same time, an exhibition utilizing the web and other digital media renders visible the material, physical side of these media—their hardware, the stuff from which they are made. All of the machinery that enters the visitor's field of vision thus destroys the illusion that everything of any importance in the digital realm only takes place onscreen. More importantly, however, other visitors will stray into the viewer's field of reference, and they will often seem more interesting than the exhibits themselves. In this way the visitor becomes one of the exhibits, for he is aware that he is being observed by the others. He is aware of his physical position in space. A computer-based installation thus prompts the viewer's conscious experience of his own body, an experience normally marginalized by solitary labor at the computer.

A computer installation stages a social event and is bestowed in turn with a political dimension. Even if it does not provoke a brawl in the futurist manner, it facilitates an encounter between diverse individuals who become aware of the communal presence of their bodies in space. Put another way, it is concerned with rendering visible the multitude flowing through the rooms and spaces of modern art museums, which have long since lost their supposed elitist character. The relative spatial separation of art exhibitions does not at all signify an aversion to the world, but rather a delocalization or deterritorialization of the viewer, which in turn serves to widen the perspective of the larger communal space. It is here, in the real space of social communication, that the cooling of the virtual can take place—a process that, if you will, counteracts the dissolution of real space into virtuality, which McLuhan once demanded of art by defining it as "exact information of how to rearrange one's psyche in order to anticipate the next blow from our own extended faculties."[23]

23 Ibid., 72.

Translated from the German by Tim Connell

RUDOLF FRIELING

TOWARD PARTICIPATION IN ART

The performance should make clear to the
listener that the hearing of the piece is his
own action—that the music, so to speak,
is his, rather than the composer's.

—John Cage on *4'33"*[1]

Who controls the definition of art—the artist, curator, critic, or viewer—is no longer the question. Art is now a contested site defined collectively by all of these actors, each of whom must surrender a measure of authorial control. With the rise of participation, the artistic arena does not merely encompass a broader range of possibilities; rather, these possibilities are being reviewed, acted upon, and changed even as they are being proposed. This is as much a promise as it is a problem. By entering an artistic situation and actively becoming part of it, the participant can actually be transformed: "I don't know what I will do for the rest of my life. It can't get any better than this!" exclaimed the artist Kiki Smith after having been carried through the streets of Manhattan as a "living icon" in Francis Alÿs's *Modern Procession* (2002; fig. 7).[2] For Smith, this might have been the moment implied by the ancient Greek term *kairos.* Whereas *tyche* refers to the active construction of situations in which chance encounters might happen (closely linked to the notion of *techne,* the promise of future technologies and utopian possibilities), *kairos* refers to the passive, unplanned encounter, made possible by a will to let go and enjoy the serendipity of the event. *Kairos* is a moment of rupture and suddenness, suggesting an unexpected presence and an opening of the senses. This naturally can be difficult to achieve in a museum context; it is easier to experience when artists reclaim the streets.

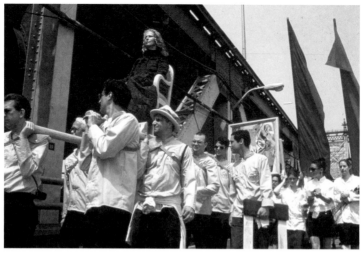

fig. 7

fig. 7
Francis Alÿs
The Modern Procession,
2002
Performance in New York,
2002 / Courtesy Public
Art Fund, New York

fig. 8
Rirkrit Tiravanija
Untitled (Pad See-ew),
1990/2002
Performance at the
San Francisco Museum
of Modern Art, 2000 /
San Francisco Museum of
Modern Art, gift of Connie
and Jack Tilton

John Cage's *4'33"* (1952; pls. 1–3), Allan Kaprow's *18 Happenings in 16 Parts* (1959), and Nam June Paik's *Random Access* (1963; pls. 24–25) and *Participation TV* (1963; pl. 23) are moments marking a beginning: something happens. This apt definition of the term *happening,* coined by Kaprow, does imply a wish for serendipity. By embracing chance, by giving up control, by inviting others to participate in the production of the artwork, by claiming the radical dismantling of traditional systems for evaluating art, these pioneering figures faced a paradox from the very start: how to do away with art by making art. Art and antiart, and art and life, have always been closely intertwined in this paradox. But for those who do take part, the paradox is precisely the driving force and pleasure principle behind much participatory art. Whatever happens, it will stand out as an *artistic* experience.

From work to process, from performance to performativity, from intent to indeterminacy, this paradigm shift has been furthered by a number of avant-gardes, including Dada, Situationism, and Fluxus. Yet, despite a history of scandals, manifestos, movements, and antimovements, the art world has generally proven derisive of participation (perhaps unsurprisingly, since few marketable objects are actually generated through such dynamics). A number of prominent artists have even voiced an explicit mistrust of or persistent antipathy toward participation—consider, for example, Bruce Nauman's dictum "I mistrust audience participation."[3] Is it a prerequisite for art to produce authorial positions even when the artists have based their practice on collaborative or participatory effects? Andy Warhol, the "author" of the first do-it-yourself artworks (see pl. 10), is still considered to be the creator of his work, precisely because the idea of the workshop and the role of the Factory could not be reconciled with an authorial position—a paradox upon which he built his career.

Artists interested in communal processes have experimented with various strategies to relinquish that very position. The desire to invest art with nonart social or political intent—a practice that is lived and not just temporarily experienced—has led some artists to make a fatal decision to step outside the artistic context entirely, moving into educational, activist, or commercial fields. Some have been involuntarily marginalized, while others have simply dropped out, such as the Brazilian Lygia Clark (see pls. 36–42), the Argentinean Marta Minujín (pl. 35), and the recently rediscovered German artist Charlotte Posenenske, whose work was featured at *Documenta 12* in 2007.

1 *A John Cage Reader: In Celebration of His Seventieth Birthday,* by Peter Gena and Jonathan Brent (New York: C. F. Peters, 1982), 22. **2** Quoted in Francis Alÿs, *The Modern Procession* (New York: Public Art Fund, 2004), 133. **3** *Bruce Nauman* (Minneapolis: Walker Art Center, 1994), 77. The closest Nauman ever came to an instructional piece was *Body Pressure* (1974), which he conceived as a series of do-it-yourself actions performed against a wall.

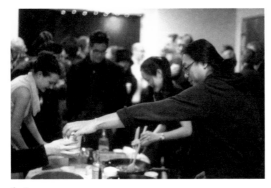

fig. 8

Artists might find tactical allies in groups, collaboratives, or networks yet still work independently, as did Felix Gonzalez-Torres (see pls. 119–21), who in the 1980s was a member of the activist collective Group Material (fig. 20). Today, the German-based conceptual artist Tino Sehgal can forgo both documenting his artistic situations and creating saleable collateral around them, yet still rise to prominence thanks to uniquely ephemeral performances in the gallery context. But this is a relatively new phenomenon, and it indicates yet another shift. Notions of participatory enactments, of the significance of the presence or trace of the visitor, and of evolving patterns or futile situations have driven recent, highly successful exhibitions by Rudolf Stingel and Rirkrit Tiravanija (see fig. 8). In 2007 a retrospective of Kaprow's ephemeral oeuvre (complete with a series of reenactments) began touring to museums in Europe and the United States. Despite the demise proclaimed by Roland Barthes, we cannot seem to get rid of the author; the harder we try the stronger the myth returns.[4] Ultimately, if artists wish to operate within the art world, they will inevitably be perceived as the ones responsible for the work, even if they involve collaborators, let others take on the actual production, utilize online networks, or—and this is our specific focus here—court unknown participants.

Although *The Art of Participation* focuses on collaborative practices in general, this essay specifically addresses questions related to what one might call open systems. In media art the term *interactive* has often been criticized for being simply euphemistic: no true interaction is possible when one must select from a predefined set of options. What interests me, rather, is something approaching true interactivity—an opening up to conditions, locations, and participants who contribute actively to the realization of a participatory work.[5] The sculptor Richard Serra once defined artistic activity by listing a series of physical actions: to roll, to crease, to fold, to store, etc. The art historian Miwon Kwon later translated Serra's concept to site-specificity: to negotiate, to coordinate, to compromise, to research, to organize, to interview, etc.[6] Today we might augment these lists with other activities that specifically highlight the participatory act: to generate, to change, to contribute, to enact, to dialogue, to translate, to appropriate, to tag, etc.

In 1969 the artist Douglas Huebler (pl. 63) proposed the idea of a work that could be realized without the direct intervention of the artist:

A system existing in the world disinterested in the purposes of art may be "plugged into" in such a way as to produce a work that possesses a separate existence and that neither changes nor comments on the system as used.... An inevitable destiny is set in motion by the specific process selected to form such a work freeing it from further decisions on my part. I like the idea that even as I eat, sleep or play the work is moving towards its completion.[7]

4 See Roland Barthes, "The Death of the Author" (1968), in *Image, Music, Text*, ed. and trans. Stephen Heath (New York: Hill & Wang, 1977). **5** The Austrian theorist Robert Pfaller coined the seemingly paradoxical term *interpassivity* as a clear critique of reductionist ideas of interactivity. See the essays collected in Pfaller, *Interpassivität: Studien über delegiertes Genießen* (Vienna: Springer, 2000). **6** See Miwon Kwon, "One Place After Another: Notes on Site Specificity," *October* 80 (Spring 1997): 103. **7** Quoted in *Live in Your Head: When Attitudes Become Form; Works, Concepts, Processes, Situations, Information*, by Harald Szeemann (Bern, Switzerland: Kunsthalle Bern, 1969), n.p.

Huebler's notion of a self-generating artwork was one of a number of related ideas that surfaced in the 1960s. In 1962 Umberto Eco introduced the notion of the "open work," and in 1970 the critic and curator Jack Burnham organized an exhibition titled *Software: Information Technology; Its New Meaning for Art* at the Jewish Museum, New York.[8] Deeply influenced by cybernetics and communication theory, Burnham's project propagated the concept of open systems. Since the introduction of technological systems into the arts, practitioners have voiced suspicion about the manufacturing of community and consent through art. Artists did not want to side with any technology that was spearheading governmental or utilitarian operations. Thus, no genre called participatory art (as opposed to, say, video art) emerged from these early discussions of conceptual art and technology.

The 1990s works associated with relational aesthetics (a description that goes back to Lygia Clark's practice of the 1970s, which centered on what she called "relational objects") and today's networked projects are both dialogical and contextual; commonly used terms include "conversational art" (Homi K. Bhabha), "dialogue-based public art" (Tom Finkelpearl), and "dialogical art" (Grant Kester).[9] In contemporary art, unlike traditional dialogical forms such as live music or theater, discursive practices are not distinct from, but rather constitute and frame, visual practice. But dialogue is not an intrinsic value. Who is talking to whom about what? What is the artistic element of participation in communities or social-networking projects? And can a shared space in Second Life help us to understand real life?[10] Even as I write in 2008, there still exists a gap between conceptual works associated with relational aesthetics, works that address social practice, and works that reflect and act upon our networked and globalized society. What role do aesthetic concerns play when an artist claims to have a real impact on communities, intersubjective actions, political agendas, and networking tools? One thing is clear: the art is constituted only through the participant's activity. In the words of the artist Liam Gillick, "My work is like the light in the fridge, it only works when there are people there to open the fridge door. Without people, it's not art—it's something else—stuff in a room."[11] One can only hope that the fridge is not empty. Tom Marioni's salon, active since 1970 (see pl. 82), makes it clear that it is not: we are offered *FREE BEER*! But seriously, what are we participating in? Does sharing a drink create a new experience? The media theorist Geert Lovink reminds us that, at least in the online world, there is a one percent rule: "If you get a group of 100 people online one will create content, 10

8 See Umberto Eco, *The Open Work* (1962), trans. Anna Cancogni (Cambridge, MA: Harvard University Press, 1989), and *Software: Information Technology; Its New Meaning for Art* (New York: Jewish Museum, 1970). Burnham's exhibition included, for example, Hans Haacke's *Visitors' Profile* (1970) as well as Sonia Sheridan's *Interactive Paper Systems* (1970), which engaged museumgoers in an exchange with the artist and a color photocopying machine. For a discussion of Burnham's legacy, see Edward A. Shanken, "The House That Jack Built: Jack Burnham's Concept of 'Software' as a Metaphor for Art" (1998), http://www.artexetra.com/house.html, and Luke Skrebowski, "All Systems Go: Recovering Jack Burnham's 'Systems Aesthetics,'" *Tate Papers*, Spring 2006, http://www.tate.org.uk/research/tateresearch/tatepapers/06spring/skrebowski.htm. Unless otherwise noted, all URLs cited in this essay were accessed June 24, 2008. **9** Grant Kester, who has written extensively about "conversation art," refers back to Mikhail Bakhtin's concept of the work of art as a "locus of differing meanings, interpretations and points of view." See Kester, "Conversation Pieces: Collaboration and Artistic Identity," in *Unlimited Partnerships: Collaboration in Contemporary Art* (Buffalo, NY: CEPA Gallery, 2000). **10** See Lynn Hershman Leeson's Second Life project *Life²* (2006–present; figs. 29–30, pls. 168–70). **11** Quoted in Claire Bishop, "Antagonism and Relational Aesthetics," *October* 110 (Fall 2004): 61.

fig. 9
László Moholy-Nagy
Telephone Picture EM 3,
1922
Porcelain enamel on steel / 9½ × 6 in. / Museum of Modern Art, New York, gift of Philip Johnson in memory of Sibyl Moholy-Nagy

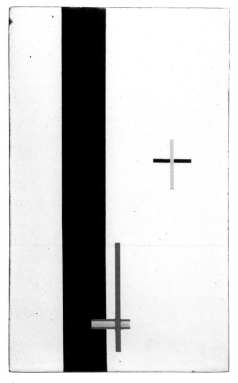

fig. 9

will interact with it (commenting or offering improvements), and the other 89 will just view it."[12] The same might apply to participatory works of art in the museum.

In order to bridge the discursive gaps between technology and contemporary art, I will look at key historic figures and situations that emerged throughout the twentieth century: Bertolt Brecht, Dada, and an innovative museum practice by Alexander Dorner in the 1920s and 1930s; explorations of radical new art forms and public actions in the 1960s; and contemporary strategies today, a field that is influenced by institutional critique without being anti-institutional, and that is embracing networking technologies without claiming a utopian notion of technology.

Between the Wars: A Vision of the Future

In Cologne in 1920 Max Ernst placed an axe next to one of his sculptures in the Dada exhibition *Spring Awakening,* while one of his drawings invited visitors to fill in a blank space he had left in the composition. Hugo Ball's Cabaret Voltaire in Zurich (see fig. 4) staged scandalous events that made art history (and prefigured the Fluxus events of the 1960s [see pls. 12–13]), and at around the same time the Bauhaus in Weimar and Dessau realized the idea of a cross-disciplinary school, helping László Moholy-Nagy, among others, to develop a practice that combined sculpture and film, introducing a time-based aspect to the perception of art in space. But Moholy-Nagy went even further, conceiving art as something that could be industrially manufactured and ordered by phone. He designed his *Telephone Pictures,* made around 1922, as drawings on graph paper, but he left the actual production to an enamel factory, ordering versions of the same work via telephone (see fig. 9).[13] Marcel Duchamp had been the first artist to "sign" a work remotely by communicating an instruction:

Take this bottle rack for yourself. I'm making it a "Ready-made," remotely. You are to inscribe it at the bottom and on the inside of the bottom circle, in small letters painted with a brush in oil, silver white color, with an inscription which I will give you herewith, and then sign it, in the same handwriting as follows: [after] Marcel Duchamp.[14]

Not only could the work be produced by others, but even the signature—the very embodiment of artistic identity—could be executed by someone else.

Alexander Dorner, the director of the Landesmuseum in Hannover, Germany, from 1923 through 1936, is generally

12 Geert Lovink, *Zero Comments: Blogging and Critical Internet Culture* (New York: Routledge, 2007), xxvii. **13** See http://www.moma.org/collection/provenance/items/92.71.html. For *Art by Telephone,* an exhibition planned by the Museum of Contemporary Art, Chicago, in 1968 but never realized, thirty-six artists, including Joseph Kosuth, Richard Serra, and James Lee Byars, were asked to call the museum to communicate their proposals, which would then be executed by MCA staff. In the same year Sol LeWitt developed his concept for wall drawings to be realized by the works' owners or museum staff. **14** Marcel Duchamp, letter to Suzanne Duchamp, January 15, 1916, reprinted in *Affectionately, Marcel: The Selected Correspondence of Marcel Duchamp,* ed. Francis M. Naumann and Hector Obalk Ludion, trans. Jill Taylor (Ghent, Belgium: Ludion Press, 2000), 44.

credited as one of the visionaries who helped to radically change the way we think about museums.[15] He not only introduced the idea of a living museum—a museum of the present—but also revolutionized the concept of display. In 1927 he collaborated with the artist El Lissitzky on the realization of the famous *Abstract Cabinet,* whose walls appeared to change according to the works on display and the movements of visitors.[16] Later, the *Room of Our Time* (fig. 10), designed

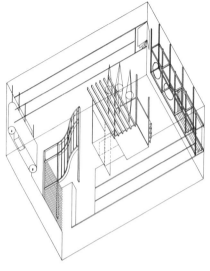

fig. 10

fig. 10
László Moholy-Nagy and Alexander Dorner *Room of Our Time,* 1931 Unrealized design for an exhibition space at the Landesmuseum, Hannover, Germany

fig. 11 Installation view of the 1971 exhibition *Robert Morris* at the Tate Gallery, London, showing visitors interacting with a sculpture

by Moholy-Nagy and Dorner in 1931, conceptualized a more dynamic role for visitors, proposing that they view films by activating rolling screens and pushing buttons to start the projections—not unlike the act of setting in motion Moholy-Nagy's *Light Prop for an Electric Stage (Light-Space Modulator)* (1930), which casts a series of abstract compositions throughout the surrounding space.[17] During the 1940s and 1950s, having fled Nazi Germany for the United States, Dorner continued to pursue his idea of a new museum:

> The next type of art museum must be not only an "art" museum in the traditional, static sense, but, strictly speaking, not a "museum" at all. A museum conserves supposedly eternal values and truths. But the new type would be a kind of powerhouse, a producer of new energies.[18]

Duchamp took this idea of energizing the reception of art as far as technology allowed. In 1938, at the *Exposition Internationale du Surréalisme* in Paris, visitors entering his totally dark space used flashlights to light up the art on display, thereby exhibiting their process of interaction with the works and the environment even as they illuminated the objects.[19]

The displacement of time and space was an artistic strategy that found its first agents in the 1920s. Its adherents proposed a vision of art that was no longer a finite object, but rather a time-based experience—a "living museum," to use Dorner's term—subject to the intervention of coproducers, be they institutional professionals, fellow artists, or audience members. Art happened through collaborative effort, sometimes via communication or remotely networked connections. Bertolt Brecht envisioned the potential of two-way communication in 1932—a year before his hopes were destroyed by Hitler and Goebbels—in the essay "The Radio as an Apparatus of Communication." He predicted that this apparatus would know

> how to receive as well as to transmit, how to let the listener speak as well as hear, how to bring him into a relationship instead of isolating him. On this principle the radio should step out of the supply business and organize its listeners as suppliers. Any attempt by the radio to give a truly public character to public occasions is a step

15 See Samuel Cauman, *The Living Museum, Experiences of an Art Historian and Museum Director: Alexander Dorner* (New York: New York University Press, 1958). **16** "Lissitzky placed these unframed, self-transforming compositions by Picasso, Leger, Gleizes, Lissitzky, Gabo, Mondrian, Baumeister, and Moholy on walls striated with miles of vertically aligned metal strips. The strips, painted in three different colors, white, black, and gray, produced a cool shimmer that changed with the slightest movement of a visitor's head. To multiply this effect, the colors were applied in a different order in different wall areas.... Inserted in these vibrating, living walls were sliding panels. These, when moved, revealed more pictures underneath." Cauman, 103–4. **17** *Room of Our Time* was never fully functional or finished. **18** Alexander Dorner, *The Way Beyond "Art"* (1947), quoted in Cauman, 206. **19** Originally Duchamp had planned a sensor-driven lighting control so that the light would shine only when someone approached the work. This failed for technical reasons.

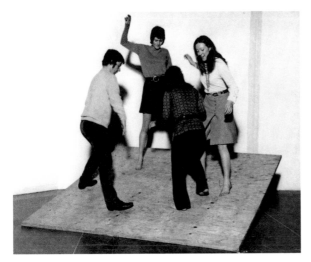

fig. 11

in the right direction....Such an attempt by the radio to put its instruction into an artistic form would link up with the efforts of modern artists to give art an instructive character.[20]

Obviously, Brecht is referring to himself as a modern artist. His proposal is based on the assumption that, were radio to make the vox populi heard, true public opinion would change society for the better—a hope we do not necessarily share today.

The 1960s: The Future Is Now

With their didactic agendas, agitprop art and Brecht's theater experiments implied a revolutionary subject. But after World War II, political art was tainted by association with fascist and communist policies that reacted strongly against the individualist notion of art. What individual or communal participation in art truly meant (beyond the vision of an educational process) was ambiguous. Postwar artists thus adopted a variety of complex strategies involving what Fluxus member Dick Higgins would term "intermedia," emphasizing an oppositional stance more than a specific agenda. Practitioners involved in Fluxus, in particular, helped to distribute a more open idea of instruction in the artistic context.

Yet the turn toward a more open model could result in a variety of actualizations of participation: a badly worded or misused instruction, a misinterpreted or disillusioning event, an artist's changing or obscuring attitude, or even the catastrophic end of the entire exhibition. In 2002 a visitor to a retrospective of work by the Fluxus artist Yoko Ono at the San Francisco Museum of Modern Art reported having an antagonistic phone conversation when Ono's infamous *Telephone Piece* (1996) rang. The encounter was conditioned by the anxiety produced by the event, the artist's unexpectedly annoyed reactions, and the public observing the conversation.[21] Alternatively, Robert Morris's 1971 retrospective at London's Tate Gallery had to be closed after visitors destroyed some of the works through overuse (see fig. 11). But to what extent can one actually speak of failure? One might argue that it was the public's enthusiastic response to the Morris exhibition that ultimately forced the institutional authorities to act. It was Ono again who "exhibited" and made explicit the aggressiveness of her (specifically male) audience through her historic and frequently reenacted 1964 performance *Cut Piece* (pl. 47), in which she literally offered up her person as an object to work on.[22] Marina Abramović took this a step further in her performance *Rhythm 0* (1974; pl. 56), during which the dynamics of visitor participation evolved from inactivity in the first hours to serious aggression later on. By the end,

20 Quoted in *Video Culture: A Critical Investigation*, ed. John G. Hanhardt (New York: Visual Studies Workshop Press, 1986), 53–54. **21** See http://www.bozos.com/yoko_ono.html. A more recent installation of the work appeared at the Institute of Contemporary Art in Philadelphia as part of the 2007 exhibition *Ensemble*; one of the guards there mentioned to me that the artist often called outside the museum's opening hours. **22** A number of artists have reinterpreted *Cut Piece*, including Lynn Hershman Leeson (1993), Felipe Dulzaides (2002), Marina Abramović (2006), and even Yoko Ono herself (1965 and 2003; pls. 45–46).

some viewers began to make such eager use of some of the potentially harmful objects Abramović had provided on a table that others present felt the need to intervene, ending the performance in order to protect the artist the moment a revolver was picked up.[23]

The possibility of ignoring instructions and social boundaries ultimately reveals the inherent conflicts of a proposal, mirroring a specific condition in which the actualization of a piece occurs. To engage with a work requires a willingness to be intrigued or challenged by its implicit and explicit rules of behavior. When these are violated, the responsibility of the participants is dramatically exposed. A participatory work thus needs an environment that makes possible the actual enactment of these rules. However, as the Morris example shows, this represents a fragile balance of trust and responsibility. The audience's exploitation of proposed situations or even the total absence of participation (a concept that no one enacts or realizes, an invitation that no one accepts)—these possibilities are inherent to the potentiality of participatory art. Yet the extent to which a work generates an ongoing engagement, as opposed to the provocation of an end, may be considered a measure of its participatory quality.

Artists have always been aware of the distinction between idea/concept/score and realization/practice/performance. In fact, one question runs persistently through discussions of participatory art: where does the artwork reside—in the text, in the act of reading, in the act of imagining the enactment, or in the act of doing it? Many Fluxus pieces relied upon the idea that one person could activate the work (or, alternatively, upon its representational activation by a select number of performers for the public), but they did not necessarily need to be acted out in space. Ono often worked with enigmatic and poetic instructions, first exhibited to a Western audience at George Maciunas's AG Gallery, New York, in 1961. The display of text was combined with the possibility of realization, offering instructions to be carried out by the visitors. Ono's *Painting to Be Stepped On* (1960)—"Leave a piece of canvas or finished painting on the floor or in the street"—was originally conceived to be completed by chance and contingent factors. The art historian Bruce Altshuler calls it a logical step that in Ono's May 1962 exhibition at the Sogetsu Art Center, Tokyo, she displayed only instructions on sheets of white paper.[24] This act of simplification and purification—which in some ways prefigured Minimalism—represented an attempt to leave behind more theatrical tactics, such as her first address to the audience during the 1962 performance *Audience Piece.* In fact, theatricality would seem to be an antithetical position for visual artists for a long time to come.

Most prolific in generating ideas and poetic strategies was the American artist George Brecht, whose event cards were distributed via Fluxus editions such as *Water*

fig. 12
George Brecht
Score for *Two Exercises*,
1961
Offset lithography /
Archiv Sohm, Staatsgalerie
Stuttgart, Germany

23 In a similar event, *Purple Cross for Absent Now* (1979), Jochen Gerz invited audience participation by asking visitors to pull on a rope tied around his neck while watching his face on a monitor. Looking only at his screen representation seemed to free people to engage in ways that included inflicting potential physical harm.
24 See Yoko Ono, *Grapefruit: A Book of Instructions* (1964; repr., New York: Simon & Schuster, 1970), n.p.

TWO EXERCISES

Consider an object. Call what is not the object "other."

EXERCISE: Add to the object, from the "other," another
object, to form a new object and a new "other."

Repeat until there is no more "other."

EXERCISE: Take a part from the object and add it to the
"other," to form a new object and a new "other."

Repeat until there is no more object.

Fall, 1961

fig. 12

Yam (1963; pl. 8) and *Fluxkit* (1965–66; pls. 15–16). These early collaborative tool kits included not only his instructions for actions, but also for the creation of objects or tableaux. The directions left almost everything to the realizer; see, for example, the instructions for *Two Exercises* (1961; fig. 12). Brecht allowed an openness and indeterminacy in the execution of his works that placed them almost on the brink of vanishing into invisibility. At the same time, they were an effective counterpoint to the neo-Dada Fluxus events staged by Joseph Beuys or Wolf Vostell, which were ultimately driven by the artist's persona (this was the inherent paradox of Beuys's collaborative and participatory political practice [see pls. 78–79]).

Although visual experimentation has had a long tradition in literature since Stéphane Mallarmé (a fact reflected by one of Dan Graham's earliest conceptual works, the *Schema* poem from 1966 [pl. 11]), it was Sol LeWitt who legitimized the linguistic formulation of an idea as artwork, triggering a whole series of art-by-instruction pieces.[25] Lawrence Weiner, who, like Huebler, was among the artists promoted by the New York gallerist Seth Siegelaub, started his signature text-based work after one of his early outdoor sculptures was destroyed by the public. His insight was that the idea was enough for him, and he consequently ranked the idea higher than any actual realization.[26] Weiner's solution to the problem of open and potentially destructive situations was conceptual and still represented a one-way communication between sender (artist) and receiver (collector), but it inspired artists such as Huebler, Graham, and Hans Haacke to examine the larger social, political, and economic powers at work in the art world—including the conditions of participating in a show, owning a work, and exhibiting. Early on, Haacke analyzed these conditions as an ideological frame:

[Artists are] unwitting partners in the arts syndrome and relate to each other dialectically. They participate jointly in the maintenance and/or development of the ideological make-up of their society. They work within that frame, set the frame, and are being framed.[27]

Those who act on a given work and its frame are thus not merely anonymous participants. They include a series of active stakeholders: the gallerist, collector, curator, critic, and representatives of supervising authorities, such as municipal or state commissions and trustees. Reflecting this political framework, Haacke's *News* (1969; pl. 70) exhibited the

25 See Sol LeWitt, "Paragraphs on Conceptual Art," *Artforum* (June 1967): 79–83, and the more playful approach of John Baldessari in his painting *Terms Most Useful in Describing Creative Works of Art* (1966–68; pl. 62). **26** The most generic of Weiner's conceptual pieces is an untitled statement from 1969: "1. The artist may construct the work / 2. The work may be fabricated / 3. The work need not be built / Each being equal and consistent with the intent of the artist / The decision as to condition rests with / The receiver upon the occasion of receivership." Szeemann, n.p. **27** Hans Haacke, "All the 'Art' That's Fit to Show," in *Art into Society, Society into Art* (London: Institute of Contemporary Arts, 1974), reprinted in *Museums by Artists*, ed. A. A. Bronson and Peggy Gale (Toronto: Art Metropole, 1983), 152.

real-time processes of political decision making by being the first artwork to bring the daily news into the gallery. Technically speaking, participation in art is a given in nearly every instance in which art is publicly exhibited (though participation in the form of professional contributions by museum or gallery staff is likely to be invisible). Artists such as Haacke and Stephen Willats (see pls. 72–74) consequently address issues of control, often deliberately limiting participation to a predefined set of choices through voting.

The implication of unwitting participants (individuals or institutions without a specific interest in the work) is a frequent participatory strategy. Consider, for example, the role of the postman in the dissemination of mail art (see pl. 21), the unsuspecting museum visitors approached by Vito Acconci during *Proximity Piece* (1970; pl. 58), the state authorities provoked by Sanja Iveković's private activity in *Triangle* (1979), the customs agents who censored Maria Eichhorn's *Prohibited Imports* (2003; pl. 117), and the Mexican police officers who played a decisive role in Francis Alÿs's *Re-enactments* (2001; pls. 133–38). A critical participatory strategy is thus to expose precisely the conditions that frame and limit actions in public space.[28] Alÿs's piece, however, goes beyond ideological critique to examine a variety of patterns of complicity. The cooperation of the authorities in his reenactment complicates the matter and irritates the viewer who witnesses the same action on parallel screens. In fact, the very notion of reenactment— see also Ono's 2003 take on *Cut Piece* (pl. 46)—points toward the possibility of shifting conditions and contexts, in the real world and in the arts. The urgency of early performance—"no rehearsal" was Abramović/Ulay's motto—is confronted with a more complex representation as rehearsal or reenactment.

The 1960s not only saw a divide between conceptual and political artists, but also marked the emergence of others who, influenced by Fluxus and the rise of happenings in the wake of Kaprow (see pls. 9, 28–34), challenged spectators emotionally or even physically. Brazilian artists were among the most active and creative in addressing art's relation to participants. Hélio Oiticica, for example, saw his installation *Eden* (1969; pl. 43) as a "suprasensorial experiment" and an embodiment of his concept of "creleisure" (creative leisure). He created a series of costumes called *Parangolés,* Brazilian slang for "agitated situation" or "sudden confusion."[29] For *Opinião 65,* a 1965 exhibition at the Museu de Arte Moderna in Rio de Janeiro, Oiticica invited street dancers to perform wearing his *P4 Cape 1*—a radical, carnivalistic intervention into an official event that resulted in the expulsion of the

28 In his essay in this volume, Robert Atkins writes about participation as a politically liberating act, with specific reference to the ACT UP movement and Antoni Muntadas. Muntadas's critical practice denounces any false hope in naive participation on a political level, as testified by *The File Room* (1994–present), his seminal online project on acts of censorship. See http://www.thefileroom.org.
29 See http://universes-in-universe.de/doc/oiticica/e_oitic3.htm.

dancers. The practice of Lygia Clark, meanwhile, evolved from the production of minimalist and constructivist sculpture to the creation of group experiences outside the art context, eventually focusing on a serious concept of therapy or "self-structuration." Like Oiticica's sensuous installations, Clark's group-therapy situations and relational objects (see pls. 36–39) sought to create temporary situations and spaces that facilitated a more open and body-centered experience of art. Thus, institutional critique could also take the form of testbeds for new and liberated social interactions. These artists provided opportunities for communal gatherings and discourse that prefigured the idea of an open system that is constructed by participants—what we might call "true" participation today. Such a system can incorporate pregiven rules and also establish new ones collaboratively. In either case, there is no work if it is not actively and collaboratively constructed, physically or mentally. "It is art if I say so" (to paraphrase Robert Rauschenberg) thus becomes "It is art if you think so" (Lawrence Weiner).[30]

The degree to which a work is a social activity can also influence its reception. If it happens in the context of the art world, it is easily identified; if it happens elsewhere, the project becomes more closely associated with community work or even invisible as art, vanishing altogether into the fabric of real life.[31] In New York, real life is constituted partly by cocktail parties, or at least we might get that impression from documents on Argentinean artists' contributions to the new communal media practice of the late 1960s. In 1968, at the Art Gallery of the Center for Inter-American Relations, Marta Minujin conceived one of the first open projects to incorporate the media in a participatory installation. She called her project, *Minucode* (pl. 35), a "multi-social and media environment experience":

> 320 people belonging to four different social groups, selected from answers to a questionnaire published in several metropolitan newspapers, were invited to four "group" cocktail parties. During the cocktail parties, which were filmed, eight representatives of each group were asked to create a second environment or light show in an adjoining room. Now you are going to have an audiovisual experience which consists in the projection of each of the cocktail parties' films and the recreation, at the same time, of the light show created by the eight representatives of each cocktail party. This experience is the MINUCODE.[32]

The artist's division of the participants into groups was intended to reflect the social divisions of "economy, politics, entertainment, and ornamentation."

Minujin's audiovisual representation of social categories was not realized in real time, and it also included a process of decision making by the artist. The Argentinean Group Frontera, however, took a different approach to participation with their recording booth and playback device (pl. 71) in the 1970 exhibition *Information*, organized by Kynaston McShine at the Museum of Modern Art, New York. "All individuals

30 In 1961 Rauschenberg was invited to participate in an exhibition at Galerie Iris Clert, Paris, in which artists were to create and display portraits of the gallery's owner. His contribution was a telegram declaring, "This is a portrait of Iris Clert if I say so." "It is art if you think so" is not a direct quote of Weiner, but rather a summary of his stance. **31** For more on this notion, see the Kester writings cited above; *What We Want Is Free: Generosity and Exchange in Recent Art*, ed. Ted Purves (Albany, NY: State University of New York, 2004); and *Taking the Matter into Common Hands: On Contemporary Art and Collaborative Practices*, ed. Johanna Billing, Maria Lind, and Lars Nilsson (London: Black Dog Publishing, 2007). **32** Marta Minujin, undated exhibition proposal, *Information* exhibition archive folders, Museum of Modern Art, New York.

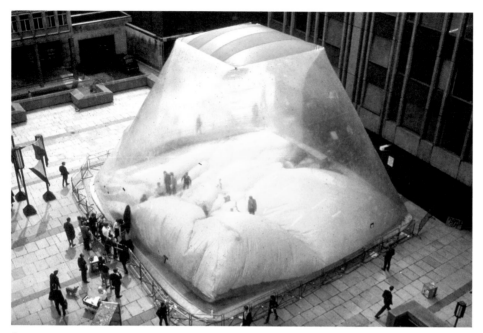

fig. 13

fig. 13
**Eventstructure
Research Group
(Theo Botschuijver,
Jeffrey Shaw, and Sean
Wellesley-Miller)**
Airground, 1968
Installation view at the
Brighton Festival, England,
1968 / Air-inflated PVC /
590½ × 590½ × 472⅓ in. /
Courtesy the artists

fig. 14
c a l c
DROPone, 1999
Installation view at
Cittadellarte, Biella, Italy,
1999 / Silk, fiberglass,
plywood, and aluminum /
236¼ × 157½ × 157½ in. /
Courtesy the artists

are creators," they stated, "but what they create is not necessarily forcefully incorpo-
rated into the cultural framework. The introduction of a micro-medium into the mass
media is necessary."[33] The group encouraged an alternative method of production that
was open to all participants, countering the dominant mode of television (and prefigur-
ing the idea of an open platform as developed in 1980 by artists such as Wendy Clarke
in her video production *Love Letters* and Kit Galloway and Sherrie Rabinowitz in their
seminal public satellite event *Hole-in-Space* [pls. 90–91]). Group Frontera's was titled
Itinerary of Experience, and it ironically envisioned participants' frustration with their own
electronic performance. Step six of the itinerary was thus described as "Person unhappy
with results," causing step seven, "Person smashing mechanism," leading to the eventual
"complete disintegration" of the piece in step twelve.[34]

 Exhibiting the audience was an ambivalent process that demanded a more active or
engaged viewer.[35] It was precisely this initial embrace of the audience's frustration, anger,
or disinterest that would be lost in some of the more didactic and utopian manifesta-
tions of alternative collaborative and participatory structures. Joseph Beuys (pls. 76–79),
for example, promoted the notion of social plastic, but he was too
much of an artistic celebrity to ever become one with his politi-
cal fight or be an equal member of a political group. Guy Debord's
Situationist International, meanwhile, dismissed the art system as
inherently "spectacular." Following the educational model of Brecht
or Beuys, other artists chose to address the supposedly passive audi-
ence directly, activating that "medium" in a very physical sense. As a
result, a gap opened between the perception of an artistic experience
as inherently open and the proclaimed activation of that process.

33 Kynaston McShine, *Information*
(New York: Museum of Modern Art,
1970), 47. **34** Other steps included
ten, "Heading for Kynaston McShine's
office," although the curator would
have departed for Argentina during
step eleven. Group Frontera, undated
exhibition proposal, *Information* exhibi-
tion archive folders, Museum of Modern
Art, New York. **35** See, for example,
Peter Weibel's closed-circuit installation
Audience Exhibited (1969) and VALIE
EXPORT's *TAPP- und TASTKINO* (TAP
and TOUCH CINEMA, 1968; pls. 49–50)
and *Facing the Family* (1971).

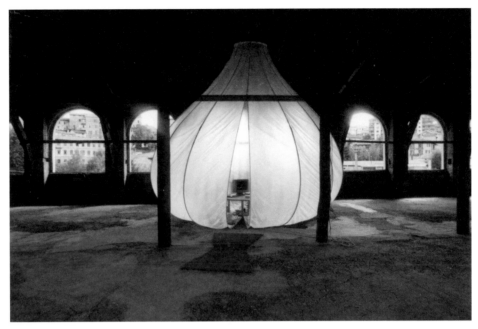

fig. 14

The 1990s to Now: Revisiting the Future

Although the utopian investment of Fluxus and early media artists in collaborative and networked practices ultimately failed to change society at large (or even the museum as an institution), practitioners of the 1990s revived their predecessors' approach to open situations, marking the end of a decade that avoided exploration of participatory social concepts.[36] A conceptual and artistic trajectory links Moholy-Nagy's *Telephone Pictures* and LeWitt's wall drawings to the 1990s, a decade that witnessed the creation of physical, networked, and online platforms for dialogue and interaction with the public—projects that often invited participants to *become* the artwork (see, for example, the video productions of Sylvie Blocher [pl. 151], Annika Eriksson, and Phil Collins).

From Ben Vautier (who exhibited himself to the public in *Sculpture vivante* [Living Sculpture, 1962]) to Ben Kinmont (who offered passersby occasions to debate his artistic proposal for *I am for you, Ich bin für Sie* [1990–92]), this trajectory moves us beyond definitions of art and nonart. It took a new generation of artists in the early 1990s—some of them associated with relational aesthetics, a term coined by Nicolas Bourriaud—to review and reformulate notions of open systems and participation that were first introduced in the 1960s. Some were content to stage conceptual gestures as opposed to concrete interventions in the social fabric of the community; others refused a

[36] The years 1977 to 1982 witnessed a series of seminal satellite projects that explored the advances of global telecommunication networks and addressed spaces for interaction that previously seemed to belong entirely to monopolistic and national agencies such as broadcasting and industrial networks. In 1977 the live satellite broadcast for the opening of *Documenta 6* included Nam June Paik, Joseph Beuys (pl. 76), and Douglas Davis; the same year Liza Bear, Willoughby Sharp, and Keith Sonnier produced *Send/Receive Satellite Network: Phase II.* "Artists' Use of Telecommunications," a February 16, 1980, conference at the San Francisco Museum of Modern Art organized by La Mamelle Inc. and SFMOMA, allowed participants to use a computer time-sharing network that offered free user accounts and functioned as an art-communication medium through an online chat and text exchange. Some participants were also able to use a slow-scan TV system (video images transmitted over the telephone). Other significant early telecommunication events, including Robert Adrian X's *The World in 24 Hours* (1982; pl. 113) and Roy Ascott's *La plissure du texte* (1983), proved too visionary to grab public attention in the 1980s—a decade in which expressive painting dominated the art scene, marginalizing artistic projects based on technology. This only changed significantly in 1992 with Ponton European Media Art Lab / Van Gogh TV's collaborative and participatory television event *Piazza virtuale* for *Documenta 9.*

specific social function for their proposals.[37] Despite an oft-proclaimed interest in social agendas associated with communal events (as seen in many Rirkrit Tiravanija projects) and in the creation of modular furniture that facilitates undefined gatherings (as in N55's *Hygiene System* [1997], Jorge Pardo's public pavilion for *Skulptur Projekte Münster 1997,* and c a l c's *DROPone* workspace for Michelangelo Pistoletto's Cittadellarte [1999; fig. 14]), most of these social spaces were confined to the art world. A second aspect is noteworthy: these updates on 1960s strategies rarely make use of today's networking technologies. They insist instead on a low-tech approach, stressing performative physical events and activities. Many refer back to the modular, precarious objects and installations of Clark and Oiticica, yet strangely ignore precedents such as the conceptual artist Tom Marioni or the activist collectives Ant Farm (see pls. 85–88) and Eventstructure Research Group (fig. 13).[38]

How, then, can an artwork include not only friends and peers, but also an undefined group of participants? How might the artist address a larger public without becoming simplistic, didactic, or compromised? Harrell Fletcher and Jon Rubin's *Pictures Collected from Museum Visitors' Wallets* (1998; pls. 123–24) started off with a participatory intervention in the museum space, which yielded the final artistic selection. Jochen Gerz, on the other hand, is no longer interested in exhibiting aesthetic choices made alone in the studio. The museum or the public space at large becomes his studio. His project *The Gift* (2000; pls. 147–50) does not question the "product" as such, but rather the way in which a work that is collaboratively produced, exhibited, and distributed can embody an actual representation of its coproducers. A community of museum visitors is documented in a temporary portrait gallery that is collected onsite but later dispersed throughout the city, region, or beyond. The museum unleashes its own products in a gesture of generosity toward those who were generous enough to contribute their portraits.

A great deal of critical attention has been directed at ways in which artists deal with institutional framing. The practice of institutional critique, as embodied by Haacke and Andrea Fraser (pl. 167), has worked to dissect the power regimes and ideological structures at work in the art world. It is equally interesting, though, to reflect on the public's use of the museum, whether prompted by an artist (Janet Cardiff's video walks [pls. 159–66]) or by the audience's own desires. Despite the structural conditions of the institutional setting—the need to obey the rules of quiet contemplation, not touch the artwork, respect the laws of ownership, etc.—visitors are constantly adopting tactical ways of using the museum. The French critic Michel de Certeau described a range of subjective counterpractices (cunning, tricks, maneuvers) as "weak." In the museum context,

fig. 15
Martin Walde
The Web, 2006
Installation view at
Kunsthaus Baselland,
Muttenz/Basel,
Switzerland, 2006 /
Strings, carbon rods, and
springs / Courtesy Galerie
Krinzinger, Vienna

37 Nicolas Bourriaud's *Relational Aesthetics* (Dijon, France: Les presses du réel, 2002) provoked numerous critical responses, most notably by Claire Bishop (to whom Liam Gillick and Grant Kester responded in turn). For a comprehensive study of their research, see Bishop's reader *Participation* (Cambridge, MA: MIT Press, 2006) and Kester's essays in *Conversation Pieces* (Berkeley: University of California Press, 2004). Whereas Bishop argues that the participatory experience needs to be acknowledged on a much broader scale, Kester—harking back to Eco's seminal *Open Work*—criticizes the lack of social responsibility and political impact from which relational aesthetics suffers even as it stakes a claim for microutopian concepts. Neither author, however, shows any interest in specifically media-related forms of participation. 38 "We propose the precarious as a new concept of existence against all the static crystallisation in the duration," Clark stated in 1983. *Lygia Clark* (Barcelona: Fundació Tàpies, 1994), 221.

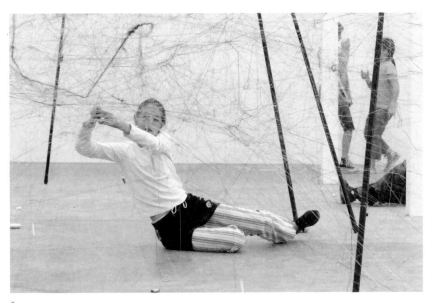

fig. 15

weak tactics might include drifting through an exhibition, simulating contemplation, or secretly taking pictures: a "fleeting and massive reality of a social activity at play with the order that contains it."[39] It is only through these personalized actions that the museum becomes what de Certeau would call "habitable"—a "space borrowed for a moment by a transient."[40] Artists such as Erwin Wurm (pls. 141–44) and Martin Walde (fig. 15), far from criticizing strong institutional ties, have successfully developed accessible yet also absurd or even obscure practices involving collaborative, performative actions. In their best moments, these actions transcend readability to posit a profound ambiguity, provoking "weak" responses toward the institution and the production process. By refusing to control such engagement through ubiquitous surveillance policies or, more subtly, to channel specific readings through didactic exhibition paths, a museum that offers open spaces for undefined interactions could radically change our general perception of the institution as an inflexible, deadening container.

Once again, artists have come to consider the museum a terrain for potentially transformative experiences, as Dorner envisioned in the 1920s. They openly address its codified spaces as social sites for singular visitors as well as for communities.[41] Without adhering to a specific political or activist agenda, artists and curators are exploring ways to address social relations beyond the ideological readings of Marxism and critical theory that dominated the discourse of the 1960s and 1970s, most notably expressed in the radical positions of Debord and the Situationists. But it is still an open question whether these practices actually constitute what Bourriaud calls "a social interstice [that] updates Situationism and reconciles it, as far as it is possible, with the

39 Michel de Certeau, *The Practice of Everyday Life,* trans. Steven Rendall (Berkeley: University of California Press, 1984), xxiv. **40** Ibid., xxi. **41** In 2002, for example, Lee Mingwei addressed the museum as a living environment and involved the museum staff as hosts of *The Living Room.* Each host, including the artist, initiated discussions about the objects and personal belongings that they had brought into the "living room." The artist also worked with students and a kindergarten community on the importance of everyday objects. "I believe that the essence of this Museum does not reside merely in its architecture and objects, but also in its staff and extended family, who make this place function as a living organism on a day-to-day basis." http://gardnermuseum.org/education/airlee_text.html.

art world."[42] Even if artists conceive their works as models for different ways of being together, of working together, of producing together—as playful, temporary interventions that are easily dissolved—they can generate meaningful aesthetic and social experiences without making (micro)utopian claims.

When an artwork is subject to public intervention, it does not necessarily become more interesting or aesthetically charged. What is exhibited is rather the extent to which simple communality or antagonistic forces are acted out. The installation *1st Public White Cube* (2001; pls. 183–92), by the net art pioneers Blank & Jeron (in collaboration with Gerrit Gohlke), stages precisely this conflict at the center of the museum galleries. It is their contention that museum space and inclusion in exhibitions are for sale—a position that is antagonistic to any curatorial vision. Yet they frame this process, define the situation, and adapt the context to their artistic needs. By the same token, online projects such as Dan Phiffer and Mushon Zer-Aviv's *ShiftSpace* (2007–present; pl. 174) and Jonah Brucker-Cohen and Mike Bennett's *BumpList: An email community for the determined* (2003; pls. 177–78) draw our attention to the distinctive conditions of participation on the internet. Contributions by Antoni Muntadas (pl. 114), Maria Eichhorn (pls. 116–17), Minerva Cuevas (pls. 130–31), and Warren Sack (pl. 155) demonstrate that the potential for global networking does not rule out exclusion and ideological framing.

To say that artists can "fill in the cracks in the social bond" may overemphasize their role, but many practitioners do understand their work as an articulation of social conditions, including "the participation of a multiplicity of voices in the democratic agon, thereby helping to mobilize passions towards democratic objectives."[43] Chantal Mouffe's philosophical critique of conciliatory notions of community and Jean-Luc Nancy's insistence on the community as an interruption of singularities ("Community is made of interruption of singularities…community is not the work of singular beings") make us aware of potential conflicts that may be addressed.[44] These ideas might inspire administrative and curatorial anxiety, but they should also be understood as possibilities for shaping a more inclusive form of practice. The museum, from this perspective, is no longer a container for art, nor does it manufacture consensual communities. If successful, it becomes a producer of and an arena for social *and* aesthetic experiences, temporarily interrupting singularities through the presentation of participatory art that actively generates a discursive public space. And as we head back home or to work after visiting the exhibition, this may resonate with us for a time, fostering a desire…

42 Bourriaud, 85. **43** Ibid., 36; Chantal Mouffe, "The Mistakes of the Moralistic Response," quoted in Liam Gillick, "Contingent Factors: A Response to Claire Bishop's 'Antagonism and Relational Aesthetics,'" *October* 115 (Winter 2006): 99. **44** Jean-Luc Nancy, *The Inoperative Community*, ed. Peter Connor (Minneapolis: Minnesota University Press, 1991), 31.

to be continued by the reader.

ROBERT ATKINS

POLITICS,
PARTICIPATION, AND
MEANING IN THE
AGE OF MASS MEDIA

you are the audience
you are my distant audience
i address you
as i would a distant relative

 —from *Audience Distant Relative* by
 Theresa Hak Kyung Cha (1977)[1]

Perception Requires Involvement

 —Antoni Muntadas (1999)

As high modernism approached its apotheosis of social disengagement and formal "purity" in the post–World War II work of painters such as Jackson Pollock and Mark Rothko, the seeds of its demise simultaneously were being sown, most strikingly by Pollock himself. He had already landed a profile in the August 8, 1949, issue of *Life* magazine when Hans Namuth, in 1950, trained his film camera upward at the artist slathering paint from a bucket onto a sheet of glass.[2] The widely seen article, film footage, and stills helped make Pollock not just a well-known artist but also the pop-culture celebrity later dubbed "Jack the Dripper" by *Time* magazine.[3] His fame was heightened by the inclusion of his work in government-sponsored exhibitions abroad, including the 1950 Venice Biennale and United States Information Agency–organized shows intended, in part, to promote America's cultural prowess and propagandize its supposedly unfettered freedom of expression. Pollock's untimely death in 1956—the result of a late-night, perhaps drunken, car crash on Long Island—was seen by some as an analogue to the tragic, romanticized death of the actor James Dean.

Neither the Cold War ideological context into which Pollock's work was thrust nor the media circus that developed around him was of Pollock's making. Both were imposed on the formerly left-leaning painter and his work. Other artists learned quickly from the mediagenic example of Pollock's life and death. His catalytic influence helped shift the global emphasis in art from the object—a representation of experience—to the *process* of

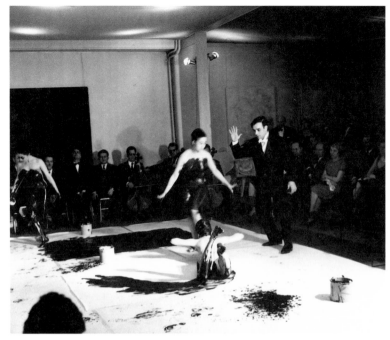

fig. 16

fig. 16
Yves Klein
*Anthropométries de
l'époque bleue,* **1960**
Performance at the
Galerie internationale
d'art contemporain, Paris,
1960 / Courtesy Yves
Klein Archives

producing that object. Like Namuth's film, the resulting theatricalized artistic "event," or spectacle, proved highly amenable to photographic and mass-media consumption.[4]

On March 9, 1960, nearly a decade after Pollock's filmic encounter with Namuth, the artist Yves Klein staged an event in Paris that we might regard today as being primarily about the "buzz." In front of a small audience of well-heeled patrons at the mainstream Galerie internationale d'art contemporain, the tuxedo-clad artist directed three nude women as they applied blue paint to their bodies and subsequently "blotted" themselves against large sheets of white paper on the floor and walls (see fig. 16). A small orchestra simultaneously played the droning tones (and silences) of Klein's forty-minute *Monotone Symphony.* This public introduction of the *Anthropométries,* as the artist called them, was documented by several filmmakers, photographers, and critics. They helped transform the evening into a succès de scandale, an outcome undoubtedly relished by gallery owner Maurice d'Arquian but probably not very helpful to Klein in his struggle to communicate the complex ideas about body and spirit underlying his art.[5] As for the elite audience, its participation was necessary to ensure that the event generated the maximum buzz.

Klein's elaborate production seems, in retrospect, to symbolize a decade's experimentation with live art across the globe. In France George Mathieu staged Art Informel painting performances in front of large audiences; in Japan artists belonging to the Gutai group ecstatically transformed themselves into "living paintbrushes" (to use Klein's term). In the United States John Cage and the Black Mountain group assembled artists of various disciplines to create multimedia events, a practice also explored in Allan Kaprow's happenings, which presented readings of

1 Quoted in Constance M. Lewallen, "Theresa Hak Kyung Cha: Her Time and Place," in *The Dream of the Audience: Theresa Hak Kyung Cha* (Berkeley: University of California, Berkeley Art Museum / University of California Press, 2001), 3. **2** *Life*'s spread also enquired whether Pollock was the greatest living painter in the United States. See "Jackson Pollock," *Life,* August 8, 1949, 42–43. **3** "The Wild Ones," *Time,* February 20, 1956, available online at http://www.time.com/time/magazine/article/0,9171,808194-1,00.html. This and all other URLs cited in this essay were accessed December 16, 2007. **4** See Sidra Stich, *Yves Klein* (Cologne: Museum Ludwig; Stuttgart, Germany: Cantz Verlag, 1994), 188. **5** Klein would become a more serious victim of media calculation when footage from a staged performance of the *Anthropométries* was reedited by the filmmaker Gualtiero Jacopetti, who transformed the segment from a celebration of art and womanhood into the dark, degrading episode ultimately used in the 1962 film *Mondo cane.*

fragmentary texts and enactments of everyday activities to audiences charged with moving from place to place during performances (see pls. 9, 28–34). Beginning in 1962, Viennese Actionists such as Günter Brus and Hermann Nitsch incorporated audience members in eroticized, sometimes violent spectacles involving butchered animals, which were darkly evocative of ancient rites.[6]

Although Pollock and Klein are among the best-known artists of the early postwar era, this essay features other artists both renowned and obscure.[7] They range from Christo, celebrated for decades for wrapping or otherwise "framing" far-flung structures and places, including Berlin's Reichstag and New York's Central Park, to contemporary groups who tamper with corporate websites or have been vital in combating the inhumanities attendant on the AIDS crisis. Some are not professional artists at all. Each individual or group, however, takes a nontraditional view of the role conventionally played by the audience, thus expanding the nature or meaning of participation in visual art. During the second half of the twentieth century, this frequently transpired in the politicizing glare of mass-media attention at a time when the foundations of our current, media-saturated existence were not only being firmly established, but also beginning to infiltrate every aspect of daily life. As artists became more adept at exploiting media coverage of their work, they also began to produce art that was designed to gain its full meaning from the press's response to it. This signaled a fundamentally new kind of audience participation and, indeed, a new genre known as media art.

6 These activities, surprisingly, overlapped with those of Fluxus, an international movement that emerged in the late 1950s. Fluxus eschewed alliances with popular culture and mass media; instead it aimed to overthrow the bourgeois routines of art and life by, paradoxically, equating art and life. Thus the self-selected participant in any self-selected activity was a Fluxus artist, capable of elevating life's everyday activities into art when performing with the proper, Zen-like attitude. Fluxus included not just live events, but also mail art, upon which instructions for, say, a walk in the woods, Fluxus-style, might be inscribed. 7 Klein, like Pollock, died in a vehicular accident—a motorcycle crash—at the age of thirty-three, which no doubt contributed to the romanticized aura that surrounds him.

It might be useful at this point to distinguish my use of the term *media art* from the altogether different understanding of the phrase by many art-world denizens, who use it to describe work created by means of computers or other technological media. The projects under consideration here are usually antiformalist and inhospitable to conventional exhibition formats, sometimes ever-unfinished. They are also typically hybrid in nature and performative in character. (As we have already seen with Pollock and Klein, it is the performative nature of an artist's practice that can transform the once-meditative process of producing an art object into an electrifying event suitable for photographic and media consumption.) To bring together such work is to map just one heterogeneous realm of practices located within what might be described as the world of art. These practices frequently overlap more fully with those of community-oriented endeavors, or even political and media activism, than with those associated with the professionalized system we call the art world.

Far from the world of art, another phenomenon emerged during the 1960s: television came of age. Six months after Klein performed his *Anthropométries* in Paris, the

first of four debates between the American presidential candidates John F. Kennedy and Richard M. Nixon—widely credited with deciding the election in favor of the telegenic Kennedy—took place. By the end of the 1960s, happenings pioneer Allan Kaprow publicly wondered how art might compete with the first manned moon landing, perhaps the decade's most highly mediated event, seen simultaneously on television by tens of millions of people. So potent was the new medium that commentators immediately recognized its ability to knit together a traumatized nation following Kennedy's assassination on November 23, 1964. A few years later, nervous American politicians and military officials lamented that the Vietnam War was being lost *because* of the public's exposure to images that brought home the horrific complexity of the Southeast Asian conflict.

In every sense, experience rather than reflection was the order of the day, and "experience" could now come in the form of televised mass media. For many viewers seeing *was* believing, and television became Western society's new witness to history, especially in the hands of the avuncular newscaster Walter Cronkite, who hosted a popular CBS series of the mid-1950s called *You Are There.* Reenactments of historical events such as the Salem witch trials and the fall of Troy were punctuated by the narrator's voiceover, "You are there." The refrain uncannily mirrored the televisual enlargement of the audience to include virtual as well as physical presence.

The rhetoric—rather than the reality—of public ownership of the airwaves is ingrained in the American consciousness. It made access to television distribution both a political issue and a recurrent concern in video art from its inception, perhaps apocryphal, in 1965, when the Fluxus artist Nam June Paik showed his just-made tapes of a papal procession at the Cafe au Go Go in New York. In Franco-era Spain, Antoni Muntadas offered TV watchers the first Spanish alternative to the nationalistic drone and centralized programming of the government-run Televisión Española (TVE). His project *Cadaqués Canal Local* (1974) brought portable video technology and the community programming it enabled to a small resort town on the Mediterranean, in the process nurturing local political activists by providing them with the means of television production. Similar projects were carried out by Videofreex, which, from 1971 through 1977, operated the longest-running pirate television channel in the United States. Dubbed Lanesville TV for its upstate New York location, it broadcast local news and town hall meetings as well as the more "artistic" output of the ten-member group, and also trained anyone interested in the techniques of television production. These media activists were hardly unique in their willingness to invite audiences to participate in the processes of television production and distribution, especially in the United States.[8]

But was it art? The distinction seemed irrelevant to nascent video artists and curators who, in keeping with the politically expansive times, simply embraced this work as falling within the purview of contemporary visual production. New

8 Other groups involved in such activities included Raindance Corporation, Revolutionary People's Communication Project, the People's Video Theater, and Global Village. Their mouthpiece was *Radical Software* magazine, which was published from 1970 though 1974. See Dara Greenwald, "The Grassroots Video Pioneers," *The Brooklyn Rail* (May 2007), http://www. brooklynrail.org/2007/5/express/video.

fig. 17
Bonnie Ora Sherk
Crossroads Community (the farm), **1974–80**
Sherk and children from Buena Vista School develop the first farm garden on state land beside the Army Street freeway interchange, San Francisco, 1976 / Courtesy the artist

fig. 17

artistic forms—performance, land, media, information, conceptual, process, and video art—emerged alongside and from the radical political ferment of the 1960s. Novelty and multiplicity were the orders of the day. Political concerns included not just international opposition to the Vietnam War and other late-colonial conflicts, but the very redefinition of politics itself: in identity- rather than class-based terms (e.g., the women's, gay, and black liberation movements). At the same time, the counterculture flourished and helped set the stage for a new ecology movement whose intentions were signaled by the first Earth Day in 1970.

Contemporary art appeared to bear little resemblance to art of the past. Seemingly anything was fair game with respect to subject matter, content, and approach. Some projects, such as Les Levine's *Canadian-Kosher Restaurant* (1969) in New York or Bonnie Ora Sherk's *Crossroads Community (the farm)* (1974–80; fig. 17) in San Francisco, seemed to lie entirely outside the bounds of art, forcing their makers' nearly invisible works to lead double lives: as functioning restaurants or parks in the real world, and as artworks when translated into documentary form in the gallery.[9] Audiences for such works participated directly, if often unwittingly; cognizant visitors were expected to participate actively in the creation of meaning (which was ideally something an audience member arrived at rather than something an artist produced).

9 For more on Levine, see Dominique Nahas, *Public Mind: Les Levine's Media Sculpture and Mass Ad Campaigns, 1969–1990* (Syracuse, NY: Everson Museum of Art, 1990), 122. On Sherk, see Linda Frye Burnham, "Between the Diaspora and the Crinoline: An Interview with Bonnie Sherk," in *The Citizen Artist: Twenty Years of Art in the Public Arena; An Anthology from* High Performance *Magazine 1978–1998,* ed. Linda Frye Burnham and Steven Durland (Gardiner, NY: Critical Press, 1998), available online at http://www.communityarts.net/readingroom/archivefiles/2002/09/between_the_dia.php.

For some practitioners, art offered a way of referring directly or indirectly to social conditions or ideologies: by bolstering and promoting political agendas (as did Hans Haacke's *MOMA-Poll* [pl. 69], a 1970 poll surveying visitor reaction to New York Governor Nelson Rockefeller's views on the Vietnam War, or Joseph Beuys's 1974 founding of the Free International University in Düsseldorf [see pl. 79]); by raising consciousness or offering psychological therapy (the 1970 Feminist Art Program in California or Lygia Clark's healings in 1970s Brazil); by providing an absurdist alternative to mass-media spectacle (Ant Farm's *Eternal Frame,* a 1976 reenactment of the Kennedy assassination, or General Idea's *Miss General Idea* pageants); by

pointing to natural history (the subtle reforesta-
tions of Alan Sonfist or the reclamation projects of
Newton and Helen Mayer Harrison); or by fram-
ing more traditional relationships between culture
and nature through remotely located installations
(the earthworks of Walter De Maria or Robert
Smithson). All of these projects offered—indeed,
sometimes demanded—unconventional means
of experiencing art. Like early postmodernism in
architecture, such celebrations of duality and mul-

fig. 18

fig. 18
**Elizabeth Sisco, Louis
Hock, and David Avalos**
*Art Rebate / Arte
Reembolso,* **1993**
Undocumented Mexican,
Mixtec Indian, and Central
American taxpayers
sign for their rebates in
McGonigle Canyon, San
Diego County, 1993 /
Courtesy the artists

fig. 19
Pages from *New West*
magazine (February 13,
1978) showing scenes
from Lowell Darling's 1978
gubernatorial campaign in
California

tiplicity mirrored life's messiness, in contrast to modernism's reductionism and obsessive
attention to so-called purity. This embrace of complexity also represented the undermin-
ing of Cold War absolutes as the Vietnam War wore down and finally ended in 1975.

If politics is defined as the relationship between the individual and society, virtually
no artwork is without political meaning. Art and propaganda—the most extreme example
of the political in visual culture—are part of the same continuum. The inseparable con-
joining of art and politics in so-called political art is simply a restatement of the insepa-
rability of form and content in (effective) art. Thus it is axiomatic that bad political art is
both bad art and bad politics. As is true with any type of visual production, evaluating
politically oriented art demands consideration of both the viewer's criteria and the cre-
ator's intentions. Surely the work's power of persuasion is also a relevant factor.

Consider two political artworks that are closer to propaganda than to the depoliti-
cized end of the visual-culture spectrum: Hans Haacke's *Shapolsky et al. Manhattan Real
Estate Holdings, a Real-Time Social System, as of May 1, 1971* (1971), a muckraking display
of charts, texts, and documentary photographs examining a Solomon R. Guggenheim
Museum trustee's real-estate holdings, and *Art Rebate / Arte Reembolso* (1993; fig. 18),
a project for which Elizabeth Sisco, Louis Hock, and David Avalos distributed ten-dollar
bills—some of it money from the National Endowment for the Arts—to undocumented
workers in San Diego. Thomas Messer, the Guggenheim's director, shuttered Haacke's
show before it even opened and fired curator Edward Fry for publicly defending it. The
activity of Sisco and her cohorts, meanwhile, garnered the anticipated outrage of politi-
cians and pundits.[10] The undocumented workers participated directly in
the artwork, while the rest of us participated via the morning paper or
evening news. What is remarkable is how profoundly the (sometimes
unpredictable) possibilities for artistic interaction with mass media have
changed over the decades: from the experience of Klein, whose inten-
tions were obscured by the press, to that of Haacke, whose censorship by the museum
was widely reported, and finally to that of Sisco, Hock, and Avalos, who *counted on* a
sensationalistic response from the media to disseminate their artistic/political message.

10 See Robert L. Pincus, "The Hidden Heart,"
San Diego Union, May 6, 2007, available online
at http://www.signonsandiego.com/union-
trib/20070506/news_lz1a06avalos.html, and
Kristine Stiles and Peter Selz, *Theories and
Documents of Contemporary Art: A Sourcebook
of Artists' Writings* (Berkeley: University of
California Press, 1996), 813.

The Fine Art of Politics:
Only You, Lowell Darling

By Jonathan Kirsch
Photographed by Ilene Segalove

"...On Valentine's Day, Californians will witness the birth of a unique breed of politician: the Artist as Merry Prankster..."

Top left: Lowell Darling, America's original urban acupuncturist, wields javelin-sized needles to cure the ills of civilization. Bottom left: Darling proves that Needles is the navel of California acupuncture by turning a Conestoga into a pincushion in the company of the town's mayor pro tem, Louise Corey. Above: When he was asked to evaluate the present governor, Darling—always the canny politician—would only say: "I can say nothing bad about Jerry Brown; I want his vote." Below: Darling demonstrates his foolproof method for binding the whole state together—a stitch along the San Andreas fault.

36 NEW WEST/FEBRUARY 13, 1978

FEBRUARY 13, 1978 NEW WEST 37

fig. 19

The *Art Rebate* project makes it clear that artists can intervene directly in social or political processes. Yet a mere twenty-five years earlier, this sort of intervention was nearly impossible. In the late modernist era, dominated mainly by abstract styles, artists participated in politics only as ordinary citizens, rather than as artist-citizens incorporating political views within their art.[11] Organizations such as the Art Workers' Coalition (1969–71) tended to train their focus on art institutions, protesting the price of admission or the paucity of works by black and female artists at museums such as the Museum of Modern Art, New York,[12] while Pop icon Andy Warhol's famous 1972 anti-Nixon print—which features the sinister-looking incumbent above the words *Vote McGovern*—was simply a campaign fund-raising poster.

Some artists' forays into the political realm were more whimsical than those of Sisco et al. During the late 1970s, a number of artists assumed performative roles as artist-candidates; these highly unconventional "politicians" simultaneously enacted and subverted thoroughly conventional electoral forms. In 1974 the oft-costumed, tap-dancing Mr. Peanut (aka performance artist Vincent Trasov) ran for mayor in Vancouver, British Columbia. He was publicly endorsed by Beat icon William Burroughs and garnered nearly 2,700 votes, or 3.4 percent of those cast.[13] In 1979 Jello Biafra, lead singer of the punk band Dead Kennedys, vigorously campaigned in the San Francisco mayoralty race and received nearly 6,600 votes (3.5 percent of those cast).[14] Lowell Darling's 1978 performance/ media art quest for the California governorship (see fig. 19)—a hard-fought campaign during which he persuaded his opponent, Governor Jerry Brown, to endorse him—garnered 62,000 votes (2 percent of those cast).[15] Audiences participated in these projects just as they participated in the usual rites of electoral

11 Figurative painters such as Peter Saul and Leon Albert Golub did make acute art protesting the Vietnam War and inhumanity in general during the 1950s and 1960s, but it was, for the most part, either widely dismissed or regarded as far out of the mainstream. **12** See Alexander Gross, *Inside the Sixties: What Really Happened on an International Scale*, http://language.home.sprynet.com/otherdex/60spenni.htm. **13** See Cathleen Thom, "'We Need More Artists in Politics,'" *The Tyee* (April 26, 2005), http://thetyee.ca/Views/2005/04/26/WeNeedArtists. **14** In a field of ten he came in fourth. See http://en.wikipedia.org/wiki/Jello_Biafra. **15** Darling's race was conducted from a pink-and-black Plymouth. The vintage, luxury-liner-scale vehicle took him to, among other destinations, the San Andreas Fault, which he laced up with giant knitting needles. TV shows such as *Entertainment Tonight* covered Darling's campaign, and the artist later appropriated and edited this output into what he termed *his* videotapes, crediting the original producers as collaborators.

democracy: by attending the candidates' events, working on their behalf, and, presumably, by voting for them.

The playfulness of these artists' candidacies draws attention to the fact that political activity in Western society is often regarded as serious, even deadening and alienating, rather than as something that might inform our lives and benefit from our meaningful participation. The notion of the political in art can thus span the spectrum from the whimsical to (far more frequently) the didactic. The artists we tend to think of as political—such as Haacke, Conrad Atkinson, Victor Burgin, Mary Kelly, and Martha Rosler—tend to produce installations with extensive texts that demand viewers' time and concentration and proffer a clear, usually left-leaning, ideological viewpoint.

The didactic installations of Group Material, on the other hand, embodied a broader emotional range than those of earlier installation artists and employed new paradigms of participatory production. Established in 1979 and housed for a time in an East Village storefront, the collective employed the input and participation—and sometimes even the belongings—of its neighbors to create thoughtful examinations of consumerism, AIDS, and other subjects (see fig. 20). Group Material represents an experimental approach to collaborative art practice that emerged at the end of the 1970s and included other New York groups such as Collaborative Projects, Inc., and Fashion Moda as well as Tim Rollins + K.O.S. (Kids of Survival), a program for Bronx teenagers that Rollins founded in 1984 and eventually evolved into a publicly funded charter school.

Collaboratively produced art can raise complex questions about participation *among* artists—not just issues of process (Group Material and Tim Rollins + K.O.S. operated by sometimes tortuously arrived-at consensus), but also of credit and ownership. Participation and collaboration are very different conditions, the latter implying shared recognition, the former merely assistance. Collaboration elevates the role of participant to cocreator, as seen in the after-the-fact partnership status that the artists Ed Keinholz, Roy Lichtenstein, and Christo accorded their wives.

Ironically, Christo's private funding of his large-scale projects through the sale of drawings and collages can seem to epitomize capitalism, at least in contrast with

fig. 20

fig. 20
Group Material
The People's Choice (Arroz con Mango), **1981**
Installation view at Group Material's East 13th Street studio, New York, 1981 / Courtesy Julie Ault

fig. 21
Judy Chicago and collaborators in the ceramics studio preparing plates for *The Dinner Party*, Santa Monica, California, 1977

fig. 22
Judy Chicago
The Dinner Party, **1979**
Installation view at the San Francisco Museum of Modern Art, 1979 / Mixed media / 576 × 504 × 36 in. / Brooklyn Museum, gift of the Elizabeth A. Sackler Foundation

fig. 21

fig. 22

government and foundation funding of the arts. Yet he is transparent about his use of volunteer labor to actualize his work, providing apparently meaningful participation to unpaid assistants as well as paid employees. His relationship with his volunteers is predicated on barter: in exchange for labor, he offers a sense of inclusion and community in a highly mediated event. The underlying beauty, scope, and mediagenic nature of the work, which is universally regarded as the property and vision of Christo and Jeanne-Claude (who plays coproducer to his director), has made it difficult to resist for even the most begrudging of critics.

Not so for Judy Chicago's *Dinner Party* (1979; figs. 21–22) and *Birth Project* (1980–85). Since the mid-1970s, Chicago's feminist oeuvre has attracted a great deal of media attention and utilized the work of volunteers. But unlike Christo's projects, the works' beauty was never a given for art-world commentators. ("Too essentialist! Too crafty! Too vulgar!" were among the epithets leveled at *The Dinner Party* upon its 1979 debut at the San Francisco Museum of Modern Art.) The volunteer labor behind *The Dinner Party* seemed to inspire a diametrically opposed response vis-à-vis Christo's apparently happier workers. Whereas his enterprise was seen as offering conviviality, Chicago's long-in-development projects were regarded as the products of something more like a sweatshop—although she gave her volunteers far more freedom to contribute than Christo ever did. Some viewed Chicago's work as not entirely her own; after 1979 complaints of misattribution and lack of credit arose from within the project, eliciting ire more reminiscent of a Hollywood studio than an artist's atelier.[16]

The election of Ronald Reagan to the presidency in 1980 brought with it a conservative backlash that drastically reduced spending on newly established and longstanding cultural programs, including the Neighborhood Arts Program and the art critics' fellowships awarded by the National Endowment for the Arts. Coincidentally, it also marked the emergence of the AIDS crisis. The onset of AIDS

16 The creative ownership of the output of Andy Warhol's Factory, too, was challenged after Warhol's death in 1987. "Superstar" collaborators and assistants began to come forward with claims of playing larger than previously known parts in producing the films, paintings, and prints that carry the Warhol imprimatur.

fig. 23

fig. 24

figs. 23–24
The AIDS Memorial Quilt, 1986–present
Detail (*fig. 23*) and installation view in Washington, D.C., 1996 (*fig. 24*) / Mixed media / Courtesy The NAMES Project Foundation

fig. 25
Thomas McGovern
ACT UP demonstration during a political fundraiser, New York City, from the series *Bearing Witness (to AIDS),* 1991
Gelatin silver print / 15 × 22 in. / Courtesy the artist

proved to be a perfect political storm; politicized by a religious right intent on reversing the previous decade's civil rights gains by lesbians and gay men, mishandled by the slow-to-act federal government, and magnified in intensity by America's lack of universal health care, it resulted in the transformation of a public-heath concern into a contentious matter of personal morality. In contrast to the government's ineffectual efforts, artists produced highly effective participatory artworks and educational campaigns in response to the epidemic.

Nearly unique to American culture is its traditional marginalization of the arts. (To dismiss this time-honored puritanism and anti-intellectualism as anachronistic is to be capable of imagining the election of a Václav Havel or Mario Vargas Llosa to the U.S. presidency.) The American artist's outsider status—beholden neither to patron nor institutional sponsor—liberated twentieth-century practitioners to pursue virtually any approach, format, or theme imaginable. These factors, in combination with the unhappy spectacle of young friends and acquaintances, artists and dealers, critics and curators dying seemingly unnatural deaths, helped prompt an outpouring of anti-AIDS public art and activism, some of it derived from the influential direct address of street works by artists such as Barbara Kruger and Jenny Holzer. The AIDS epidemic also yielded two of the most influential media artworks in history: *Silence = Death* and *The Red Ribbon* project. Theorized as conceptual artworks, both were meant to be attached to the garments of audience-participants, although donning them could bring the wearer disapprobation or insult.

Silence = Death, the graphic emblem that has become synonymous with ACT UP and AIDS activism, was conceived in 1988 by a group of six anonymous gay men. For the buttons and stickers that bore their defiant message, they inverted the pink triangle that the

fig. 25

Nazis forced homosexuals to wear in concentration camps and printed the injunction *Silence = Death* in white beneath it. (Gay activists of the 1970s had already appropriated the pink triangle as a symbol of gay liberation.) *The Red Ribbon* was designed in 1991 by Visual AIDS Artist Caucus as a symbol of commitment to people with AIDS and as a means of acknowledging the AIDS crisis at a time of fearful silence about HIV.[17] It debuted on the televised Tony Award ceremonies in 1991, and by the end of that year it was prominently displayed on lapels at the Emmys and the Oscars, the U.S. Open, Freddie Mercury's "A Concert for Life" tribute in London, and even on presidential candidate Jerry Brown's suit jacket. The handlers who removed it from Barbara Bush's bodice at the 1992 Republican Convention in Houston feared its apparently subversive political message, but by then *The Red Ribbon*—like any successful media artwork—had already begun to assume a life of its own. In some communities it remains a vital conversation starter; in others it is merely an outdated fashion accessory.

One of the high-water marks of participation in recent art is *The NAMES Project AIDS Quilt,* often known simply as *The AIDS Quilt* and now trademarked as *The AIDS Memorial Quilt* (figs. 23–24). Organized in San Francisco in 1986 by the activist Cleve Jones and now headquartered in Atlanta, it is that rare phenomenon in contemporary culture, a genuine community artwork with no initial connections to professional artists, galleries, or art institutions.[18] Contributions to *The AIDS Memorial Quilt* are democratically evaluated according only to standards of size (each must measure three by six feet) and durability. The now-gigantic work comprises more than forty-six thousand quilted, appliquéd, and collaged rectangles commemorating more than 17 percent of American AIDS deaths—ordinary citizens as well as celebrated public figures such as Arthur Ashe, Rock Hudson, and Michel Foucault.[19]

In 1988 the quilt adorned the cover of *People* magazine; a year later it was nominated for the Nobel Peace Prize. This work of community craft had morphed, as *The Red Ribbon* would a few years later, into *the* media artwork of its moment. In both cases, as with *Silence = Death,* the message is primarily political: a call for discussion and social responsibility. Confrontational, ACT UP–style direct action, however, remains the leading model of (embodied) political activism (see fig. 25)—evidence of which was on view at the January 2007 meeting of the World Social

17 Personal disclosure: I was one of four cofounders of this New York–based group of arts professionals that produced, beginning in 1989, the annual Day Without Art on December 1 as well as *The Red Ribbon* and numerous educational campaigns. 18 The notion of community is both misunderstood and degraded by mass media and corporate advertisers, which link it primarily to consumption. Art commentators also misuse the term by applying it to what they regard as nonmainstream perspectives (such as those of the so-called Latino community), rather than to the output of those without formal training. Common sense, of course, dictates that in a pluralistic society, various kinds of art will be produced, and that some of that art will be the recognizable products of artist-members of varied ethnic, gender, sexual, or religious minorities, while some will not. 19 See http://www.aidsquilt.org.

Forum in Nairobi, where a demonstrator protested against "Big Pharma" with an obviously ACT UP–inspired placard that read *You Get Rich / We Die.* It is worth emphasizing that both tactics emerged prior to the onset of ubiquitous electronic communication, a fact that renders the accomplishment even more noteworthy.

Today, by contrast, electronic mass media proffer a stay-at-home model of globally oriented entertainment and political involvement that renders the two nearly indistinguishable. Antithetical to traditional notions of community and direct action, new media-style audience participation invariably involves acts performed in solitude. Little, after all, separates voting for a favorite contestant on *American Idol* from pledging dollars to the Democratic or Republic National Committees online.[20] Not much time or effort is required for either.

Online art, which came into its own after the 1994 release of the browser software necessary to navigate the World Wide Web, can offer an alternative to media couch-potato-ism. One early trend in online art was the utilization of the database, which employs the computer's stellar capability for crunching information and making it accessible. Among the earliest such works is Muntadas's *The File Room* (1994–present), at http://www.thefileroom.org. A fully interactive, ever-expanding database documenting nearly one thousand cases of social and cultural censorship contributed by approximately twenty-five hundred daily visitors, it spans three thousand years and most of the globe.[21] The archive categorizes incidents of censorship by geographical location, date, medium, and grounds for censorship (including nudity, religious rationale, and sexual/gender orientation), and it is likely to remind audiences of the priority of culture in determining the nature of censorious activity. Harking back to so-called information art and the conceptualism of the 1970s, Muntadas has referred to *The File Room*—à la Joseph Beuys—as a "social sculpture" that "gains its meaning through a group effort of individuals, organizations, and institutions."[22]

A less collaborative approach, fully grounded in the ethos of contemporary culture, is the "tactical media" advocated by the anarchist Hakim Bey. A favorite slogan of tactical activists is "Don't hate the media, become the media"—a strategy taken up by an American collective, the Yes Men, in 2004. On the twentieth anniversary of the Bhopal Disaster, which killed thousands in India, a group member appeared on the BBC as a Dow Chemical Company spokesman, announcing that the company would accept all responsibility for

20 In fact, during a sort of ongoing telethon in spring 2007, viewers of *American Idol* had, by May 1, contributed more than $70 million to alleviate poverty in Africa and in Hurricane Katrina–affected areas of the United States. See http://en.wikipedia.org/wiki/Idol_Gives_Back. **21** Visitor statistics provided in an email to the author on February 22, 2006, from Svetlana Mintcheva of the National Coalition Against Censorship, which hosts *The File Room* on its server. *The File Room* can also take the form of a physical installation; see pl. 114. **22** Antoni Muntadas, email to the author, March 16, 2000.

the damages, while a fake Dow website, located at a real-sounding URL, announced precisely the opposite. A second television appearance by the phony spokesman created further confusion, ensuring major press coverage of the gaffes and drawing increased attention to the tragedy of 1984. The group has wreaked similar havoc on the World Trade Organization and the U.S. Department of Housing and Urban Development. In 2006 a Yes Men member appeared in New Orleans posing as a HUD representative, promising to reopen public housing facilities that had closed following Hurricane Katrina and announcing that the major oil companies would donate money to rebuild damaged levees.[23]

23 See http://en.wikipedia.org/wiki/ The_Yes_Men. The group's exploits have been captured on film in the United Artists–distributed documentary *The Yes Men* (2003).

For most teenagers and young adults today, participation in mass media comprises membership in online social networking communities such as MySpace or Facebook, which have come to be known more generally as Web 2.0. These free sites offer little in the way of meaningful social involvement along the lines of contributions made to projects such as *The AIDS Memorial Quilt* or *The File Room.* Due to its uncensored, entirely elective nature, participation in the new mass media has acquired an undeserved patina of democracy and ideological neutrality. Although some (small) percentage of content posted by artists and other individuals to MySpace or YouTube is undoubtedly intellectually stimulating or politically progressive, those sites are gigantic databases that can only reflect the outlooks, concerns, and prejudices of their users. The video footage on YouTube is not merely pluralistic; it encompasses postings that can only be described as virulently misogynistic, racist, or homophobic. The shock of seeing, for example, an apparent church choir singing about the need to eliminate homosexuals is only compounded by a list of links to other virulently antigay footage available to site visitors.

Although we can hardly blame the software for its ersatz value neutrality—that is, its refusal to distinguish between the rhetoric of the neo-Nazi and the freedom fighter in Sudan—we can blame the sites' corporate owners for their lassitude in confronting the ethical implications of their hands-off attitude toward posted content. Indeed, what seems a simple issue—should reprehensibly racist, homophobic, or misogynistic footage be contextualized or characterized in any way by those responsible for its potentially widespread distribution?—is in fact extraordinarily complex. The problem is, of course, legal as well as ethical. Unfortunately, court rulings have not kept pace with new technologies, nor have they tended to conform to one another. The American courts' tendency to consider anything posted online as *published,* in the journalistic sense, is inadequate given the impossibility of monitoring millions of daily postings. The European courts' tendency, on the other hand, to comply with the European Union's stringent antihate speech laws has hardly proved up to the task of obviating so-called socially unacceptable speech.

What has all this got to do with art? At the most basic level, as mentioned above, artists interested in mass media have already begun to produce works for YouTube

and other new-media venues, just as they have created projects for eBay, the online auction site. But in a larger sense, in a world riven by ideological and values-oriented strife, the suffocating expansion of mass media raises complementary issues about the value and place of art and about the political and ethical roles artists and art institutions see themselves playing in twenty-first-century society.

figs. 26–27
Antoni Muntadas
On Translation: Warning (Perception Requires Involvement), **1999**
Installation views at Artsonje Center, Seoul, 2007 (*fig. 26*), and in Venice, Italy, 2005 (*fig. 27*) / Courtesy the artist

fig. 26

As mass media encroaches on virtually every aspect of personal and social life, participation now seems no more complicated than owning—or having access to—a modem-equipped computer. Whereas post–World War II existential angst derived largely from the psychic inability of many to participate in what seemed a murderous society, today there exist no psychological barriers to social participation. The paralysis of existential man has evolved into the highly individuated indifference, or channeled automatism, of postmodern human. A recent and deceptively simple gesture by Muntadas—a text work reading *Warning: Perception Requires Involvement,* translated into more than a half-dozen languages (see figs. 26–27)—suggests a paradoxically sincere and ironic answer to the ever-present question of how the individual might participate in art or society. The artist implies that there is plenty for viewers to see and learn, but that something is demanded of them as well: they must engage *critically.* How else to struggle against the ideologically predigested perspectives of mass media and institutions? How else to keep alive the possibility of agency—of acting rather than being acted upon—in the face of all-encompassing postmodern culture? Participation per se can be taken for granted in the media-entertainment state. If art is to continue to matter, artists must not only provide alternative ways of participating, but also of cultivating critical perspectives that ensure the possibility of individual and collective engagement in an age when the meaning of both are tortuously twisted by the forces of global capital.

fig. 27

LEV MANOVICH

ART AFTER WEB 2.0

The explosion of user-created content (sometimes referred to as participatory or social media) on the web since 2005 has unleashed a new media universe. On a practical level, this was made possible by the convergence of free web platforms, inexpensive software that enables people to share their own media and access materials produced by others, the rapid fall in prices for professional-quality media-capture devices such as high-definition video cameras, and the addition of camera and video features to mobile phones. Importantly, however, this universe is not simply a scaled-up version of twentieth-century media culture. Instead, we have moved into the new realm of social media.[1] What does this shift mean for the ways in which media function and the terms we use to talk about them? And what does the exponential rise in the number of people who are able to produce, remix, and share media—often with skills equal to those of professionally trained artists—mean for the practice of art? These are the questions with which this essay will engage.

Social media are often discussed today in relation to Web 2.0, a term coined by Tim O'Reilly in 2004. Web 2.0 refers to a number of technical, economic, and social developments: besides social media, other important related concepts are user-generated content, network as platform, folksonomy, syndication, and mass collaboration. I will not summarize all of these here—Wikipedia, which is itself a great example of Web 2.0, does

this better than I ever could. My goal is not to provide a detailed analysis of the social and cultural effects of Web 2.0; rather, I would like to put forward a few questions and make a few points related to video and moving-image cultures on the web, with particular attention to their effect on professional art practice.

To get the discussion started, consider two principal tendencies of Web 2.0. First, in the present decade we have seen a gradual shift from a majority of internet users accessing content produced by a much smaller number of professional producers to a growing number of users accessing content produced by other nonprofessionals. Second, if the web of the 1990s was primarily a publishing medium, in the 2000s it has increasingly became a communication medium. Communication between users, including conversations around user-generated content, can take place in a variety of forms besides email, including "posts, comments, reviews, ratings, gestures and tokens, votes, links, badges, video."[2]

What do these trends mean for culture in general and professional art practice in particular? First of all, it does not mean that every user has become a producer. According to 2007 statistics, only between 0.5 and 1.5 percent of users of the most popular social media sites (Flickr, YouTube, and Wikipedia) contributed content. Others remained consumers of content produced by this tiny cohort. Does this imply that professionally produced content continues to dominate people's sources of news and media? If by content we mean typical twentieth-century mass media—news, television shows, narrative films and videos, computer games, literature, and music—then the answer is often yes. For instance, in 2007 only two blogs made it into the list of the hundred most-read news sources. Yet at the same time we have seen the emergence of the so-called long tail phenomenon, which refers to the fact that most of the content available online—including that produced by nonprofessionals—succeeds in finding an audience.[3] These audiences may be tiny but they do exist. In the mid-2000s, for example, every track out of a million or so available through iTunes sold at least once per quarter. In other words, every track—no matter how obscure—found at least one listener. This translates into a new economics of media. As researchers who have studied the long tail have demonstrated, in many industries the total volume of sales generated by low-popularity items exceeds the volume generated by the top forty.[4]

Let us now consider another set of statistics showing that people are increasingly getting their information from social media sites. In January 2008 Wikipedia ranked as the ninth most-visited website; Facebook was at five, and MySpace was at three. According to the company that collects these statistics, it is more than likely that these numbers are U.S.-biased, and that the rankings in other countries are different.[5] However, a general

fig. 28
IBM Collaborative User Experience Research Group
History Flow, 2003
Online project (http://www.research.ibm.com/visual/projects/history_flow/gallery.htm) / Courtesy Fernanda B. Viégas and Martin Wattenburg

1 See Adrian Chan, "Social Media: Paradigm Shift?," http://www.gravity7.com/paradigm_shift_1.html. Unless otherwise noted, this and all other URLs cited in this essay were accessed February 11, 2008. My descriptions throughout of interfaces, features, and common uses of social media sites also derive from early 2008; many details will surely have changed by the time you read this book. 2 Ibid. 3 The term *long tail* was coined by Chris Anderson in 2004. See Anderson, "The Long Tail," *Wired* 12, no. 10 (October 2004): 170–77, available online at http://www.wired.com/wired/archive/12.10/tail.html. 4 More long tail statistics can be found in Tom Michael, "The Long Tail of Search," Zoekmachine Marketing Blog, posted September 17, 2007, http://www.zoekmachine-marketing-blog.com/artikels/white-paper-the-long-tail-of-search/. 5 See http://www.alexa.com/site/help/traffic_learn_more (accessed February 7, 2008).

fig. 28

trend toward the increased use of social media sites—global and local—can be observed in most countries.

The number of people participating in social networks, sharing media, and creating user-generated content is astonishing—at least from the perspective of early 2008. (In 2012 or 2018 it may seem trivial in comparison to what will be happening then.) MySpace, for example, claims 300 million users. Cyworld, a Korean site similar to MySpace: 90 percent of South Koreans in their twenties and 25 percent of that country's total population (as of 2006). Hi5, a leading social media site in Central America: 100 million users. Facebook: 14 million photo uploads daily. The number of new videos uploaded to YouTube every twenty-four hours: 65,000 (as of July 2006).[6]

If these numbers seem amazing, consider a relatively new platform for media production and consumption: the mobile phone. In early 2007, 2.2 billion people had cell phones; by the end of 2008 this number is expected to be 3 billion. Obviously, people in an Indian village sharing one mobile phone are probably not making video blogs for global consumption—but this is today. Note the following trend: in mid-2007 Flickr contained approximately 600 million images. By November 2007 this number had more than tripled.[7]

These statistics are impressive, but how should they be interpreted? They do not tell us about users' actual media diets, which obviously vary between places and demographics. For instance, we do not have exact numbers (at least, they are not freely available) regarding what people watch on sites such as YouTube: the percentage of user-generated content versus commercial

6 See http://en.wikipedia.org/wiki/Myspace, http://en.wikipedia.org/wiki/Cyworld, http://www.pipl.com/statistics/social-networks/size-growth/, http://en.wikipedia.org/wiki/Facebook, and http://en.wikipedia.org/wiki/Youtube. 7 See George Oates, "Holy Moly!," Flickr Blog, posted November 13, 2007, http://blog.flickr.net/en/2007/11/13/holy-moly.

content such as music videos, anime, game trailers, and movie clips.[8] We also do not have exact figures regarding the percentage of people's daily information intake that comes from nonprofessional sources versus big news organizations, television, and commercially realized films and music.

fig. 29

figs. 29–30
Lynn Hershman Leeson
Life², 2006–present
Online project (http://
slurl.com/secondlife/
NEWare/128/128/0) /
Collection of the artist

These numbers are difficult to establish today because commercial information and media not only arrive via traditional channels such as newspapers, TV stations, and movie theaters, but also via the same channels that carry user-generated content: blogs, RSS feeds, Facebook posted items and notes, YouTube videos, and so forth. Simply counting how many people follow a particular communication channel is no longer an accurate way to gauge what they are watching. Yet even if we did have precise statistics, they would still not clarify the roles of commercial sources and user-produced content in forming people's understanding of the world, themselves, and others. More precisely, what are the relative weights of ideas expressed in large-circulation media and alternatives available elsewhere? If one person gets all her news via blogs, does this automatically mean that her understanding of world issues is different from that of someone who only reads mainstream newspapers?

8 According to research conducted by Michael Wesch, in early 2007 approximately 14 percent of YouTube offerings were commercially produced videos. Wesch, "The State of Research" (panel, 24/7: A DIY Video Summit, University of Southern California, Los Angeles, February 28, 2007).

The Practice of Everyday (Media) Life: Tactics as Strategies

For a variety of reasons, the media, business, consumer electronics and web industries, and academics have all converged to celebrate content created and exchanged by users. In academic discussions, in particular, disproportional attention is given to genres such as youth media, activist media, and political mashups, which are indeed important but do not represent the typical usage of hundreds of millions of people.

In celebrating user-generated content and implicitly equating it with all that is alternative and progressive, academic discussions often avoid asking certain basic critical questions. For instance, to what extent is the phenomenon of user-generated content driven by the consumer electronics industry (the producers of digital cameras, video cameras, music players, laptops, and so on)? To what extent is this phenomenon also driven by social media companies (which, after all, are in the business of getting as much traffic to their sites as possible so they can make money by selling advertising and usage data)?

This leads to another question: given that a significant percentage of user-generated content either follows templates and conventions established by the professional entertainment industry or directly reuses professionally produced content (for instance, anime

fig. 30

music videos), does this mean that people's identities and imagination are now even more firmly colonized by commercial media than in the twentieth century? In other words, is the replacement of the mass consumption of commercial culture by users' mass production of cultural objects a progressive development? Or does it merely constitute a further stage in the evolution of the culture industry?[9] If twentieth-century subjects simply consumed the products of the culture industry, twenty-first-century "prosumers" and "pro-ams" are passionately imitating it, creating their own cultural products that follow templates established by professionals and/or rely on professional content.

The case in point is anime music videos (often termed AMV). A search for this phrase on YouTube on May 4, 2008, returned 280,000 results. AnimeMusicVideos.org, the main web portal for AMV makers before the action moved to YouTube, contained 130,510 videos as of February 9, 2008. AMV are made by fans who edit together clips from one or more anime series and put them to music, which generally comes from sources such as professional music videos. Some AMV also use footage from video games. In the last few years AMV makers have started to add visual effects available in software such as Adobe After Effects. But regardless of the particular sources and combinations, the majority of AMV feature video and music drawn from commercial media products. AMV makers see themselves as editors who rework others' material rather than as filmmakers or animators who create from scratch.[10]

To help us analyze AMV culture, let us put to work the categories set up by Michel de Certeau in his 1980 book *The Practice of Everyday Life*.[11] De Certeau makes a distinction between the "strategies" used by institutions and power structures and the "tactics" used by modern subjects in their everyday lives. Tactics are ways in which individuals negotiate strategies that were set for them. For instance, to take one example discussed by de Certeau, a city's layout, signage, driving and parking rules, and official maps are strategies created by the government and corporations. The ways an individual moves through the city—taking shortcuts, wandering aimlessly, or navigating favorite routes—are tactics. In other words, an individual cannot

9 See Theodor W. Adorno, *The Culture Industry: Selected Essays on Mass Culture*, ed. J. M. Bernstein (New York: Routledge, 2001). **10** Information provided by Tim Park (AnimeMusicVideos.org), in conversation with the author, February 9, 2008. **11** See Michel de Certeau, *The Practice of Everyday Life*, trans. Steven Rendall (Berkeley: University of California Press, 1984).

physically reorganize the city, but she can adapt it to her needs by choosing how to nego-
tiate it. A tactic "expects to have to work on things in order to make them its own, or to
make them 'habitable.'"[12]

12 http://en.wikipedia.org/wiki/
The_Practice_of_Everyday_Life
(accessed February 8, 2008).

fig. 31
Marcos Weskamp
Flickr Graph, **2005**
Online project (http://
www.marumushi.com/
apps/flickrgraph/) /
Courtesy the artist and
Phillip Ingham

In modern societies, as de Certeau points out, most of the
objects that people use in everyday life are mass-produced goods;
these goods are expressions of the strategies of designers, producers, and marketers.
People build their identities and populate their worlds with these readily available objects
using different tactics: bricolage, assembly, customization, and—to use a term that was
not a part of de Certeau's vocabulary but has become important in the 1990s—remix.
For instance, people rarely wear outfits in which every piece is by a single designer,
as in fashion shows; they usually mix and match different pieces from different sources.
They also wear clothing in ways that the designers may not have
intended, and they customize the clothing with buttons, belts, and
other accessories. The same goes for the ways in which people
decorate their living spaces, prepare meals, and construct their life-
styles in general.

The Practice of Everyday Life offers an excellent intellectual par-
adigm for thinking about vernacular culture, but we have witnessed
many significant changes since the book was published in the early
1980s. These changes are not drastic in the area of governance,
though even there we have seen moves toward more transparency
and visibility. In the sphere of the consumer economy, however, the
changes have been quite substantial. Strategies and tactics are now
often linked closely in an interactive relationship, and their features
are frequently reversed. This is particularly true of "born digital"
industries and media such as software, computer games, websites,
and social networks. Such products are explicitly designed to be
customized by users. Consider, for instance, the original graphical
user interface, popularized by Apple's Macintosh in 1984, which
allowed users to customize the appearance and functions of the
computer and its applications to their liking. The same applies to
recent web interfaces—iGoogle, for instance, which allows the user
to set up a custom home page by selecting from many applications
and information sources. Facebook, Flickr, Google, and other social
media companies encourage others to write mashup applications
that repurpose their data and add new services (as of early 2008,
Facebook hosted more than 15,000 applications written by outside
developers). The explicit strategy of customization is not limited to
the web; many computer games, for example, now ship with a level

fig. 31

editor that allows users to create their own playing levels.

Although industries dealing with the physical world are moving much more slowly, they are on the same trajectory. In 2003, for instance, Toyota introduced the Scion automobile, the marketing of which centered on the idea of extensive customization. Nike, Adidas, and Puma have all experimented with allowing consumers to design their own shoes by choosing from a broad range of parts. (In the case of Puma's Mongolian Barbeque concept, a few thousand unique shoes can be constructed.[13]) In early 2008 Bug Labs introduced what they called "the Lego of gadgets": an open-source consumer electronics platform consisting of a minicomputer and modules such as a digital camera and an LCD screen.[14] The recent celebration of DIY practice in various consumer industries is another example of this growing trend. To revisit the terms set out by de Certeau in *The Practice of Everyday Life,* these companies' new strategies mimic the tactics of bricolage and reassembly. In other words, the logic of tactics has now become the logic of strategies.

The Web 2.0 paradigm represents the most dramatic reconfiguration to date of the relationship between tactics and strategies. According to de Certeau, tactics do not necessarily result in objects or anything stable or permanent. As summarized by Wikipedia, "Unlike the strategy, [the tactic] lacks the centralised structure and permanence that would enable it to set itself up as a competitor to some other entity.... It renders its own activities an 'unmappable' form of subversion."[15] Since the 1980s, however, the consumer and culture industries have systematically turned every subculture (particularly youth subcultures) into product. In short, cultural tactics evolved by individuals are sold back to them as strategies. If you want to oppose the mainstream, you now have plenty of "oppositional" lifestyles—with every subcultural nuance, from music and visual styles to clothes and slang—available for purchase.

These adaptations, however, still tend to focus on distinct subcultures: bohemian, hip-hop, rap, rock, punk, skinhead, goth, etc.[16] But in the 2000s the transformation of people's tactics into corporate strategies began to take a new direction.

13 See https://www.puma.com/secure/mbbq/ (accessed February 8, 2008). 14 See http://buglabs.net/ (accessed February 8, 2008). 15 http://en.wikipedia.org/wiki/The_Practice_of_Everyday_Life. 16 See http://en.wikipedia.org/wiki/history_of_subcultures_in_the_20th_century (accessed February 10, 2008).

The developments of the previous decade—the web platform, the dramatically decreased cost of consumer devices for media capture and playback, the increase in global travel, and the growing consumer economies of many countries—led to an explosion of user-generated content available in digital form: websites, blogs, discussion forums, maps,

digital photos, video, and music. Responding to this turn of events, Web 2.0 companies created powerful platforms designed to host all this content. MySpace, Facebook, Orkut, LiveJournal, Blogger, Flickr, YouTube, hi5, Cyworld, Wretch, Baidu, and thousands of other social media sites make such content instantly available worldwide (except, of course, in countries that block or filter them). These platforms do not just reveal the particular features of individual subcultures, but also make public details of the everyday lives of hundreds of millions of people who make and upload media or text.

What was once ephemeral, transient, untraceable, and invisible has thus become permanent, mappable, and viewable. Social media platforms give users unlimited storage and plenty of tools to organize, promote, and broadcast their thoughts, opinions, behavior, and media to others. You can already directly stream video using your laptop or mobile phone, and it is only a matter of time before the constant broadcasting of one's life becomes as common as email. If you follow the evolution from the MyLifeBits project (2001) to Slife software (2007) and Yahoo! Live's personal broadcasting service (2008), the trajectory toward the ongoing capture and dissemination of everyday life is clear.

According to de Certeau's analysis, a tactic can easily break up and regroup. In contrast, strategies are slow to change. The strategies used by social media companies today, however, do the exact opposite: they are designed to be flexible and they continually change. (Of course, all businesses in the age of globalization have had to become adaptable, mobile, and ready to break up and regroup, but they rarely achieve the flexibility of web companies and developers.[17]) According to Tim O'Reilly, one important feature of Web 2.0 applications is "design for 'hackability' and remixability."[18] Most major Web 2.0 companies—including Amazon, eBay, Flickr, Google, Microsoft, Yahoo!, and YouTube—thus make available their programming interfaces and some of their data to encourage others to create their own applications.[19]

Today, in sum, the strategies used by social media companies can often look like tactics, while tactics can look like strategies. Since the companies that create social media platforms make money from luring as many as visitors as possible (thereby serving advertisements, selling add-on services, and gathering usage data to sell to other companies), they have a direct interest in having users pour as much of their lives into these platforms as possible. Consequently, they give users the ability to customize their online lives (for instance, by controlling what is seen by whom) and to expand the functionality of the platforms themselves.

This, however, does not mean strategies and tactics have completely changed places. If we look at the actual media content produced by users, the relationship between the two remains unchanged. As mentioned above, for many decades companies

17 A typical statement from the business community: "Competition is changing overnight, and product lifecycles often last for just a few months. Permanence has been torn asunder. We are in a time that demands a new agility and flexibility: and everyone must have the skill and insight to prepare for a future that is rushing at them faster than ever before." Jim Carroll, "The Masters of Business Imagination Manifesto aka The Masters of Business Innovation," http://www.jimcarroll.com/10s/10MBI.htm. **18** Tim O'Reilly, "What Is Web 2.0: Design Patterns and Business Models for the Next Generation of Software," http://www.oreillynet.com/pub/a/oreilly/tim/news/2005/09/30/what-is-web-20.html?page=4 (accessed February 8, 2008). **19** See http://en.wikipedia.org/wiki/Mashup_%28web_application_hybrid%29.

have been turning the elements of various subcultures into commercial products. But these subcultures are rarely developed completely from scratch—they are themselves the result of individuals' appropriation or remix of earlier commercial cultures.[20] AMV subculture is a case in point. On the one hand, it exemplifies the new strategies-as-tactics phenomenon: AMV are hosted on mainstream social media sites such as YouTube, so they are not exactly transient or unmappable (you can search them, see how other users rated them, and so forth). On the other hand, on the level of content, the great majority of AMV consist of passages lifted from commercial anime and music. This does not mean that AMV are not creative or original, only that their creativity is different from the romantic/modernist model of making something new. To use de Certeau's terms, AMV represent a form of tactical creativity that works to make things habitable.

Conversations through Media

Thus far I have discussed social media using familiar terminology. However, the very terms I have most frequently invoked—content, cultural production, and cultural consumption—are themselves being redefined by Web 2.0 practices. Today we are seeing new kinds of communication in which content, opinion, and conversation often cannot be clearly separated. Blogging is a good example, since many entries are copied by blog writers from other sources and then commented upon. Consider also online forums or the comments below website entries: the original posts may generate long discussions that go in new directions, with the first items long forgotten.

Often the words *content, news,* and *media* function as tokens to initiate or maintain conversations. I am thinking here of people posting pictures on one another's MySpace pages or exchanging gifts on Facebook. What kind of gift you get is less important than the act of getting a gift, or that of posting a comment or a picture. Although it may appear that such conversations simply foreground communicative functions that the linguist Roman Jakobson described as emotive or phatic, detailed analysis may reveal them to be a genuinely new phenomenon.[21]

The beginnings of such analysis can be found in the work of the social media designer Adrian Chan. As he points out, "All cultures practice the exchange of tokens that bear and carry meanings, communicate interest and count as personal and social transactions." Token gestures "cue, signal, indicate users' interests in one another." While the use of tokens is not unique to social media, some of the features Chan points out do indeed appear to be new. For instance, he notes that the use of tokens is often "accompanied by ambiguity of intent and motive (the token's meaning may be codified while the user's motive for using it may not). This can

20 A very interesting feature in *Wired* described a creative relationship between commercial manga publishers and fans in Japan. The story quotes Keiji Takeda, one of the main organizers of Japanese fan conventions, as saying, "[The convention floor] is where we're finding the next generation of authors. The publishers understand the value of not destroying that." Daniel H. Pink, "Japan, Ink," *Wired* 15, no. 11 (November 2007): 216–33, available online at http://www.wired.com/techbiz/media/magazine/15-11/ff_manga?currentPage=3.
21 See Louis Hébert, "The Functions of Language" (2006), in *Signo,* http://www.signosemio.com/jakobson/a_fonctions.asp (accessed February 7, 2008).

double up the meaning of interaction and communication, allowing the recipients of tokens to respond to the token or to the user behind its use."[22]

Another novel communication situation involves conversations around a piece of media—for instance, comments added by users beneath a Flickr photo or a YouTube video that respond not only to the media object but also to one another.[23] Such conversation structures are also common in real life: think of a typical discussion in a graduate film studies class, for instance. However, web infrastructure and software allow these conversations to be distributed in space and time—people can respond to one another regardless of their respective locations, and the conversation can, in theory, go on forever. (The web is, in fact, millions of such conversations taking place at the same time.) These conversations are quite common: according to a 2007 report of the Pew Internet and American Life Project, 89 percent of American teenagers who post pictures online reported that people comment on their photos at least some of the time.[24]

Equally interesting are conversations that take place through images or video—for instance, responding to a video with another video. This is, in fact, a standard feature of the YouTube interface.[25] Social media sites contain countless examples of conversations through media, but for me the most interesting case so far is the five-minute theoretical video *Web 2.0 . . . the Machine Is Us/ing Us,* posted by the cultural anthropologist Michael Wesch on January 31, 2007.[26] As of May 12, 2008, this video had been watched 5,371,859 times. It had also generated twenty-eight video responses ranging from short, thirty-second comments to long, equally theoretical, and carefully crafted videos.

As is the case with any other feature of contemporary digital culture, it is possible to find precedents for all of these communication situations. For instance, modern art may be understood as conversations between different artists or artistic schools. That is, one artist/movement is responding to work produced earlier by another artist/movement. Thus Modernism reacted to classical nineteenth-century culture, Jasper Johns and other Pop artists to Abstract Expressionism, Jean-Luc Godard to Hollywood-style narrative cinema, and so on. To use the terms of YouTube, we might say that Godard posted a video response to one huge clip called "classical narrative cinema." But the Hollywood studios did not respond—at least not for another thirty years.

As can be seen from these examples, conversations between artists and movements were typically not true conversations. One artist/school produced something, another artist/school made something in response, and that was all. The first artist/school usually did not react in turn. Beginning in the 1980s, however, professional media practices begin to respond to one another more quickly, and the conversations were no

22 All Chan quotes appear at http://www.gravity7.com/paradigm_shift_1.html.
23 According to a survey conducted in 2007, 13 percent of internet users who watch videos also post comments about them. See Pew Internet and American Life Project, "Reports: Technology and Media Use," July 25, 2007, http://www.pewinternet.org/PPF/r/219/report_display.asp. Of course, it is not just videos that inspire commentary, reviews, and discussions; the media object in question might be software, a photograph, or a previously posted comment. The Pew statistics, unfortunately, do not tell how many comments are responses to other comments.
24 See Pew Internet and American Life Project, "Reports: Family, Friends, and Community," December 19, 2007, http://www.pewinternet.org/PPF/r/230/report_display.asp. **25** The phenomenon of conversation through media was first pointed out in 2006 by Derek Lomas in relation to comments on MySpace pages. **26** See http://youtube.com/watch?v=6gmP4nkoEOE (accessed May 12, 2008).

longer one-way. Music videos influence the editing strategies of feature film and television; similarly, the aesthetics of motion graphics are now slipping into other narratives. Cinematography, for example, a discipline that once applied only to film, has been taken up by the video game industry. Such conversations are still different, however, than communications between individuals in networked environments that take place through media. In the latter case, it is individuals rather than professional cultural producers who are exchanging media messages, and the exchange can happen within hours.

Is Art after Web 2.0 Still Possible?

Have professional artists (including video and media artists) benefited from the explosion of online content and the easy availability of media publishing platforms? Does the fact that we now have platforms where anyone can publish videos and charge for downloads mean that artists have new distribution channels for their work? Or has professional art become irrelevant in the world of social media, where hundreds of millions of people upload and download video, audio, and photographs daily; content produced by an unknown author may be downloaded millions of times; and media objects move fluently and rapidly between users, devices, contexts, and networks? Modern artists have thus far succeeded in meeting the challenges of each generation of media technology, but can professional art survive the extreme democratization of media production and access?

On one level this question is meaningless. Never in the history of modern art has it done so well commercially. No longer a pursuit for the few, contemporary art has become yet another form of mass culture. Today its popularity often rivals that of other mass media. Most importantly, contemporary art has become a legitimate investment category; with all the money invested in this market, it is unlikely that it will ever collapse entirely. (Of course, history has repeatedly shown that even the most stable political regimes do eventually fail.)

Since the beginning of globalization, the institution of contemporary art has experienced a level of growth that parallels the rise of social media in the 2000s. Ever more countries have joined the global world and adopted Western values in their cultural politics—including the support, collection, and promotion of contemporary art. By 2004, for example, Shanghai had not one but three museums of contemporary art, plus more large spaces for showing recent

work than New York or London. "Starchitects" such as Frank Gehry and Zaha Hadid are now building museums and cultural centers on Saadiyat Island in Abu Dhabi, the capital of the United Arab Emirates. Rem Koolhaas is building a new museum of contemporary art in Riga, Latvia. The list continues, but you get the idea.

In the case of social media, the unprecedented growth in the number of people uploading and viewing one another's media has led to a lot of innovation. Although the typical video diary or anime on YouTube may not be that special, enough are. In fact, in nearly every medium in which the technologies of production have been democratized (including video, music, animation, and graphic design), I have encountered many projects that not only rival those produced by the best-known commercial companies and professional artists, but also often explore new areas not yet touched on by those with more symbolic capital.

Who is doing these projects? In my observations, while some do come from prosumers, pro-ams, and other amateurs, most are done by young professionals or professionals in training (i.e., students). The emergence of the internet as the standard communication medium of the 1990s means that in most cultural fields today, nearly every company, regardless of size or geographic location, has a web presence and posts new work online. Perhaps more importantly, students can now put their projects before a global audience, see what others are doing, and work together to develop new tools (see, for example, the Processing.org community).

We are not talking about "classical" social media produced by the general public and uploaded to YouTube and Flickr. At least at present, many such portfolios, sample projects, and demo reels produced by young designers and students are being uploaded to specialized aggregation sites known to people in relevant fields. By way of example, sites that I consult regularly include xplsv.tv (motion graphics and animation), Coroflot (design portfolios from around the world), Archinect (projects by architecture students), and Infosthetics (information visualization projects). In my view a significant percentage of the work found on these websites represents the most innovative cultural production today. At very least, they make it clear that the world of professional art does not have exclusive license to creativity and innovation.

Perhaps, however, the most sophisticated forms of conceptual innovation may be linked to the development of Web 2.0 itself—namely, the new creative software tools (web mashups, Firefox plugins, Facebook applications, etc.) designed by individuals and small collectives as well as large companies such as Google. Ultimately, social media's true challenge to art may not be the excellent cultural production of students and nonprofessionals that is now readily available online. It may lie in the very dynamics of Web 2.0 culture: its incessant innovation, energy, and unpredictability.

fig. 32
Robert Hodgin,
The Barbarian Group
Flocking Application,
2007
Online project (http://
www.barbariangroup.com/
portfolio/fox_movies_
japan_horror) / Courtesy
the artist

INSTRUCTIONS AND KEY COMMANDS
PRESS ? TO HIDE

S SAVE IMAGES (1480x1110 · PNG) 1 TOGGLES RENDERING OF BIRDS M MAGNETIC COLLISION AVOIDANCE
C CAMERA MODE (stationary or tracking) 2 TOGGLES RENDERING OF STRING [/] ADJUSTS MAGNETIC CHARGE
B BEZIER CURVES + / − ADDS or SUBTRACTS 25 BIRDS Q TOGGLES MAGNETIC AUTOCYCLE
 ↑ / ↓ ADJUSTS DRAG G TOGGLES GRAVITY BALL
 ↑ / ↓ ADJUSTS GRAVITY F TOGGLES FLOOR PLANE

fig. 32

PLATES

JOHN CAGE

I was intent on making something that didn't tell people what to do. —John Cage

4'33" (1952) is a composition of silence lasting four minutes and thirty-three seconds. Without instrumentation, the score highlights ambient sounds surrounding the performance: noises in the environment and those produced by the audience. Having decided there is no such thing as absolute silence, Cage chose to define it as the absence of intentional sound. In this he was influenced not only by avant-garde composition and Surrealism, but also by Eastern philosophy and Zen Buddhism. Indeterminacy, chance, and nonlinear progression became integral to the structure of his music. By scoring silence, Cage sought to open his listeners to divine influences, making music a process of discovery rather than one of forced communication.

As a teacher at Black Mountain College, Cage became familiar with Robert Rauschenberg's White Paintings (see pl. 4) the year before composing *4'33"*. According to Cage, the paintings—blank panels of white oil on canvas—were not just objects, but also "ways of seeing…airports for shadows and for dust, but you could also say that they were mirrors of the air." They inspired him to compose a silent work, so that music could "catch up" to painting.

4'33" premiered at the Benefit Artists Welfare Fund concert in Woodstock, New York, in August 1952; it was performed by David Tudor, a pianist who also taught at Black Mountain College. Tudor used the original manuscript (now lost), written in conventional grand staff notation and containing empty measures in three movements. Tudor later reconstructed two versions according to his recollection of the original score (see pl. 1). The Irwin Kremen manuscript (1953; pl. 2) represents a graphic departure. Each movement is laid out in "proportional notation": as a timeline in which an eighth of an inch equals one second. Visually, this version appears remarkably similar to Rauschenberg's White Paintings. The score constructs a time within which to hear chance sounds, just as the White Paintings provide a reflective space in which to observe fleeting images. Video documentation of Cage performing the work survives in Nam June Paik's *A Tribute to John Cage* (1973/1976; pl. 3), in which the composer sits at a grand piano in Boston's Harvard Square, and in Henning Lohner's *4'33" in Berlin (with John Cage), raw material video pictures cat. # 001* (1990), filmed amid the rubble of the Berlin Wall. —MP

1 *4'33"* 1952 / Musical score with handwritten notes by David Tudor / 12½ × 9½ in. / Courtesy the Getty Research Institute, Los Angeles

2

4 **Robert Rauschenberg** *White Painting (Three Panel)* 1951 /
Oil on canvas / 72 × 108 in. / San Francisco Museum of Modern
Art, purchased through a gift of Phyllis Wattis

Rauschenberg created *White Painting (Three Panel)* as a student at
Black Mountain College. He later noted that his painting instructor,
Josef Albers, taught him "such respect for all colors that it took
years before I could use more than two colors at once." Avoiding
color, content, and narrative, Rauschenberg chose to paint in white
in order to avoid imposing his own preferences and refrain from
subordinating one color to another. —MP

2 *4'33"* 1952 / Irwin Kremen score in
proportional notation (Edition Peters no.
6777a), 1953 / 8½ × 11 in. / Courtesy C. F.
Peters Corporation 3 *4'33"* 1952 / Excerpt
from *A Tribute to John Cage* by Nam June Paik,
1973/1976 / Single-channel color video with
sound, 3:55 min. / San Francisco Museum
of Modern Art, Camille W. and William S.
Broadbent Fund

3

GEORGE BRECHT

Chance was important to Brecht even before he attended John Cage's experimental composition course at the New School for Social Research, New York, in 1958–59. Earlier in the decade he would roll a sheet into a ball, spray it with water and ink, and call the result "a painting made by chance." Brecht and Cage shared a belief in using chance as an operation, thereby tapping into the forces of nature and the objective universe and making the invisible observable. Brecht was a chemist before he became an artist; he believed art and science were both tools, intimately related to each other as ways to understand nature and humanity.

Cage's class led to what Brecht and his Fluxus contemporaries were best known for: an emphasis on the event. They made scores for performances, directions to guide individual or group activities. Through such events Brecht aimed to reveal the patterns and interconnected relationships in all aspects of life. His first solo exhibition, *Toward Events* (1959; pl. 6), involved a unique game of solitaire and the audience's interaction with objects in a case, a dome, and a cabinet.

Beginning in 1959, Brecht made approximately a hundred event scores that were published in a box called *Water Yam* (1963; pl. 8). They were small white cards with black type, some bearing a few words or bulleted instructions. For Brecht, an event addressed a field of phenomena, with dissimilar elements timed to take place simultaneously courtesy of the participants. What occurred during the event was the function of Brecht's score and the participants' interpretations of the text. Merely reading the score, he claimed, represented a performance. The intention was to undermine his own authorship; the viewer became a collaborator capable of deciding how to interpret the artist's instructions. "It's just to see what happens when things come together," he noted. "The research comes into the making of them, and once they're made, the research continues in the process of discovering how people interact with them; how I interact with them." —MP

5 *Deck: A Fluxgame* 1966 / Fluxus edition: plastic box and offset lithography / 2⅝ × 3¹¹⁄₁₆ × ⅞ in. / The Gilbert and Lila Silverman Fluxus Collection, Detroit 6 *Toward Events* 1959 / Announcement for an exhibition at Reuben Gallery, New York, 1959 / Offset lithography on paper bag / 9¹⁵⁄₁₆ × 6¼ in. / Archiv Sohm, Staatsgalerie Stuttgart, Germany

5

6/57		Found	Structure
8/57	A	Dominos	Koan
		Xylophone	
Late 1957		Board	Marbles
1/57	D	4 Frames	Blair

THE CASE is found on a table. It is approached by one to
several people and opened.
The contents are removed and used in ways appropriate
to their nature.
The case is repacked and closed.
The event (which lasts possibly 10 - 30 minutes)
comprises all sensible occurrences between approach
and abandonment of the case.

ThE DOME stands on a cloth set for the array of its con-
tents. This array accomplished, necessary actions
taken, the pieces are returned to their places.

THE CABINET.

SOLITAIRE 1 is played on a unique set of 27 cards based
on the variables number, size, and color. Each card
carries one of three values for each of the variables
(1, 2, or 3; large, medium, or small; black, white,
or brown). Choose a single "effective variable".
Mix the deck and deal three cards in a row. If two
or more have the same value of the effective variable,
move the other upon the one at the left. Continue
dealing the whole deck by rows of three upon the
previous piles and spaces. Move cards from right to
left whenever they can be matched in value. These
moves are made only with individual cards, not with
piles. When the deck is exhausted, pick up piles in
the same order as dealt, turn them over to form a
new hand, and deal again by threes. Whenever three
cards of the same value appear one at the top of each
pile, discard them from the pack. The game is won if
all nine threes of a kind are so discarded. Continue
redealing the pack without limit until the game is
won or reaches an impasse.

7 *Universal Machine* 1965 / MAT MOT
edition: cloth-covered box, offset lithography,
glass, buttons, stainless-steel ball bearing,
balsa wood, wood toothpicks, glass beads,
metal hook and eye, brass washer, and iron
snap clasp, ed. 73/100 / 11 × 11 × 1⁹⁄₁₆ in. /
The Gilbert and Lila Silverman Fluxus
Collection, Detroit 8 *Water Yam* 1963 /
Fluxus edition: wood and Masonite box and
offset lithography / 9⅝ × 8⅞ × 1⅞ in. /
The Gilbert and Lila Silverman Fluxus
Collection, Detroit

9 **Allan Kaprow** *Words* 1962 /
Happening at Smolin Gallery, New York,
1962 / Allan Kaprow Estate, Hauser &
Wirth Zürich London

Kaprow was John Cage's student at the
New School for Social Research, New York,
when he began working on what he later
called "the first proto-happenings." He
coined the term *happening* in a 1958 essay
on the painter Jackson Pollock (he chose
it as a neutral name for an event or per-
formance). For *Words*, Kaprow created an
environment using random text gathered
from publications. He hung two rolls of
cloth covered with words side by side, invit-
ing visitors to manipulate them and gener-
ate new phrases. He also stapled hundreds
of words to the gallery walls and a central
pillar, encouraging viewers to remove and
reposition the text. —MP

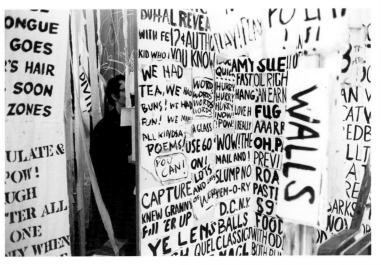

ANDY
WARHOL

In the early 1960s Warhol developed his signature Pop aesthetic, adopting an iconography of industrially produced images and a formula of monotony and repetition. His paintings of Campbell's soup cans and newspaper headlines and his drawings of dollar bills were still "original" artworks, objects that were unique rather than reproduced through printing, film, or video. However, his *Do It Yourself* series, produced around 1962, functioned as a test ground for a new concept of authorship. The compositions are clearly derived from how-to books and paint-by-number hobby kits containing pigments and outlined scenes on canvas board—the specific domain of children and amateur painters. In these canvases and drawings, generic painterly motifs such as flowers, landscapes, and sailboats are only partially filled out, as if the artist had abandoned the idea halfway through the project. One could also, however, read this as the moment in which just enough pigment had been applied to establish a pattern of corresponding colors and numbers. From here on, it is implied, anybody could potentially fill in the details and complete the work. As the artist bluntly commented, always playfully burnishing his Pop image: "I think somebody should be able to do all my paintings for me.... I think it would be so great if more people took up silk screens so that no one would know whether my picture was mine or somebody else's." In other words, he would be happy for anything that looked like a Warhol, even if it were not, to be attributed to him. Artworks such as the *Do It Yourself* drawing of flowers (pl. 10) and *Dance Diagram—Tango* (both 1962) were not meant to implicate the audience as active participants in his production, as did contemporary projects by the members of Fluxus. Instead they sought to profit from a kind of division of labor, enlisting others to work toward the mass production of Warhol images. Such projects prefigure the artist's later film work with the Factory, which significantly extended his interest in anonymous authorship and collective production. —*RF*

10

10 *Do It Yourself* 1962 / Colored crayon on paper / 25 × 18 in. / Princeton University Art Museum, courtesy Sonnabend Collection

	SCHEMA:
(Number of)	adjectives
(Number of)	adverbs
(Percentage of)	area not occupied by type
(Percentage of)	area occupied by type
(Number of)	columns
(Number of)	conjunctions
(Depth of)	depression of type into surface of page
(Number of)	gerunds
(Number of)	infinitives
(Number of)	letters of alphabets
(Number of)	lines
(Number of)	mathematical symbols
(Number of)	nouns
(Number of)	numbers
(Number of)	participles
(Perimeter of)	page
(Weight of)	paper sheet
(Type)	paper stock
(Thinness of)	paper
(Number of)	prepositions
(Number of)	pronouns
(Number of point)	size type
(Name of)	typeface
(Number of)	words
(Number of)	words capitalized
(Number of)	words italicized
(Number of)	words not capitalized
(Number of)	words not italicized

11 **Dan Graham** *Schema* 1966 / Printed matter / Courtesy the artist

Graham's series of *Schema,* begun in 1966, are among the earliest examples of conceptual art. The artist conceived these schematic poems as generators of text to be realized by collaborators and editors at magazines and publishing houses. The *Schema* here is a typical example: a score devised for mass production and distribution via print. "(Systems of) information (in-formation) exist halfway between material and concept, without being either one," asserted Graham in 1969. The resulting texts, which approximate our contemporary notion of software and code, were published in *Aspen* magazine in 1967 and later in magazines such as *Extensions, Art-Language, Interfunktionen, Studio International,* and *Flash Art.* —RF

WOLF VOSTELL

Vostell started involving participants in his actions as one of the founding members of the Fluxus movement in Germany. His signature was not only to engage and activate his audiences, but also to shock them—an attempt to let disparate elements collide. His praxis of "decollage"—Vostell's term for a destructive but also constructive artistic position—included instructional pieces such as his first happening in Paris, *Petit Ceinture* (Small Loop, 1962); altered television sets such as *TV Dé-collage* (1963); and a range of sculptural and graphic elements. *Do it yourself* (1963) invited the public to reuse the *New York Times* as an artistic material by reducing it to pulp in a blender and adding perfume and sneeze powder. He employed smoke bombs in his most notorious happening, *You—A Decollage Happening* (pl. 12), realized on Long Island, New York, on April 19, 1964, with the help of his friend Allan Kaprow. Though it was performed in the United States, *You* was influenced by a German aesthetic still trying to come to terms with the trauma of the Holocaust and World War II. The event score (pl. 13), which Vostell called a "psychogram," took a newspaper clipping on the wartime death of two Polish partisans as a point of departure. The happening involved a series of staged actions at a variety of sites, including an empty white swimming pool, where participants were asked to use revolvers to shoot paint at one another while piling up to form a heap of "corpses." They then crawled along a length of barbed wire to a tennis court and an area with burning TV sets, to be watched while wearing gas masks. At one point, as they passed a stinking horse stable, a loudspeaker addressed the participants: "You, you." The stage direction, however, countered the chaotic action, instructing participants to "Try to be the most friendly to everybody." The event asked a lot from those who decided to participate, but also from those who just stood by and watched. The spectacle involved all of the senses, and it concluded with an "action-lecture" in which the audience was free to join in by humming. All of Vostell's happenings shared a sense of absurdity, physical extremes, and an often monumental scale. *You* in particular succeeded as a satire on the absurdity of life and the atrocities of war. —RF

12 *You—A Decollage Happening* 1964 / Happening in Great Neck, New York, 1964 / Photo: Peter Moore 13 *You—A Decollage Happening* 1964 / Documentation of a happening in Great Neck, New York, 1964 / Ink, gouache, and spray paint on cardboard / 19¹¹⁄₁₆ x 23⅝ in. / Archiv Sohm, Staatsgalerie Stuttgart, Germany

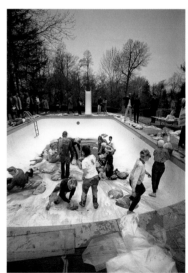

12

14 **Joseph Beuys, Bazon Brock, Rolf Jährling, Ute Klophaus, Charlotte Moorman, Nam June Paik, Eckart Rahn, Tomas Schmit, and Wolf Vostell** *24-Stunden* (24 Hours) 1965 / Catalogue of a happening at Galerie Parnass, Wuppertal, Germany, 1965 / Offset lithography, plastic, and flour / 4¼ × 3 × 2 in. / Special Collections, San Francisco Museum of Modern Art Research Library

Masterminded by Beuys, the action *24-Stunden* (24 Hours) took place on June 5, 1965, at Galerie Parnass in Wuppertal, Germany, from midnight to midnight. It included simultaneous Fluxus activities by Brock, Paik, Moorman (who performed in her transparent plastic dress), Schmit, Vostell (who performed a cycle of seventeen actions), and Paik's *Robot K-456* (pl. 26), the first nonhuman "action artist." The catalogue, published soon afterward by Hansen & Hansen, documents the events and includes, in a cavity cut into the interior pages, a small plastic bag filled with flour (the raw material for one of Vostell's contributions: "Occupy yourself for 24 hours with flour and illustrations. Cover the photos with flour and only let the smile of a face shine through"). —RF

FLUXUS

In the late 1950s John Cage taught a series of courses on experimental composition at the New School for Social Research, New York. Attended by artists such as Allan Kaprow, George Brecht, and Yoko Ono, the classes laid the foundation for the Fluxus movement by encouraging a younger generation of practitioners to use chance in their work.

Most active between 1962 and 1978, Fluxus emerged as a loose, international association of artists working in a wide range of media, including musical scores, performances, events, publications, and multiples. The name derived from the dictionary definition of *flux,* implying change, flow, and indeterminacy. At one time or another, Fluxus artists working individually and collectively under the Fluxus banner included Brecht, Ono, Ay-o, Robert Filliou, Dick Higgins, Alison Knowles, George Maciunas, Charlotte Moorman, Nam June Paik, Mieko Shiomi, Daniel Isaac Spoerri, Ben Vautier, Wolf Vostell, and La Monte Young. They hailed from America, Japan, Korea, and several European countries, including Czechoslovakia, Denmark, France, Germany, Holland, Italy, and Sweden.

Informally structured, the group comprised writers, musicians, and artists who did not define themselves as part of a strict movement. Instead, as Brecht described it, "Each of us had his own ideas about what Fluxus was and so much the better.... For me, Fluxus was a group of people who got along with each other and who were interested in each other's work and personality." In spirit Fluxus was antibourgeois, antiart, and rebellious against Modernism, the movement that dominated high art of the late 1940s to the early 1960s. Like Dada and Surrealism, Fluxus questioned the value of art and the artist, finding precedent in Marcel Duchamp's readymade objects and in Cage's advocacy of chance and indeterminacy. Fluxus artists consciously incorporated audience participation and life itself into their work.

Maciunas designed or produced components of many of the collective's object-based "anthologies." One such example is *Fluxkit* (1965–66; pls. 15–16), a vinyl attaché case housing multiples by various artists. In the late 1960s Maciunas assembled three versions, with silk-screened labels of his own design, that contained between twenty and forty items by other Fluxus artists. Many include versions of Brecht's *Water Yam* (1963; pl. 8) along with event scores, texts, and "Fluxbox" games or puzzles (significant in the Fluxus repertoire because they are innately playful and encourage interaction). —*MP*

15

15–16 *Fluxkit* 1965–66 / Fluxus edition: vinyl attaché case, metal hinges, and silkscreen / 12⅝ × 16¹⁵⁄₁₆ × 4¹⁵⁄₁₆ in. / The Gilbert and Lila Silverman Fluxus Collection, Detroit

17 **Joseph Beuys** *Intuition* 1968 / Wood, graphite, and metal
staples / 11⅞ × 8⅜ × 2¼ in. / Walker Art Center, Minneapolis, Alfred
and Marie Greisinger Collection, T. B. Walker Acquisition Fund, 1992
18 Beuys signing *Intuition* boxes at his studio, Düsseldorf, Germany,
ca. 1968–69

Between 1968 and 1985, in association with Wolfgang Feelisch's
Vice-Versand Editions, Beuys produced approximately twelve thou-
sand wooden boxes, each with the word *intuition* penciled inside.
Displaying variation in timber and nails, the boxes were meant to be
filled by their owners with intuition and new meaning on a daily basis.
In 1972 Beuys signed copies in front of the Staatliche Kunstakademie
Düsseldorf, Germany, as a form of political protest. Having been dis-
missed from his post as professor of sculpture, he resumed his classes
in front of the academy and used the boxes to disseminate his plea for
a new role for art outside the institutional context. —*MP*

17

18

MIEKO SHIOMI

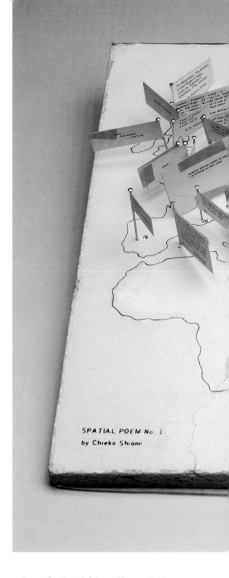

Shiomi (also known as Chieko Shiomi) studied music and musical theory in Japan; in 1960 she cofounded, with Takehisa Kosugi and others, the avant-garde Ongaku (Music) group. Shiomi and her colleagues were familiar with the work of John Cage, La Monte Young, and George Brecht, and she took a particular interest in Brecht's events, adopting his term to describe some of her own projects. George Maciunas invited her to collaborate with Fluxus, and in 1964 she lived in New York and participated in Fluxus events. After returning to Japan in 1965, she remained an international Fluxus member, and working remotely she made use of the post.

Shiomi began *Spatial Poems* in 1965; the nine separately scored events took place over the course of a decade. The work was text-, object-, and action-based. To initiate each project she mailed notes to artists around the world, asking them to participate in an event and send documentation back to her. She pinned the results like flags on a map of the world, marking each event in a geographical context. Shiomi's interest in using the earth as a stage echoes the thinking of Cage and Brecht, both of whom aimed, through their work, to tap into nature, the universe, and life itself. *Spatial Poem No. 1* (1965; pls. 19–20), a "word event," asked participants to write a word on a card and place it anywhere in the world. Collaborators included Nam June Paik, who considered writing "sweet salt" but decided not to, "since there is no such thing." Alison Knowles described dropping a red feather, labeled "feather," from a fire escape. The wind deposited the feather on Broadway and Canal Streets; after landing in a grate it disappeared. Daniel Isaac Spoerri chose the word "merde," which he left in room 13 at the Hotel Carcassonne, 24 rue Mouffetard, Paris. —MP

19 **Score for *Spatial Poem No. 1*** 1965 / Letterpress / 2 x 6 in. / The Gilbert and Lila Silverman Fluxus Collection, Detroit
20 ***Spatial Poem No. 1*** 1965 / Fluxus edition: stenciled map on painted composition board, masking tape, pins, and offset lithography / 11^{15}/$_{16}$ × 18 × ⅞ in. / The Gilbert and Lila Silverman Fluxus Collection, Detroit

```
A SERIES OF SPATIAL POEMS

No. I

Write a word (or words) on the
enclosed card and place it somewhere.

Let me know your word and place
so that I can make a distribution
chart of them on a world map, which
will be sent to every participants.

                    Chieko Shiomi
```

19

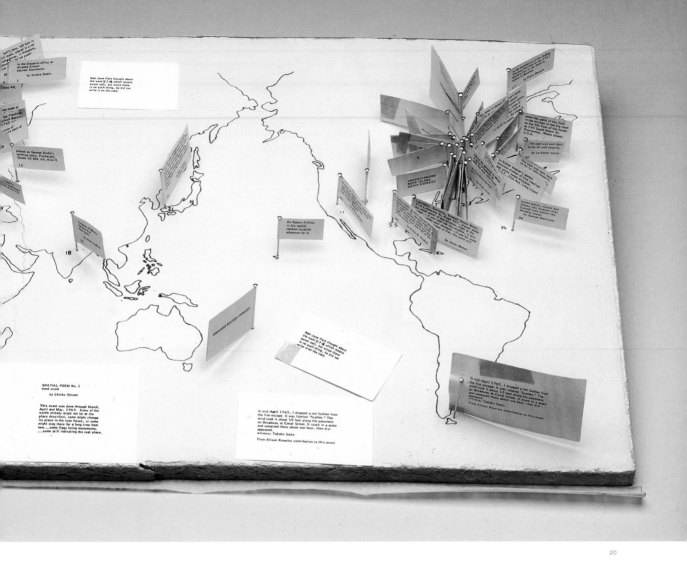

21 **Ray Johnson** *Untitled (Quick Self-Service Post Office)* 1972 / Collage on envelope / 4⅛ × 9⅜ in. / Courtesy the Estate of Ray Johnson at Richard L. Feigen & Co., New York

In the late 1960s Johnson became disenchanted with painting and began to make mail art instead. These collages (torn-up photographs and drawings with handwritten instructions) were mailed to a growing and fluid network of artists and friends. He asked that recipients change and add to his letters before sending them back to him or forwarding them on to others. Over the years thousands of pieces of mail art were sent across the globe. —*MP*

NAM JUNE PAIK

Though marketed to the masses, television, for Paik, did not live up to its full potential for audience participation and two-way communication. The Korean-born artist's interactive intentions radically reconfigured television's sculptural form and reprogrammed its content. Arguably the founding father of video art, Paik began experimenting with the new medium in the 1960s with a series of manipulated televisions designed to be played like instruments. His first solo exhibition, *Exposition of Electronic Music—Electronic Television* (1963) at Galerie Parnass in Wuppertal, Germany, featured two major bodies of work: sound objects and prepared televisions that drew on his musical education and performance activity as a member of Fluxus.

By speaking into the integrated microphone of *Participation TV* (1963; pl. 23), the viewer creates a voice-generated television image—unpredictable explosions of lines—as acoustic signals feed through an amplifier and into the monitor. The artist also experimented with substituting normal broadcast imagery for abstract visual patterns. The electromagnetically distorted images of *Magnet TV* (1965; pl. 22) informed his 1969–70 invention (with Shuya Abe) of the Paik-Abe Video Synthesizer, a tool he used to make endless variations of vibrantly colored forms in his videotapes. With Abe, Paik created the remote-controlled *Robot K-456* (1964; pl. 26), which synthesized his interest in performance and media. Paik's interest in chance imagery and his indeterminist work principle was also evident in his expanded cinema masterpiece *Zen for Film* (1964). A visual nod to John Cage's silent composition *4'33"* (1952; pls. 1–3), the work involved the projection of clear film leader. The blank projection exposed the presence of dust particles in the environment as well as the silhouetted form of any individual positioned between the projector and screen. Cage's musical aesthetic of a democratization of sounds was a significant influence on Paik's investigations of an open form of music through which listeners become actors. For instance, the Wuppertal exhibition included *Random Access* (1963; pls. 24–25), in which the participant could perform an unconventional composition by running the sound head from a tape recorder over multiple strips of prerecorded audiotape. Paik's innovative use of media was thus characterized not only by technological achievement, but also by the guiding principle of user interaction. —*TZ*

22 **Magnet TV** 1965 / Seventeen-inch black-and-white television and magnet / 28⅜ × 19¼ × 24½ in. / Whitney Museum of American Art, New York 23 **Participation TV** 1963/1969 / Installation view at the David Bermant Foundation, Santa Ynez, California, 2007 / Manipulated television, signal amplifiers, and microphone / 30 × 32 × 24 in. / David Bermant Foundation

22

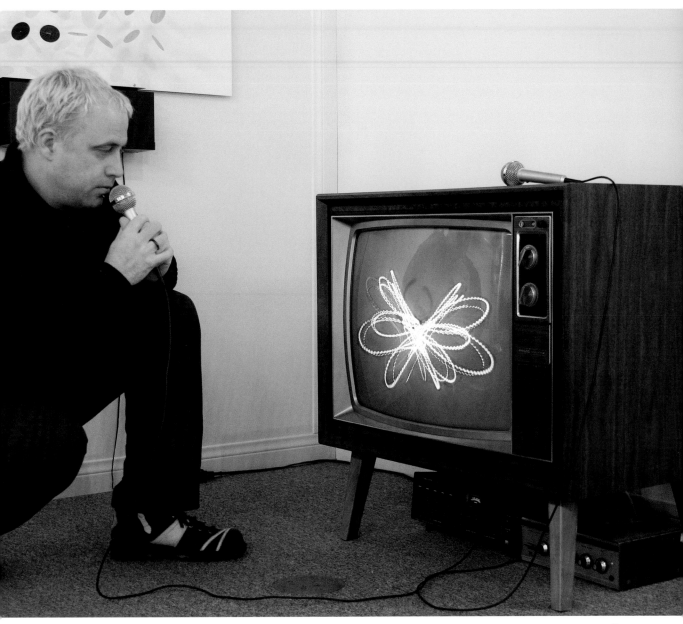

23

24

24 *Random Access Music* 1963/1978 /
Installation view at the Kunsthalle Basel,
Switzerland, 1991 / Score, audiotape,
recording head, and Plexiglas / 18½ × 24⅘ ×
1⅔ in. / Private collection 25 *Random Access*
1963 / Installation view at Galerie Parnass,
Wuppertal, Germany, 1963 / Audiotape,
recording head, and speakers / Courtesy
Estate of Nam June Paik 26 *Robot K-456*
1964 / Performance at Galerie Parnass,
Wuppertal, Germany, 1965 / Courtesy
Estate of Nam June Paik

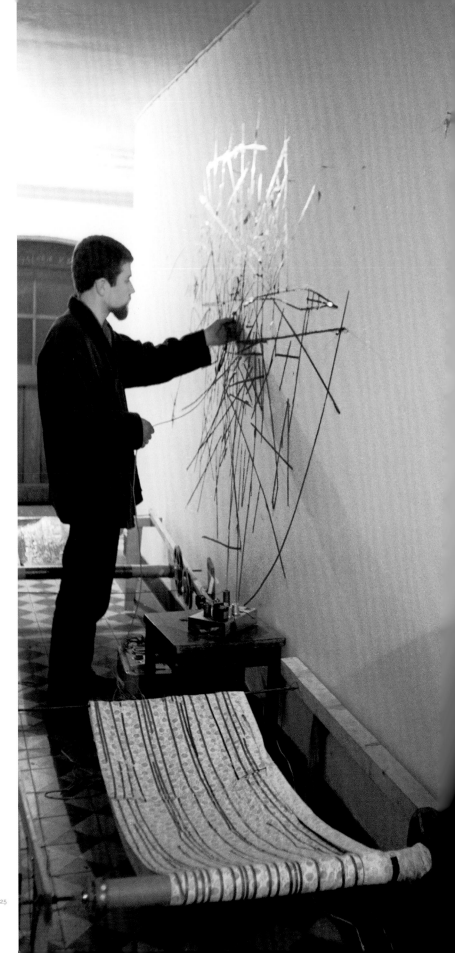

25

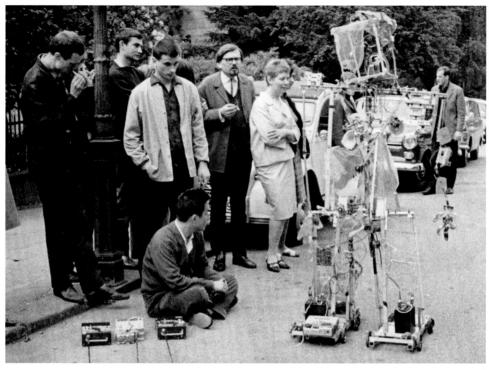

26

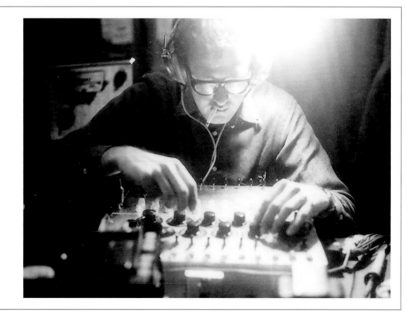

27 **Max Neuhaus** *Public Supply I* 1966 /
Network communication project in New
York, 1966 / Courtesy the artist

Sound art pioneer Neuhaus demonstrated
how the existing networks of telephone
and radio could be used for artistic ends.
His project *Public Supply I* enabled people
calling New York's WBAI radio station to
contribute sounds to an aural network.
Using his own technology, Neuhaus mixed
the incoming calls at the studio, including
feedback produced by listeners turning on
their radios, and broadcast this material
live as a sonic collage. For the artist, the
result was not about "a musical product
to be listened to, but forming a dialogue,
a dialogue without language, a sound
dialogue." —*TZ*

ALLAN KAPROW

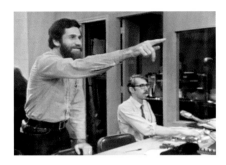

Kaprow not only staged the first happening in 1958, he was also among the first artists to actively involve the audience in his work. A Kaprow project might ask participants to contribute text to the walls of an installation or move furniture around a room (see pls. 9, 28). With *Hello* (pls. 29–34) he brought his event-based strategies to public television in the form of a "telehappening." In 1969 David Atwood and Fred Barzyk, producers at WGBH Boston, invited Kaprow and five other artists—Nam June Paik, Otto Piene, James Seawright, Thomas Tadlock, and Aldo Tambellini—to investigate the new medium of video as part of the program *The Medium Is the Medium.*

Kaprow's segment linked four sites in Boston (the Massachusetts Institute of Technology, a hospital, an educational videotape library, and Boston Airport) via monitors, facilitating communication between the remote locations. A group of people at the studio watched the jumble of monitors, calling out to familiar faces. At the WGBH studio, engineers in the control room were assigned to switch the audio and video signals at random so that the collaborators were only in partial and brief contact with one another. Kaprow recounts:

> Most of the participants were friends or their children at the school. A few didn't know everybody and tried to become acquainted by this curious means. We called out, often in vain, Hello! Hello! Bob! I see you! I hear you but I don't see you now! Bob! Bob? The people gestured wildly as if this would bring their friends to them.... It was all very human and very silly. At the end when the equipment was shut off one by one, a lone participant kept speaking out to no one, finally drifted into monologue and said goodbye to himself.

The artist likened his project to a picture telephone (the phone, unlike video, being a familiar personal and social medium at that time), and it clearly anticipated the video-conferencing technology that is prevalent today. The segment that aired for WGBH was in fact a small model experiment for a larger project that Kaprow acknowledged was unfeasible. This concept included a global network of simultaneously transmitting and receiving TV arcades, each equipped with more than a hundred different monitors and open twenty-four hours a day. —*TZ*

28 ***Push and Pull: A Furniture Comedy for Hans Hofmann*** 1963 / Happening at the Santini Brothers warehouse, New York, 1963 / Allan Kaprow Estate, Hauser & Wirth Zürich London 29-34 ***Hello*** 1969 / Excerpt from *The Medium Is the Medium* / Single-channel black-and-white video with sound, 4:85 min. / Courtesy Electronic Arts Intermix, New York

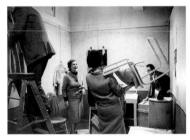

28

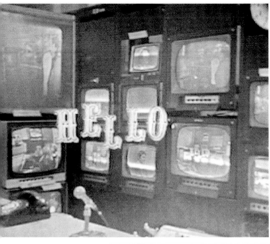

29–34

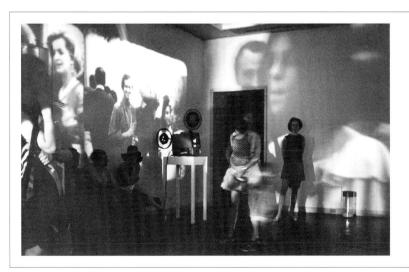

35 **Marta Minujín** *Minucode* 1968 /
Event at the Center for Inter-American
Relations, New York, 1968 / Courtesy the
Museum of Modern Art Archives, New York

Minujín examined group behavior in social
situations through a series of works in the
1960s. Exploiting the conventions of the
cocktail party, the Argentinean artist orga-
nized four successive evening gatherings in
Manhattan, inviting 320 people affiliated by
profession: artists, economists, politicians,
and fashion industry professionals. Eight
representatives of each group were moved
to an adjoining room, a sensorial environ-
ment influenced by the light shows of the
era. Recorded footage of the parties and
light shows were later projected in a gallery
and experienced by the same guests. —TZ

LYGIA CLARK

I began with geometry but I was looking for an organic space where one could enter the painting. —Lygia Clark

Even in her early career, in her paintings of the late 1950s, Clark strived to convey a sense of space and movement, evoking a dialectical relationship between viewer and picture. Her sculptural series of the 1960s, *Bichos* (Animals), required still more from the spectator. They were composed of hinged movable plates, rectangular or circular in shape or a combination of both. Clark likened the hinges to spines, and she thought of the sculptures as organic entities. The structure of the plates and spine determine the possible positions of a *Bicho,* but its ultimate form depends upon its manipulation by the spectator. The artist called this interaction "a type of body-to-body relationship between two living organisms."

Clark's later work progressed to a form of body art. After a wrist injury, she removed the plastic bag that protected her cast from humidity, filled it with air, used an elastic band to close it off, and pressed a stone against it to experience the play of pressure. Clark called this her "first experiment" and the ensuing artworks "propositions" in order to counter the notion of a passive art object. She wanted to create material with which to experience the body, to force the spectator "to rediscover the meaning of our routine gestures." Designed to be explored by two people together, Clark's *Dialogues* involve objects and materials that she modified to create fractured perceptions. *Diálogo: Óculos* (Dialogue: Goggles, 1968; pl. 41), for example, is a set of two attached goggles that uses mirrors to fragment the wearers' vision. *Diálogo de mãos* (Hand Dialogue, 1966; pl. 42) is an elastic Möbius strip that is worn on the hands of two participants. The dialogue is not between viewer and work, but rather between the participants as they bind their hands together with the strip. The same concept is explored at larger scale in *Rede de elástico* (Elastic Net, 1973; pls. 36–39), which transforms the familiar form of a net into an open structure and an undefined situation: how the elastic is used depends entirely on the dynamics of the participants. Other propositions include elements that are more obviously therapeutic. Clark's relational objects of the 1970s, for instance, created relaxing situations for the participants or "subjects" using items such as pillows, mattresses, blankets, and small stones. —*MP*

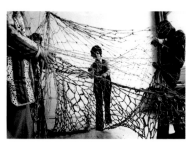

36

37

38

36–39 *Rede de elástico* (Elastic Net) 1973 / Installation views at the artist's studio, Paris, ca. 1975 (pls. 36, 39), and in Rio de Janeiro, 1973 (pls. 37, 38) / Rubber / Clark Family Collection, Rio de Janeiro

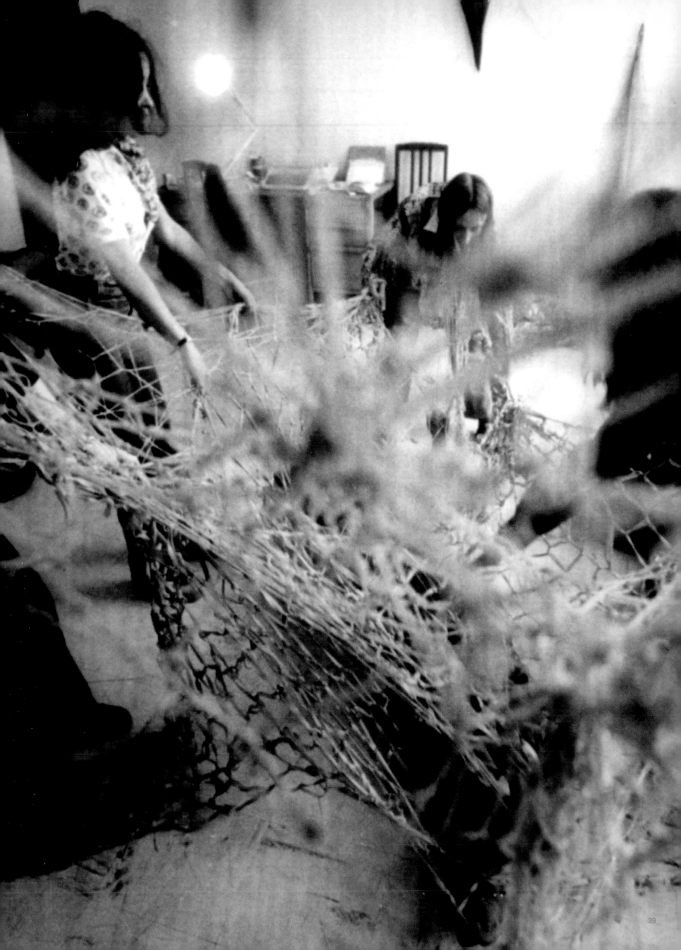

40

41

40 ***Máscaras sensoriais*** (Sensorial Masks)
1967 / Installation view at Paço Imperial,
Rio de Janeiro, 1986 / Cloth masks with
ear devices and goggles, fabric, metal, seeds,
plastic, polyethylene, mirrors, glass, shells,
steel wool, sponge, and tissue / Each: approx.
25⅝ × 19¾ × ⅛ in. / Clark Family Collection,
Rio de Janeiro 41 ***Diálogo: Óculos*** (Dialogue:
Goggles) 1968 / Modified diving goggles,
metal, and mirror / 3 × 7 × 11½ in. / Clark
Family Collection, Rio de Janeiro 42 ***Diálogo
de mãos*** (Hand Dialogue) 1966 / Installation
view in Rio de Janeiro, 1973 / Elastic / 6⅝ ×
¾ in. / Clark Family Collection, Rio de Janeiro

42

43

43 **Hélio Oiticica** *Eden* 1969 / Installation view at the Whitechapel
Art Gallery, London, 1969 / Mixed media / Courtesy Projeto Hélio
Oiticica 44 **Hélio Oiticica** *Nests* 1970 / Installation view at the
Museum of Modern Art, New York, 1970 / Mixed media / Courtesy
Projeto Hélio Oiticica

Like his fellow Brazilian Lygia Clark, Oiticica dismissed art objects
in favor of art experiences. For his 1969 *Whitechapel Experiment* he
created a campus, or floor plan, of multisensorial encounters that he
called *Eden*. The installation invited visitors to experience his idea of
"creleisure": a neologism combining *creation* and *leisure*. People were
asked to take off their shoes before entering large boxes filled with
sand and straw or cabinlike structures with mattresses and blankets.
Multilevel like bunkbeds, *Nests* was a cluster of cells divided by filmy
curtains, to be climbed into and inhabited by visitors. —*MP*

44

YOKO ONO

45 *Cut Piece* 1965 / Performance at Carnegie Hall, New York, 1965 / Courtesy the artist
46 *Cut Piece* 2003 / Performance at Théâtre le Ranelagh, Paris, 2003 / Courtesy the artist
47 *Cut Piece* 1964 / Performance at Yamaichi Concert Hall, Kyoto, 1964 / Courtesy the artist

Performer sits on stage with pair of scissors placed in front of him. It is announced that members of the audience may come on stage—one at a time—to cut a small piece of the performer's clothing to take with them. Performer remains motionless throughout the piece. Piece ends at the performer's option. —Yoko Ono, instructions for *Cut Piece* (1964)

The aesthetic of Fluxus, particularly the incorporation of everyday activity and audience input to determine artistic content, was crucial to Ono's performances, events, and other projects. She was an early and active member of Fluxus in New York, hosting a concert series from December 1960 to June 1961 at her Chambers Street loft that helped launch the movement. Her solo work included concerts involving the performance of commonplace activities, rhythmic background sounds, and atonal wailing, all intended to facilitate an understanding of perception and encourage "introspective meditation."

Ono premiered *Cut Piece* in 1964 at Yamaichi Concert Hall in Kyoto (pl. 47) and performed it again in 1965 at Carnegie Hall in New York (pl. 45). In both versions Ono sat onstage wearing an expensive suit. Audience members cut off pieces of her clothes and undergarments until she was left nearly nude. The event was inspired by a Buddhist allegory in which Buddha sacrifices himself and enters a state of supreme awareness. Ono considered allowing the audience to cut off her clothes to be a Buddha-like gift. In the act of cutting, volunteers entered an exchange with the artist as the vulnerable "object." Other members of the audience participated in this exchange as voyeurs, witnessing the atmosphere of discomfort. Tensions arose during the performances, and there were moments of potential aggression, but Ono also recalls that "there were quiet and beautiful silences—quiet and beautiful movements."

In 2003 Ono reprised the piece at Théâtre le Ranelagh in Paris (pl. 46). This time, however, her printed statement asked the audience to "Come and cut a piece of my clothing wherever you like, the size of less than a postcard, and send it to the one you love." In the decades since its inception, the work had evolved from an exploration of violence to an expression of kindness and peace. —*MP*

45

46

Back to You
112 Greene St., New York: January 16, 1974

Dressed only in pants, I was lying on a table inside a freight
elevator with the door closed. Next to me on the table was a
small dish of 5/8" steel push pins. Liza Bear requested a
volunteer from the audience, and he was escorted to the elevator.
As the door opened, a camera framing me from the waist up was
turned on, and the audience viewed this scene on several
monitors placed near the elevator. As the elevator went to the
basement and returned, Liza told the audience that a sign in the
elevator instructed the volunteer to "Please push pins into my
body." The volunteer stuck 4 pins into my stomach and 1 pin
into my foot during the elevator trip. When the elevator
returned to the floor, the door opened, the volunteer stepped
out, and the camera was turned off. The elevator returned to
the basement.

48 **Chris Burden** *Back to You* 1974 / Performance at 112 Greene
Street, New York, 1974 / Collection of the artist

VALIE EXPORT

The screening takes place in the dark as usual: except that the movie room has shrunk a little. It only has room for two hands. In order to see the film, which in this case means to sense and feel it, the "spectator" (consumer) has to put both hands through the entrance to the movie house. —VALIE EXPORT

Strapped to the artist's bare torso, a curtained box—a miniature movie theater—becomes the site for direct contact between performer and audience. In 1968, offering her breasts as the screen, EXPORT created *TAPP- und TASTKINO* (TAP and TOUCH CINEMA, pls. 49–50), which she referred to as the first genuine women's film. Demonstrating the agency of a woman to control the viewing context and display of the female body, this example of her work in expanded cinema counters the objectification of women in film. As a feminist action, it also confronted taboos related to codes of sexuality, attempting to liberate and socialize the physical experience of the body. The private act of engaging in voyeuristic fantasy at the cinema became public when enacted before a crowd. Participants faced the awkward experience of touching a stranger's body while simultaneously looking directly at her indifferent face.

EXPORT premiered the piece with an introductory statement on November 11, 1968, at the Maraisiade "Junger Film 68" festival in Vienna. A legendary second performance (pictured here) was held on November 14 on the Stachus square in Munich. There, acting as sideshow barker, collaborator Peter Weibel solicited both men and women to "visit" the cinema for up to twelve seconds. The artist's cloth-curtained Styrofoam box was too fragile to use after the first three performances; she wore a longer, more protruding aluminum version (designed by Wolfgang Ernst for the Underground Explosion festival) for the remaining performances, including a September 12, 1969, action performed (again with Weibel) in Munich's Stachus for broadcast by the Austrian public television station ORF.

From 1969 through 1971 EXPORT toured her mobile cinema throughout Europe. Several of the performances provoked hostile reactions. Police banned a performance scheduled for Stuttgart because of a riot that broke out in Essen, during which EXPORT sustained a head injury. A 1971 Cologne performance by Erika Mies (with EXPORT on megaphone) particularly angered the audience, which took the artists for prostitutes. —TZ

49

49–50 *TAPP- und TASTKINO* (TAP and TOUCH CINEMA) 1968 / Performance at the Stachus, Munich, 1968 / Generali Foundation, Vienna

51 **Niki de Saint-Phalle, Jean Tinguely, and Per Olof Ultvedt**
Hon: en Kathedral 1966 / Installation view at the Moderna Museet,
Stockholm, 1966 / Metal, wire, fabric, and paint / 240 × 1,131 ×
360 in. / Courtesy the Niki Charitable Art Foundation

Saint-Phalle collaborated with Tinguely and Ultvedt on the enormous
sculptural installation *Hon: en Kathedral*. Returning to the proverbial
place of origin, spectators passed between the legs and into the womb
of a brightly colored reclining woman. One of a series of female figures
Saint-Phalle called *Nanas,* the ninety-foot-long sculpture housed a
variety of social spaces: a milk bar, a planetarium, an aquarium, a
movie theater, and an art gallery of forged modern masterpieces. —*TZ*

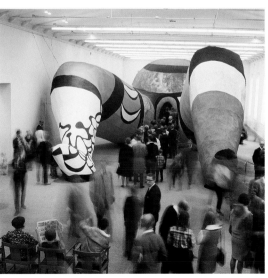

ABRAMOVIĆ / ULAY

We are standing naked in the main entrance of the museum, facing each other. The public entering the museum has to pass sideways through the small space between us. Each person passing has to choose which one of us to face. —Abramović/Ulay

52–55 *Imponderabilia* 1977 / Performance at the Galleria Communale d'Arte Moderna, Bologna, Italy, 1977 / Courtesy the artist and Sean Kelly Gallery, New York

From 1976 to 1988 the Netherlands-based Marina Abramović and Ulay collaborated on numerous performances. In one of them, recorded on video in 1977 at the Galleria Communale d'Arte Moderna in Bologna, Italy, the naked duo flanked the entrance, an unavoidable obstacle for visitors to negotiate if they wanted to access the museum. Although the public could not avoid physical contact, they clearly tried to maintain some distance by not making eye contact (see pls. 52–55). Once inside, visitors discovered they had been filmed by a hidden camera and were confronted by the following wall text: "Imponderable. Such imponderable human factors as one's aesthetic sensitivity / the overriding importance of imponderables in determining human contact." Though the artists intended the performance to last for three hours, the police ended the controversial event after ninety minutes. The resulting video, titled *Imponderabilia,* centers on the visitors' reactions and reflects the artists' longstanding interest in the body, gender, and interpersonal relationships.

Abramović's solo performances pushed the boundaries of performer-audience interaction and physical vulnerability. In the infamous endurance work *Rhythm 0* (1974; pl. 56), a sign on the wall invited the audience to do whatever they wanted to the artist's body using any of the seventy-two items (a fountain pen, a rose, a knife, scissors) she had provided on a table. The performance offered a fascinating study of social behavior; the audience's aggressive actions escalated over the course of six hours, during which Abramović's clothes were cut off, her body sliced with razors, and a loaded gun held to her head until another audience member wrested it away. —*TZ*

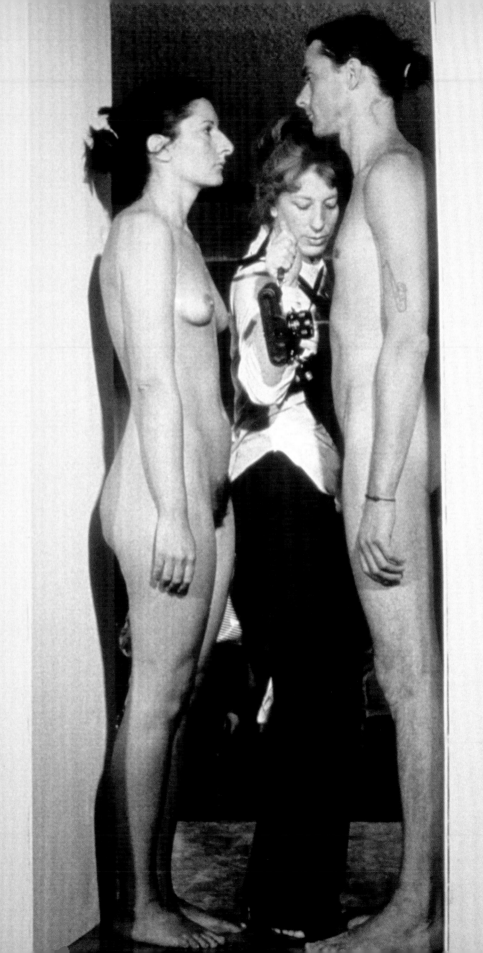

53

54

55

56 *Rhythm 0* 1974 / Performance at Studio
Morra, Naples, Italy, 1974 / Courtesy the
artist and Sean Kelly Gallery, New York

57 **Barbara T. Smith** *Feed Me* 1973 / Performance at the Museum
of Conceptual Art, San Francisco, 1973 / Courtesy the artist

In contrast to the violence of Marina Abramović's *Rhythm 0* and
other endurance performances of the 1970s, Smith's *Feed Me* proposed
pleasure and required that the audience negotiate with the artist as
to the nature of their private interaction. Over the course of one night
(April 20, 1973), as part of the San Francisco Museum of Conceptual
Art's *All Night Sculptures* series, the predominantly male visitors
entered a room one at a time, encountering the naked artist and a
looped recording that insisted that they feed her. Smith, seated on a
divan, surrounded herself with food, beverages, body oils, and per-
fumes, allowing conversation and affection as nourishment. —*TZ*

VITO ACCONCI

The performance *Proximity Piece* (pls. 58–59) unfolded over fifty-two days during the 1970 exhibition *Software* at the Jewish Museum, New York. Acconci chose random museum visitors to follow through the exhibition galleries, sneaking up on them and invading their personal space. He indirectly affected their movements, as many turned away from the man standing too close. Given the subtlety of the intervention, the viewing public was often unaware that an artwork was taking place and they were part of it. In Acconci's photographic documentation, individuals are framed with the artist as both appear to look at art objects. *Proximity Piece* effectively merges the real space of the museum (the viewing context) with the production of the artwork.

Acconci had previously used the strategy of randomly tracking strangers in *Following Piece* (1969; pl. 60), in which he trailed passersby on the streets until they entered private places. The act of following could last minutes or hours and, like *Proximity Piece,* relied on the anonymity of the artist in relation to the public. Acconci carried out the performance every day for a month, sending a description of each pursuit to a different member of the art community. His type-written accounts and photographs constituted an essential part of the artwork: the activities of outsiders as reported back to insiders. Both works relied on the participation of people who had not agreed to take part and did not even know they were involved.

Though Acconci remained silent during these performances, language is central to the work as disseminated and displayed. He frequently probes the dynamic with his audiences by foregrounding spoken language, specifically fantasy. In the best-known example, *Seedbed* (1972), visitors overheard the artist as he masturbated in a concealed space below the floorboards. In *35 Approaches* (1970) the artist mailed daily letters addressing a specific imagined recipient: "You in the blue dress: (or, You in the orange pants:) / I want you. / I am enclosing a gift, a sample from my body, as an introduction and a token of my availability." Acconci has continually blurred the boundary between his private sphere and the public domain of the art venue, as when he delivered the contents of his apartment to a gallery or rerouted his mail to be delivered to a museum and guarded as art objects. —*TZ*

58 ***Proximity Piece*** 1970 / Performance at the Jewish Museum, New York, 1970 / Courtesy Acconci Studio

PROXIMITY PIECE:
Notes 1970

Performance as operational mode: preference pattern of the opponent (utility function).

•

Performer as regulator/performer as conformer

•

Performance as double assessment: A's assessment of the situation when B tries to penetrate that assessment (A knowing, all the while, that it has as one of its features the fact that B will try to penetrate it). (A performance can consist of a series of conditional avowals, where one performer will pursue a given course of action if the other party engages, or does not engage, in another course of action.)

•

Moving. (Intransitive: clear space.)
Moving into something - which becomes, inevitably, 'moving something.' (Transitive: cluttered space.)
Performance as loss of focus (we're too close to each other to focus on each other): Performance as blur ('Get your face out of my face' - ' He shook his fist in my face' - he can't face me, he can only feel me as the space he's been forced into).

•

Flexibility/Rigidity.
Availability/Virtual Indifference.
Saturation/Insufficiency.

•

Tenacious performance (I'm clinging to the viewer, I won't lose the viewer, the viewer can't move away.)
Elastic performance (I'm moving with the viewer as the viewer shifts around, I'm bending with the viewer in order to keep at the viewer).
Self-determinative performance (My decision is to make my place: the viewer is incidental, the viewer happens to be in the way).
(Or vice-versa: 'The viewer clings to me, the viewer won't lose me…')

•

Agglutinative performance. Participative performance. Adjunctive performance. Complemental performance.

•

'Performing a person' by bringing that person to a finished state (closing the person in, forcing the person to stay where he/she is, as he/she is).
'Performing a person' by accomplishing that person (becoming that person, playing that person's role as he/she moves out of his/her role and I stay in).

PROXIMITY PIECE:
Additional Notes 1972

Reasons to move: move to a point, move in order to make a still point (if someone is there, I have to keep that person from getting away from the point, missing the point.)

59 *Proximity Piece* 1970, printed 2008 /
Digital pigment prints mounted on board /
68 × 22 in. / Courtesy Acconci Studio
60 *Following Piece* 1969 / Performance in
New York, 1969 / Courtesy Acconci Studio

60

61 **Adrian Piper** *Catalysis IV* 1970–71 / Performance in New York,
1972 / Generali Foundation, Vienna

Piper's *Catalysis* was a series of conceptual performances in Manhattan
that violated social norms of public behavior. The resulting photo-
graphs document the artist bearing a *WET PAINT* sign in a crowded
street, stuffing her mouth with a towel on public transportation, wear-
ing smelly clothes inside a store, and playing a recording of belching
sounds inside a library. Piper never announced that she was perform-
ing; unlike televised pranks, the interventions offered no moment of
revelation for the strangers who witnessed her behavior. By escaping
the confines of the art context, Piper risked appearing repellent, if not
crazy. Acting as a catalytic agent for chance reactions, she dissolved
the boundary between art and life. —*TZ*

JOHN BALDESSARI

In 1970 Baldessari decided to come to terms with his artistic past and make a fresh start by burning most of his unsold paintings created prior to 1966. Called *Cremation Project,* the ritual act took place in a crematorium. Baldessari documented the destruction photographically, complementing the pictures with a bronze plaque bearing his name and the dates May 1953 and March 1966, along with an ash-filled urn. The year 1966 marked the moment at which, seeking a new form for his work, he had started to paint "nothing." Instead of approaching subjects pictorially, he began painting text: simple black words on standard white or gray canvas. Drawing on his pedagogical background and sense of humor, he frequently depicted clichés on how to make art and achieve success. In an interview Baldessari stated, "I was weary of doing relational painting and began wondering if straight information would serve. I sought to use language not as a visual element but as something to read. That is, a notebook entry about painting could replace the painting."

Baldessari's text paintings are semiotic investigations, games in which the words themselves are not important. They are tautological: the words bring to mind images and the images lead back to words, information, or thought. In making them, Baldessari acted as a strategist or, in his own words, as a producer: he purchased the canvases already prepared, devised the text or appropriated excerpts from previously published books, and hired professional sign painters to produce the finished works. One example, *A Painting That Is Its Own Documentation* (1968) begins: "JUNE 19, 1968 IDEA CONCEIVED AT 10:25 A.M. NATIONAL CITY, CALIF. BY JOHN BALDESSARI." The text continues with details of the painting's making and provenance (the list of exhibitions and dates includes a presentation at the San Francisco Museum of Modern Art in 1990) and expands to fill additional canvases as the documentation grows. In *Terms Most Useful in Describing Creative Works of Art* (1966–68; pl. 62), Baldessari offers fifty-odd words for the reader to consider, from "GIVE VISION" to "AROUSE," "CRITICIZE," and "IMPART." —MP

62 **Terms Most Useful in Describing Creative Works of Art** 1966–68 / Acrylic on canvas / 113¾ × 96 in. / Museum of Contemporary Art, San Diego, gift of John Oldenkamp

TERMS MOST USEFUL IN DESCRIBING CREATIVE WORKS OF ART:

GIVE VISION	ENJOY	DISCIPLINE
DIRECTION	CHARM	DELICATE
FLAVOR	INFLUENCE	COMMAND ATTENTION
A NEW SLANT	INTEREST	EXALT
FORCE	DELIGHT	DEVELOP
UNIQUENESS	AROUSE	SATISFY
PERMANENCE	COMMUNICATE	BEAUTIFY
INSPIRATION	CULTIVATE	IDENTIFY
A GLOW	NURTURE	INSPIRE
MOTIVATION	PLAN INTELLIGENTLY	ORIGINATE
ENCHANTMENT	DETACH	CREATE
BLEND	TRANSFER	ASSOCIATE
ENLIGHTEN	CHALLENGE	CHERISH
INVIGORATE	ELEVATE	ALTER
ENTHRALL	SATIATE	REVISE
TAKE SERIOUSLY	IMPROVE	CRITICIZE
PRECISE CARE	VALUE	IMPRESS
OUT OF THE ORDINARY	FLAGRANCE	IMPART

62

63 **Douglas Huebler** *Variable Piece No. 44* 1971 / Photographs and printed text mounted on board / 18 × 24⅛ in. / Tate, London, purchased 1974

Huebler's *Variable Piece No. 44* began in 1971 as an edition of 100, a work "in process" to last ten years. Huebler asked the owner of each edition to have a photograph taken of his face and sent to the owners of the previous and subsequent edition numbers. Over time the chain broke down and commitments went unfulfilled. In 1981, in order to finalize the work, Huebler contacted the owners again, asking them to send recent and old photos of themselves. Having received responses from about a third of the owners, he declared the project completed to his satisfaction, as it turned out to be an accurate reflection of the process. —*MP*

DAN GRAHAM

Since the mid-1960s Graham has produced a body of work that functions as a sustained phenomenological inquiry into architectural space and time. *Performer/ Audience/Mirror* (1977; pl. 64) investigates the nature of perception and participation. In the video documentation of his performance at Video Free America in San Francisco, we see the artist standing in front of a silent, seated audience with a mirrored wall behind him. His improvised, continuous observations and interpretations of his and the crowd's physical movements articulate the cycles of awareness occurring within his own consciousness and between himself and his viewers. The piece proceeds through four basic stages: Graham faces the audience and describes his external features and behavior; he describes the audience's external appearance and behavior; he turns to face the mirror, moving about as he describes himself again; and then he describes the audience as he sees it reversed in the mirror. The mirror serves to diminish the boundary between performer and audience as the group collectively becomes conscious of their own bodies and of the performance context. The piece emphasizes the shared present moment, with a constant play between delayed observations and instantaneous visual perception.

At the same time that he was videotaping his performances, Graham was also producing installations using mirrors and live recording situations to probe real versus delayed time. In *Opposing Mirrors and Video Monitors on Time Delay* (1974; pl. 66), the viewer sees him- or herself in a seemingly infinite space created by surveillance cameras, monitors, and mirrors reflecting the opposite side of the room. The images recorded by the cameras are played back on the monitors with a five-second delay. Graham has used the device of time delay repeatedly in his installations; he considers the effect to be present even in works without cameras, such as his pavilions. One such structure, *Double Cylinder (The Kiss)* (pl. 65), commissioned in 1994 by the San Francisco Museum of Modern Art, is constructed of two-way mirror, transparent glass, and steel. The mirror (a central motif for Graham and for a number of his contemporaries) both extends and disrupts the space, which is ultimately activated only by the presence of the viewer who moves in and out of it. It also lends a history of cultural associations as a tool of self-identification and social manipulation. —TZ

64 *Performer/Audience/Mirror* 1977 / Performance at Video Free America, San Francisco, 1978 / Courtesy Marian Goodman Gallery, New York

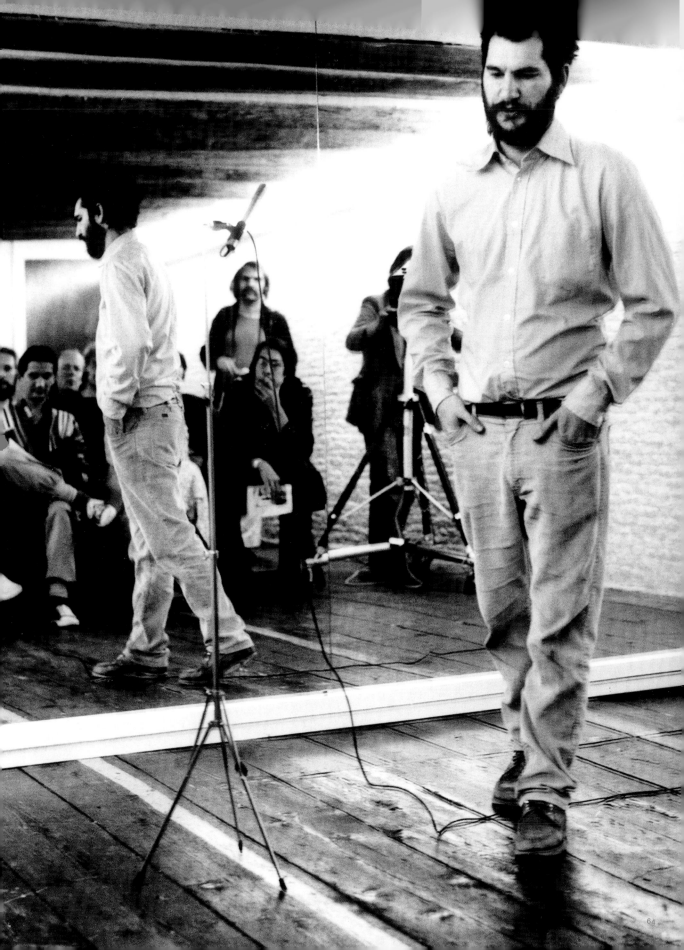

65

65 *Double Cylinder (The Kiss)* 1994 /
Installation view at the San Francisco Museum
of Modern Art, 1996 / Two-way mirror, glass,
and steel / Each cylinder: 96 × 96 × 96 in. /
San Francisco Museum of Modern Art,
Accessions Committee Fund 66 *Opposing
Mirrors and Video Monitors on Time Delay*
1974/1993 / Installation view at the San
Francisco Museum of Modern Art, 2004 /
Mirrors, cameras, monitors, and time delay /
San Francisco Museum of Modern Art, gift of
Dare and Themis Michos and Accessions
Committee Fund

66

67 **Joan Jonas** *Mirror Piece II* 1970 /
Performance at Emanu-El Midtown
YM-YWHA, New York, 1970 / Photo:
Peter Moore

Fragmented reflections of bodies and space
in continual flux unite Jonas's early perfor-
mances with mirrors. *Mirror Piece I* (1969)
and *Mirror Piece II* created the illusion of
dislocated space as participants carried
wall mirrors in formal patterns. Jonas's
performance choreography was informed
in part by postmodern dance of the 1960s,
which emphasized natural and pedestrian
movement. Repositioning the mirrors
established a tension between the precision
of the image (a fragment of the surround-
ings or audience) and its loss through con-
stant transition—a participatory game that
relied on the presence of people constantly
looking at their reflections. The mirror has
remained a frequent prop and metaphor in
Jonas's work to this day. —*TZ*

68 **Peter Campus** *dor* 1975 / Installation view at the San
Francisco Museum of Modern Art, 2008 / Closed-circuit color video
installation / San Francisco Museum of Modern Art, Accessions
Committee Fund

In the 1970s Campus developed a series of closed-circuit video
installations that examine the viewer's confrontation with his or her
own image. The work *dor,* for example, probes the nature of vision
and the relationship between absence and presence. Moving toward
the entrance of a dark, empty room, the viewer steps into an area
surveyed by a video camera, becoming part of a live recording that
is projected onto a wall inside. Entering the installation, one crosses
paths with one's own electronically generated image, an illusion that
disappears once the viewer is inside. Campus makes us aware that we
can never perceive ourselves as others do. —*TZ*

HANS HAACKE

Originally presented as part of *Prospect 69* at the Städtische Kunsthalle Düsseldorf, Germany, Haacke's *News* (1969; pl. 70) featured a telex machine that printed a news stream from the German press agency DPA. Large paper piles spilled onto the floor, and visitors were welcome to pick up portions to read. Questioning public access to information and raising awareness of the omnipresent media machine, Haacke brought the news—and by extension the larger world—into the gallery, a space normally reserved for the reading of art. An assertion of the importance of facing political realities, Haacke's gesture is an apt reflection of the times, as a number of artists were then challenging the supposed autonomy of the artwork and neutrality of the museum. In 1969 he joined the Art Workers' Coalition, a New York group that fought for various museum policy reforms and also pressured cultural institutions to show solidarity with the international anti–Vietnam War movement.

The following year Haacke addressed the news once more in a direct critique of the economic and political ties of museums. His famous *MOMA-Poll* (pl. 69) at the Museum of Modern Art, New York, asked visitors whether New York governor (and MoMA board member) Nelson Rockefeller's refusal to denounce President Richard Nixon's Indochina policy would be reason not to vote for Rockefeller in the coming November election. The response to this query was plainly visible: the acrylic ballot boxes revealed that there were twice as many yes votes.

News does not analyze news content but simply delivers it, spewing out stories upon stories. The sheer volume of paper, growing as a sculpture over time, gives form to the constant cycle of processing and discarding information. The teletype machine and news source are updated each time the piece is installed; the 2008 version, for example, uses a dot-matrix printer and a subscription to an RSS newsfeed. —*TZ*

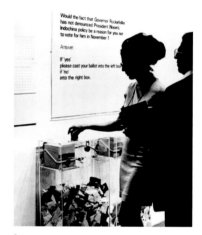

69

69 *MOMA-Poll* 1970 / Installation view at the Museum of Modern Art, New York, 1970 / Acrylic ballot boxes, paper ballots, and photoelectrically triggered counters / Two boxes, each: 40 × 20 × 10 in. / Collection of the artist 70 *News* 1969 / Installation view at the Jewish Museum, New York, 1970 / Teletype machine and wire service / Collection of the artist

70

71 **Group Frontera** *Itinerary of Experience* 1970 / Installation view at the Museum of Modern Art, New York, 1970 / Mixed media / Courtesy the artists

The Argentinean collective Group Frontera (Adolfo Bronowski, Carlos Espartaco, Mercedes Esteves, and Ines Gross) participated in *Information,* MoMA's watershed 1970 exhibition of conceptual art. Their contribution involved a recording booth in which visitors responded to a questionnaire on personal politics that probed attitudes toward a range of topics, including sex, art, and government. Upon leaving the booth, participants could watch the playback of taped interview sessions on a grid of wall-mounted monitors. —*TZ*

STEPHEN WILLATS

Influenced by cybernetics, semiotics, and information theory, Willats is one of the key figures of British conceptual art. Keenly interested in networking tools, technologies of interaction, scientific methods, and social patterns, he emerged in the 1960s as one of the pioneers of a practice that moved outside the artistic arena of the museum and gallery to address cultural and sociopolitical concerns more directly. Pieces such as *Social Resource Project for Tennis Clubs* (1972) explored specific nonart environments and their relation to their inhabitants. With a focus on what the artist calls the "environmental fact," Willats's investigations took the form of what today might be termed community projects. *Variable Sheets* (1965; reformulated in 1991 as *New Directions,* part of the *Multiple Clothing* series) examines the ways in which clothes express social relationships. The work also offers an indication of Willats's interest in a linguistic definition of reality: participants don recombinable garments equipped with clear plastic pockets, which they can fill with words of their choosing. This direction was further developed in *Meta Filter* (1973–74), an early computer-based artwork in which two participants discuss a set of images about people's everyday lives. *A Moment of Action* (1974; pls. 72–74) also explores the link between images and words: six wall-mounted panels present a series of photographs of the same woman annotated with six different "tags" (Context, Identity, Intention, Action, Effect, and Reflection) and corresponding analytical data. The gallery visitor is asked to fill out a questionnaire judging the appropriateness of the variables. The artwork thus becomes an agent for addressing and reflecting upon the production of value and meaning. In Willats's words, "In the concept of counter consciousness the object's status as an icon is replaced with the perception of the object functioning as an agent or tool, that is integral to our relationships, to the making of society." In 1972 the artist founded a Centre for Behavioural Art dedicated to fieldwork in a variety of contexts, from housing projects to underground clubs and, in this case, art spaces. —*RF*

72–74 **A Moment of Action** 1974 / Gelatin silver prints, gouache, ink, and Letraset mounted on card stock with questionnaire and clipboard / Six panels, each: 25 × 16 in. / Courtesy Victoria Miro Gallery

Select from the list of variables below, one that you consider best describes the effect of the person depicted above's actions.

1)Mutuality.
2)Compliance.
3)Conflict.
4)Uncertainty.
5)Dependence.
6)Detachment.
7)Competition.
8)Command.
9)Segregation.
10)Association.

72

Identity.

Effect.

73

74

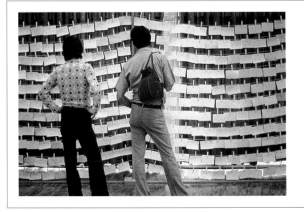

75 **Mónica Mayer** *El tendedero* (The Clothesline) 1978 / Installation view at the Museo de Arte Moderno, Mexico City, 1978 / Clothesline, clothespins, wood, and paper / 78¾ × 137⅞ in. / Courtesy the artist

Mayer became involved in the Movimiento Feminista Mexicano in the mid-1970s, confronting issues of sexism and social injustice. In 1978 she installed *El tendedero* (The Clothesline) at the Museo de Arte Moderno in Mexico City. In preparation she asked some eight hundred women to fill in the blank in the following statement, writing their answers on pink slips of paper: "As a woman, what I detest most about Mexico City is ___." Their responses, which mostly referred to sexual aggression and harassment, were clipped to clotheslines in the gallery, forming a "wall" more than eleven feet wide and six feet tall. The installation kept evolving as female visitors added their own comments. —*MP*

JOSEPH BEUYS

In his signature felt hat, fisherman's vest, and jeans, Beuys strides vigorously toward the camera in the print multiple *La rivoluzione siamo noi* (We Are the Revolution, 1972; pl. 77). Here, as in many of his post-Fluxus actions, the artist combined his own iconic persona with a compelling slogan, inviting us to join him in his revolutionary stance toward art and societal change. The same call to action was communicated by the sculptural objects that stemmed from his performances, including diagrammatic blackboard drawings such as *Rose for Direct Democracy* (1973) and *Board II (Everyone Is an Artist)* (1978).

Together with video art pioneers Nam June Paik and Douglas Davis, Beuys participated in the first live international satellite telecast on June 27, 1977, when *Documenta 6* transmitted their performances to more than twenty-five countries. Beuys's contribution was a compelling nine-minute speech that he delivered without notes directly to the television camera (see pl. 76). The lecture expounded his theory of art as social sculpture: "art that no longer refers solely to the modern art world, to the artist, but comprehends a notion of art relating to everyone and to [the] very question and problem of the social organism in which people live. Without doubt, such a notion of art would no longer refer exclusively to the specialists within the modern art world but extend to the whole work of humanity."

Beuys's utopian writings and lectures continue to have a major impact on critical thinking about the role of the artist and the social implications of art. In 1974 Beuys, who was regarded as an influential and performative teacher, founded the Free International University for Creativity and Interdisciplinary Research (FIU), a school outside the academic system that admitted all students (see pl. 79). A project under the auspices of FIU, *7000 Eichen* (7000 Oaks; pl. 78) embodied Beuys's political and ecological activism and mirrored his involvement in the founding of the Green Party in Germany. Beuys began this expansive living monument in 1982 for *Documenta 7* in Kassel, Germany; it was completed by his son, Wenzel Beuys, in 1987, a year after the artist's death. It was a symbolic beginning for an artwork that was intended to be ongoing: a group effort of individuals and institutions planting thousands of trees and basalt markers in public spaces worldwide. —*TZ*

76 ***Documenta 6 Satellite Telecast***
1977 / Single-channel color video with sound / Courtesy Electronic Arts Intermix, New York 77 ***La rivoluzione siamo noi***
(We Are the Revolution) 1972 / Screen print on polyester with handwritten text / 75³⁄₁₆ × 40⅛ in. / Collection of Pamela and Richard Kramlich, San Francisco

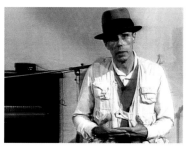

76

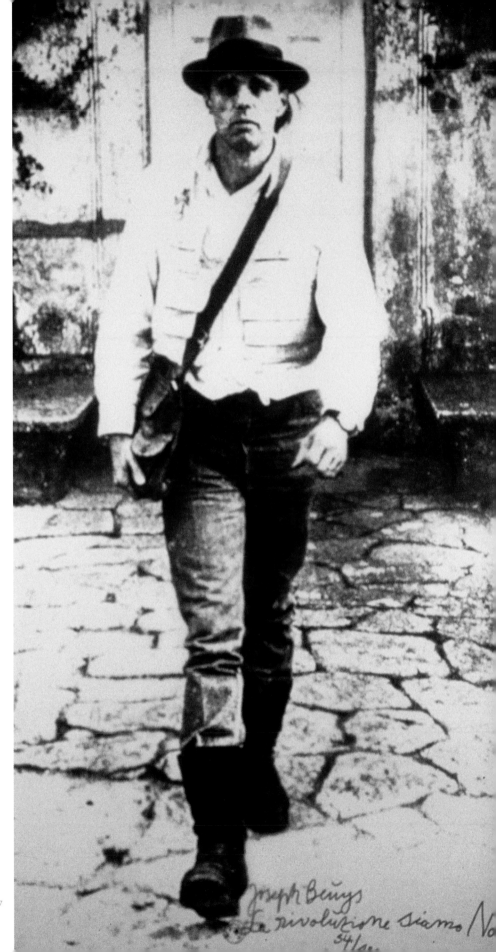

Joseph Beuys
La rivoluzione siamo Noi
54/cc

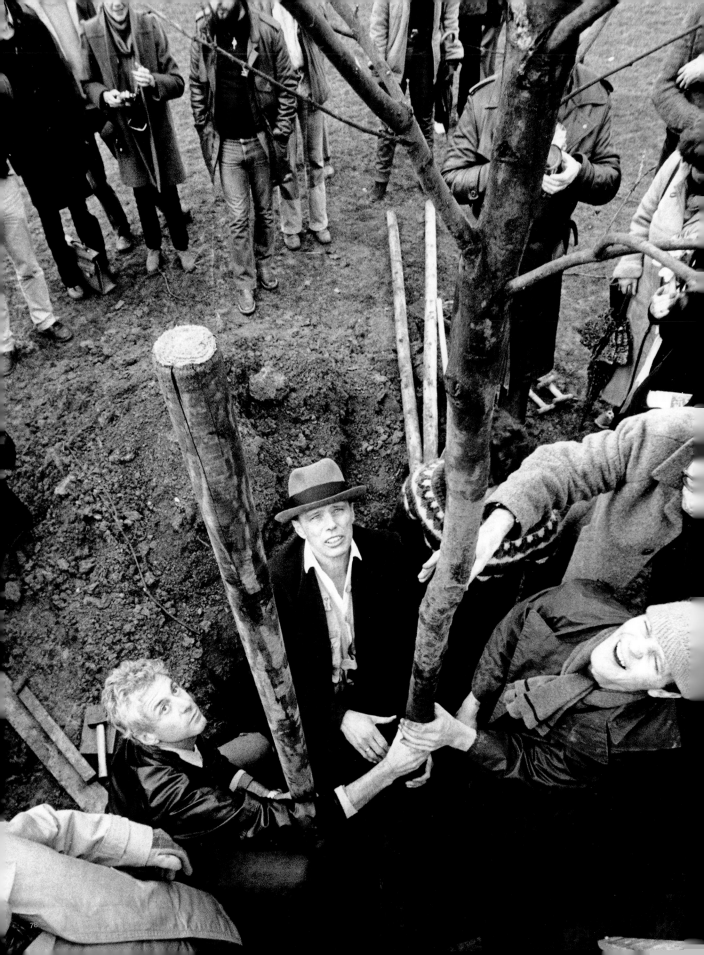

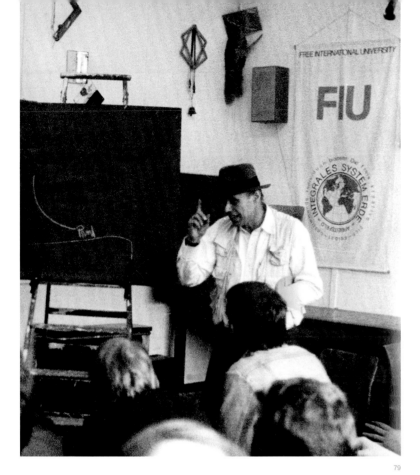

78 **7000 Eichen** (7000 Oaks) 1982–87 /
Action in Kassel, Germany, 1982 79 Beuys
lecturing at the Free International University,
ca. 1980

79

80

81

80–81 **Suzanne Lacy and Linda Pruess** *International Dinner Party* 1979 / Event at the San
Francisco Museum of Modern Art, 1979 / Courtesy the artists

Lacy and Pruess organized *International Dinner Party* in conjunction with the March 14, 1979,
opening of Judy Chicago's *The Dinner Party* (fig. 22) at the San Francisco Museum of Modern Art.
The action began as a twenty-four-hour dinner party involving more than two thousand women
around the world. The artists invited participants to host dinners that evening in honor of
women in their respective regions. Each party sent a collective message via telegram for display
in one of several albums. The artists marked the location of each dinner on a black-and-white
map of the world. In this pre-internet era, the global event necessitated that the artists gather
mailing lists from organizations and send thousands of postcards to solicit participants. —TZ

TOM MARIONI

The 1970s witnessed an unprecedented rise of conceptual art in the San Francisco Bay Area. Marioni, a leading pioneer, founded the Museum of Conceptual Art (MOCA) in San Francisco's South of Market district as early as 1970. He considered MOCA to be a large-scale social artwork: an interactive installation housing events and actions by its many member artists. Along with 112 Greene Street, the Kitchen, and P.S.1 in New York and F Space in Los Angeles, Marioni's conceptual art museum was one of the first alternative, artist-run spaces in the United States. On Wednesday nights he started hosting free salons, and to this day he organizes gatherings in his studio where artists can meet, converse, and drink beer. He draws his inspiration from an activity remembered fondly from his art school days: drinking beer with friends.

In 1970, around the same time that he started his studio salon, Marioni installed *The Act of Drinking Beer with Friends Is the Highest Form of Art* at the Oakland Museum of California under the pseudonym Allan Fish:

> I invited sixteen friends to the museum on a Monday when it was normally closed.... I told the curator, George Neubert, to get the beer and to be there. Everybody showed up, and we drank and had a good time. The debris was left on exhibit as record of the event. Basically, the show consisted of the evidence of the act. It was an important work for me, because it defined Action rather than Object as art.

As bartenders and beer drinkers, Marioni's friends became collaborators in this social artwork. Since then the project has been installed as a fully functioning beer salon at a variety of museums and other venues, anticipating by nearly two decades the 1990s practice of taking over traditional art spaces with bars, clubs, and social events. The salon was part of an exhibition at the San Francisco Museum of Modern Art in 1979 (see pl. 82); its detritus (empty beer bottles, shelves, and a Coldspot refrigerator), reassembled as the installation *FREE BEER (The Act of Drinking Beer with Friends Is the Highest Form of Art)* (1970–79), now resides in SFMOMA's permanent collection. —MP

82 *The Act of Drinking Beer with Friends Is the Highest Form of Art* 1970–2008 / Salon at the San Francisco Museum of Modern Art, 1979 / Courtesy the artist

83

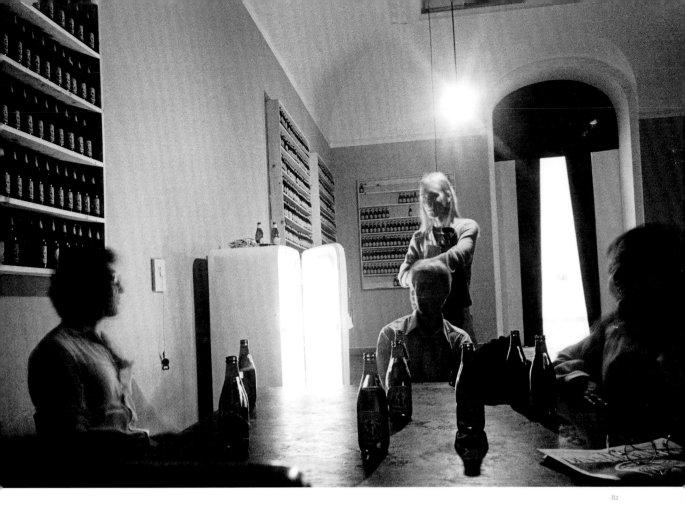

84

83 **Gordon Matta-Clark** *Food* 1971–73 /
Restaurant and social space in New York /
Courtesy David Zwirner, New York
84 **Gordon Matta-Clark** *Fresh Air Cart*
1972 / Installation view in New York, 1972 /
Steel, canvas, rubber, and oxygen masks /
71 × 91 × 34 in. / Courtesy David Zwirner,
New York

A working restaurant installed at the
corner of Prince and Wooster Streets in
Manhattan's SoHo neighborhood, *Food* was
conceived in 1971 by Matta-Clark in col-
laboration with Tina Girouard, Suzy Harris,
Rachel Lew, and Carol Goodden. *Food*
served food, but the restaurant maintained
a flexible schedule to help the artists who
worked there; it also acted as a meeting
place where they could generate activity
and discussion. With a similar sense of civic
duty, Matta-Clark's *Fresh Air Cart* offered
passersby on New York city streets "pure
air" from an oxygen tank as a respite from
urban pollution. —MP

CHIP LORD
CURTIS SCHREIER
BRUCE TOMB

In 1968 Chip Lord and Doug Michels (joined later by Curtis Schreier) founded Ant Farm, a multidisciplinary collective involved with alternative architecture, performance, and video. Based in San Francisco (and later Houston), they embraced the youth counterculture of the time, which influenced their visionary desire to work collaboratively outside the traditional art realm. Idealistic, nonhierarchical, and culturally "underground," the collective took its name from a friend who commented that its members worked like an ant farm. Notable projects include the air-filled vinyl *Inflatables* (1969–72), performances such as *Citizens Time Capsule* (1975; pl. 86), the *Cadillac Ranch* (1974) installation in Amarillo, Texas, and videos such *Media Burn* (1975).

Lord and Michels grew up loving American cars; as teenagers they often worked on customizing Fords and Cadillacs. Lord describes the American Interstate Highway System, started in 1956, as a "monument to the machine: the automobile." The highways allowed for increased mobility across the United States, but they also tore apart cities and displaced historic communities. As a gesture of both tribute and critique, Ant Farm customized a van with video equipment and skylights—their response to "nomadic truckitecture"—and drove cross-country in 1971, staging lectures and events along the way (see pls. 85, 88). "We felt that the roadside environment was changing fast and deserved precise documentation of the motels and cheap restaurants, road-side attractions, gas stations, and gift shops that made Route 66 so junky and important in the fifties," they later wrote.

In 2008 the San Francisco Museum of Modern Art commissioned Lord and Schreier, along with the collaborating artist Tomb, to revisit this project via *Ant Farm Media Van v.08 (Time Capsule)* (pl. 87). The artists are converting a 1972 Chevy C10 van into a time capsule, combining analog and digital media. The interior of the van houses a media hub: Ant Farm videos and a 35mm slide show of roadside documentation from the 1971 journey will be projected onto the back window. The media console, dubbed "Hookah" (another nod to the 1970s), will include a technical interface where visitors can plug in iPods, cell phones, and other personal devices to upload picture, video, and music files. The Hookah as time capsule and digital archive is scheduled to be accessed in the year 2030. —MP

85 *Media Van* 1971 / Installation view in Sausalito, California, 1971 / Customized 1971 Chevy van and video equipment / Courtesy the artists 86 *Citizens Time Capsule* 1975–2000 / Installation view in Lewiston, New York, 1975 / 1967 Oldsmobile Vista Cruiser station wagon and donated objects / Courtesy the artists

85

1970
MEDIA VAN V.8
CAPSULE
V. 2008
LORD · SCHREIER · TOMB
~~FEB~~ 2007
MAY 15,

1970
NETWORK

FLAT SCREENS

HOOKAH

SERVER +
TECH GEAR
UNDER THE HOOD

AF TECHNICIAN
(IN LAB COAT)

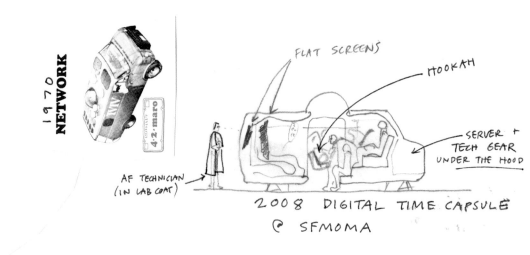

2008 DIGITAL TIME CAPSULE
@ SFMOMA

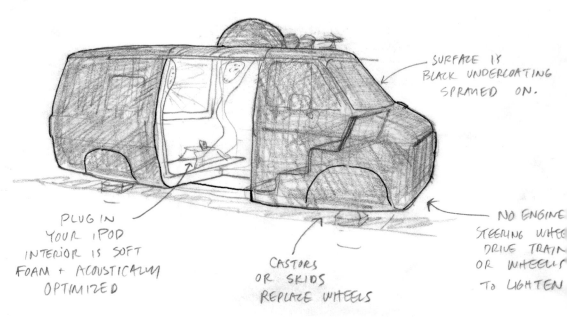

SURFACE IS
BLACK UNDERCOATING
SPRAYED ON.

PLUG IN
YOUR IPOD
INTERIOR IS SOFT
FOAM + ACOUSTICALLY
OPTIMIZED

CASTORS
OR SKIDS
REPLACE WHEELS

NO ENGINE
STEERING WHEEL
DRIVE TRAIN
OR WHEELS
TO LIGHTEN

87

138

88

87 **Conceptual rendering of *Ant Farm Media Van v.08 (Time Capsule)*** 2007 /
Graphite on paper / 11 × 17 in. / Courtesy
the artists 88 ***Truckstop Network Placemat***
1971 / Offset lithography / 11 × 17 in. /
San Francisco Museum of Modern Art, gift
of the artists

89 **Jon Rubin** *FREEmobile* 2003 / Installation view in Seattle,
2003 / Customized 1968 Chevy step van, free goods and services,
and music / Courtesy the artist

Rubin's *FREEmobile* toured Hillman City, a south Seattle neighbor-
hood, during the summer of 2003. Each weekend a different resident
drove through the district in Rubin's custom-modified 1968 Chevy
van, which had the word *FREE* emblazoned on both sides. The drivers
and their families handed out free homemade items (crocheted book-
marks, hand-printed T-shirts) or offered personal services (psychic
readings, hair braiding, bike repair) to their neighbors. The project
introduced residents to one another, exhibiting and distributing their
local folk culture. Reminiscent of an ice cream truck but offering
nothing for sale, *FREEmobile* presented an alternative to commercial
mass production. —*TZ*

KIT GALLOWAY
SHERRIE RABINOWITZ

From mail art and radio broadcasts to telephone and facsimile transmissions, there is a long history of artists using communications systems to transcend geographic boundaries. Since they began collaborating in 1975, Los Angeles–based Galloway and Rabinowitz have exploited satellite technology as a dynamic medium for live performance and social interaction.

In works such as *Satellite Arts Project* (1977), organized with the assistance of NASA, several performing artists appeared in the virtual space of a live composite image, producing a new context for media-based performance. In 1980 Galloway and Rabinowitz organized *Hole-in-Space* (pls. 90–91), a live, three-evening event involving pedestrians at Lincoln Center for the Performing Arts, New York, and the Broadway department store at the Century City Shopping Center, Los Angeles. Walking by a window, passersby were suddenly faced with an electronically generated apparition of people they could see and with whom they could speak. The project afforded a window to another place; the artists offered no explanation for the large televised images, which were visible for two hours per day in both locations. The project began on November 11, was followed by a day of rest, and then continued for two consecutive evenings, eventually becoming overcrowded due to the news coverage. The artists describe the progression of this "public communication sculpture" as "the evening of discovery, followed by the evening of intentional word-of-mouth rendezvous, followed by a mass migration of families and trans-continental loved ones, some of which had not seen each other for over twenty years." The video documentation reveals exhibitionistic, enthusiastic, and humorous exchanges between strangers as well as poignant reunions. Today the work is sometimes presented as an installation, with the black-and-white footage from each transmission channel projected on two facing screens—a formal reference to the windows at the original sites.

Electronic Café (1984; pls. 92–111) significantly furthered Galloway and Rabinowitz's concept of social space. As part of the 1984 Olympic Arts Festival in Los Angeles, they established the first cybercafes at the Museum of Contemporary Art and four restaurants that represented the cultural diversity of the city's neighborhoods. There, video printers, telewriters, laser discs, and a computer server facilitated the exchange of drawings, poems, photos, and messages. Since 1989 the artists have expanded the concept to link different locations around the world. —*TZ*

90–91 *Hole-in-Space* 1980 / Live two-way telecommunication event in New York (pl. 90) and Los Angeles (pl. 91), 1980 / Courtesy the artists

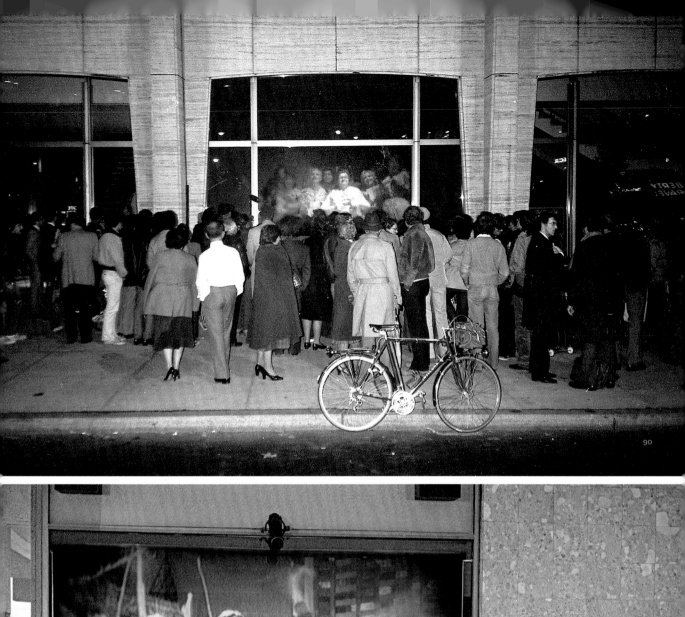

90

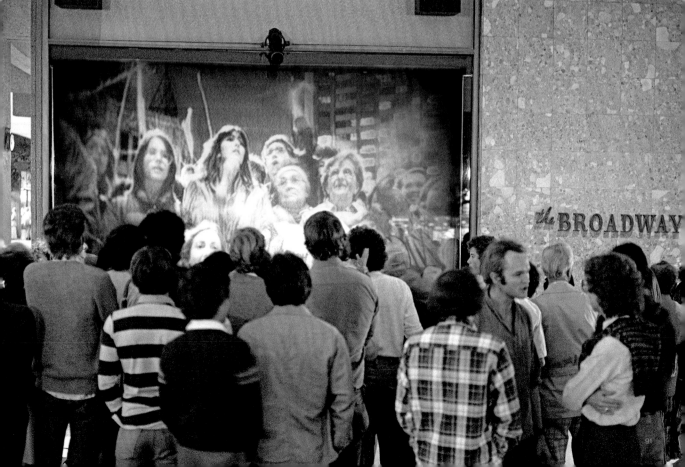

ELECTRONIC CAFE

A COMPUTER AND MULTI-MEDIA
TELECOLLABORATION NETWORK
BRINGING TOGETHER
FIVE CULTURALLY DIVERCE
LOS ANGELES CAFES
IN A VISUAL DIALOGUE

92–111

92–111 *Electronic Café* 1984 / Network of
five linked cybercafes, Los Angeles, 1984 /
Courtesy the artists

112 **telewissen / Herbert Schuhmacher** *Documenta der Leute* (People's Documenta)
1972 / Installation view in Kassel, Germany, 1972 / Closed-circuit video installation in
Volkswagen van / Courtesy Herbert Schuhmacher

On the streets outside *Documenta* 5 (1972), the German video collective telewissen ("teleknowl-
edge") conducted documentary, man-on-the-street interviews with passersby, playing back their
pictures on monitors in a van outside the exhibition. The group used portable video equipment
(then unfamiliar to the general public) as a tool for discovery and improved communications,
encouraging critical public dialogue on a range of topics and exhibiting the audience as part of
the project. —*TZ*

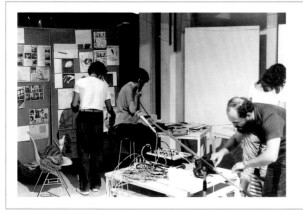

113 **Robert Adrian X** *The World in 24 Hours* 1982 /
Telecommunications happening in Linz, Austria, 1982 /
Courtesy the artist

The artist Robert Adrian X began working with telecom technology
in 1979. In 1982 he conceived a daylong telecommunication project for
the Ars Electronica festival, linking twenty-four participating artists
and groups around the world to a central project base at the broadcast-
ing facilities of the radio station ORF in Linz, Austria. As noon arrived
in each linked city, visual materials were transmitted through a variety
of simple, readily available devices (telephone, wireless radio, slow-
scan television, and fax machine) connected via telephone or amateur
wireless connections. —*TZ*

ANTONI MUNTADAS

Tracing a history of social and cultural censorship since antiquity, Muntadas's *The File Room* (http://www.thefileroom.org, 1994–present) exists as an online database that accumulates cases through the input of site visitors. The artist has developed an expansive system that reflects not only on censorship, but also on the archive. The public can submit cases by filling out an online form documenting the date, location, medium, and grounds for censorship; they can also browse the archive of cases, definitions of censorship, anticensorship resources, and essays on the project. The archive gives equal weight to all cases, retaining the integrity of each individual citation. This tool is intended to be organically shaped by users from a wide range of disciplines.

In 1994, at the Chicago Cultural Center, Muntadas first presented *The File Room* as an installation—an ominous, dimly lit room of file cabinets and computer terminals (see pl. 114). The installation provided access to the project website, notable at a time when only a fraction of the public was familiar with the internet. The presentation corresponded with Muntadas's earlier installation-based works, such as *The Boardroom* (1987), which mirrored the bureaucratic spaces of powerful institutions.

The project is informed by two key developments of the 1990s: the birth of internet art and the aftermath of high-profile battles over arts censorship (notably the 1989–91 controversy over National Endowment for the Arts funding in America). While *The File Room* addresses a diversity of censored subjects, it effectively demonstrates how the arts have been and continue to be an easy target, systematically coming under fire for allegedly subversive content. A 1988 case uploaded by Muntadas is one of the earliest submissions to the archive and an indicator of the personal impetus of the project, succinctly documenting his own history as a censored artist. After inviting Muntadas to produce the video *TVE: Primer Intento,* Televisión Española (TVE), which controlled the rights to the project, chose not to broadcast the work, never giving an official explanation. The video represented more than two years of filming and research in TVE's archives.

Since 1999 Muntadas's strategy of revealing what might otherwise not be apparent has also informed his ongoing *On Translation* series, which addresses sociopolitical issues in relation to the concept of transcription and interpretation (see figs. 26–27). —*TZ*

114 *The File Room* 1994 / Installation view at the Chicago Cultural Center, 1994 / Metal file cabinets, computer monitors, desk, and chair / Courtesy the artist

115 **Josh On** *They Rule* 2004–present / Online project (http://www.theyrule.net) / Courtesy the artist

They sit on the boards of the largest companies in America. Many sit on government committees. They make decisions that affect our lives. They rule. —Josh On

In 2004 the San Francisco Bay Area artist On launched *They Rule,* a forum for examining the insidious hold of private interests over American politics. Tapping into publicly accessible databases, the website identifies the ruling class of our capitalist society and maps the connections between these individuals. The project exploits key attributes of the internet—visualizing social networks, conducting data searches, soliciting user-generated maps and weblog submissions—in the service of online activism. —*TZ*

MARIA EICHHORN

The economic, social, and legal conditions of art are integral aspects of Eichhorn's conceptual practice. Many of her projects also address and involve collaboration. Perhaps most notably, her installation *Arbeit/Freizeit* (Work/Leisure, 1996; pl. 116) invited staff at the Berlin headquarters of Generali Insurance to contribute to an exhibition of objects representing how they occupied themselves at the office and in their spare time. Eichhorn displayed the very personal objects they submitted in a vitrine in the office lobby.

In another Eichhorn project, however, it is the documentation of the conditions of engagement that constitutes the work. *Prohibited Imports* (pl. 117), first shown at Masataka Hayakawa Gallery, Tokyo, in 2003, examines ordinances relating to freedom of speech and the legal curtailment of that freedom, with specific reference to Japanese customs authorities' practice of censoring imported books. The artist mailed several parcels of books on AIDS, activism, gender, and art with explicit visual content from Berlin to her Tokyo gallery, assuming that Japanese officials would open and censor them. She discovered that the only publication censored by authorities at Tokyo's Narita Airport was *Mapplethorpe: Die große Werkmonographie,* a German catalogue of Robert Mapplethorpe's photography published in 1992. Two copies of the book were sent in separate shipments. One copy was censored; the other was not.

Eichhorn's installation displays the two copies of the Mapplethorpe book on the upper shelf of a wall-mounted vitrine, open to the same spread so viewers can compare one photograph in censored and uncensored form. The picture in question is Mapplethorpe's 1977 photograph *Patrice, N.Y.C.*; eighteen other reproductions in the publication were also censored, indicating a thorough reading of the book by the Japanese authorities. The artist has lined up the other books she shipped in the lower part of the case, as though on a bookshelf, together with volumes on legislation, the state of the law and jurisdiction, freedom of the press, and freedom of speech in Japan.

Who actually censors and exactly how it is done are questions that remain unanswered. According to the customs officials, the imported goods were deemed articles that "injure public security or morals." Since the idea of the project was for customs to censor the books and, by censoring them, become a "coproducer" of the work, the gallery also had to become a party to censorship. —*RF*

116 *Arbeit/Freizeit* (Work/Leisure) 1996 / Wood, Plexiglas, halogen spotlights, and mixed media / 86⅗ × 63 × 63 in. / Courtesy Galerie Barbara Weiss, Berlin 117 *Prohibited Imports* 2003 / Offset lithography, glass, and wood / 30¼ × 18⅝ × 15 in. / Collection of the artist

116

118 **Jens Haaning** *Super Discount*
1998 / Market event at Fri-Art, Fribourg,
Switzerland, 1998 / Courtesy Galleri
Nicolai Wallner, Copenhagen

Haaning creates installations that reveal
the disjunctions inherent in heterogeneous
societies. By producing an environment
for exchange, he accentuates the foreign
within a nation's borders. In 1998 he
staged a supermarket, *Super Discount,* that
questioned the market value of common
goods and compared the economies of
France and Switzerland. Food, cleaning
supplies, and gin were purchased in France
and imported to Fribourg for sale at Fri-Art.
Prices tend to be high in Switzerland, which
is independent from the European Union;
Super Discount provided a 35 percent sav-
ings compared to local stores, to the benefit
of museum visitors. —MP

FELIX GONZALEZ-TORRES

Museum visitors are not typically permitted to touch artwork, much less take it home with them. However, with Gonzalez-Torres's takeaway pieces—stacks of mass-produced prints or piles of candy—the viewer is necessary to complete the work. By offering gifts without dictating what was to be done with them, the artist acknowledged that the individual posters or cellophane-wrapped candies have a future life beyond the gallery. One may find surviving prints pinned to someone's wall or even used as wrapping paper. Gonzalez-Torres's gift economy uses the exhibition context to question the uniqueness of the art object.

These works are not only about the generosity of giving but also the difficulty of letting go. Gonzalez-Torres started making the stack and candy pieces when his partner, Ross Laycock, was dying of AIDS, partly as a way of coming to terms with Laycock's physical deterioration and eventual disappearance. The color, form, or weight of a given piece frequently carried personal significance for the artist. For instance, the amount of candy in *"Untitled" (Loverboys)* (1991) corresponds to the combined body weight of the artist and his lover, thus serving as a nonrepresentational double portrait.

The basic forms of Gonzalez-Torres's floor and corner pieces evoke the precedent of minimalist sculpture but are imbued with poetic intimacy. He employed quotidian manufactured materials (lightbulbs, beaded curtains, clocks, and candy) that are associated with personal effects or household fixtures. The titles' parenthetical elements reveal the works' political undertones. *"Untitled" (Public Opinion)* (1991; pl. 121), for example, reflects on the conservative cultural climate of the United States. Whereas some stack pieces are text-based, others reproduce empty expanses of sky or sea. *"Untitled"* (1992/1993; pl. 119) belongs to a melancholic series of silhouetted birds against overcast skies. The striking image was repurposed in posters, billboards (pl. 120), and passports, alluding to the passage of time and the transitory state of being. —*TZ*

119 *"Untitled"* 1992/1993 / Installation view at the San Francisco Museum of Modern Art, 2008 / Offset lithography (endless copies) / 8 × 44½ × 33½ in. / San Francisco Museum of Modern Art, Accessions Committee Fund

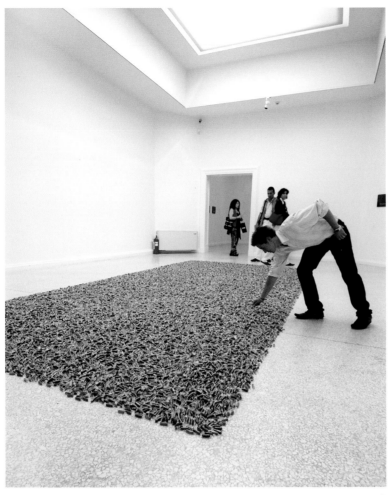

120 *"Untitled" (Strange Bird)* 1993 /
Billboard / The Felix Gonzalez-Torres
Foundation, courtesy Andrea Rosen Gallery,
New York 121 *"Untitled" (Public Opinion)*
1991 / Installation view at the Venice Biennale,
2007 / Black rod licorice candies individually
wrapped in cellophane (endless supply) / The
Felix Gonzalez-Torres Foundation, courtesy
Andrea Rosen Gallery, New York

121

122 **Joana Hadjithomas and Khalil
Joreige** *Circle of Confusion* 1997 /
Installation view at the Cour Carrée du
Louvre, Paris, 2007 / Chromogenic print,
glue, and mirror / 118⅛ × 157½ in. /
Courtesy In Situ / Fabienne Leclerc, Paris

The Lebanese filmmakers and artists
Hadjithomas and Joreige have produced
a body of work on the legacy of political
conflict in their home country. *Circle of
Confusion* depicts an aerial view of Beirut
after the war, cut into three thousand tes-
sellated sections and attached to a gigantic
mirror. On the back of each numbered
fragment is the message "Beirut does not
exist." When the viewer takes away a piece
as a souvenir, it reveals part of the mirror.
As the representation of the city gradually
disappears, the mirror reflects ever more of
the gallery and its occupants. —*TZ*

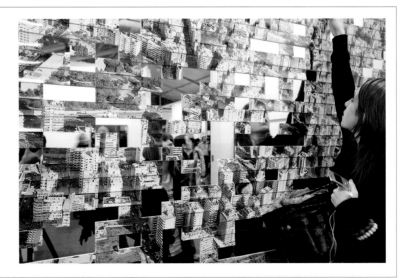

HARRELL FLETCHER
JON RUBIN

Fletcher and Rubin have been influential in the development of art as social practice, undertaking individual and collaborative projects with a number of different communities. Interested in engaging nonart audiences and marginal groups, they often work to undermine the gallery and the museum as exclusive domains. Open calls for participation have hence become a seminal aspect of their production.

In 1998 the artists set up a copy stand in the lobby of the San Francisco Museum of Modern Art and asked visitors to allow them to photograph snapshots in their wallets (see pl. 123). Fletcher and Rubin viewed the project as a way to address the anticipated preciousness of the objects people expect to see when they come to a museum. The finished piece, titled *Pictures Collected from Museum Visitors' Wallets* (pl. 124), is a selection of ten enlarged and framed chromogenic prints. Folded corners and other signs of wear give these rephotographed snapshots the patina of well-loved mementos.

Fletcher and Rubin had collaborated on site-specific projects in the past, notably *Some People from Around Here* (1997; pl. 125). This temporary public installation in Fairfield, California, consisted of eight-foot-tall portraits of six locals they met during their stay as the town's artists in residence. The billboard-size likenesses were painted on plywood and placed alongside the I-80 freeway outside the city. During the three months the project was there, an estimated ten million people saw the installation while driving by. —*TZ*

123–24 *Pictures Collected from Museum Visitors' Wallets* 1998 / Gathering photographs at the San Francisco Museum of Modern Art, 1998 (pl. 123), and installation view at SFMOMA, 2004 (pl. 124) / Chromogenic prints / Ten prints, each: 40 × 30 in. / San Francisco Museum of Modern Art, purchased through a gift of the Wallace Alexander Gerbode Foundation

123

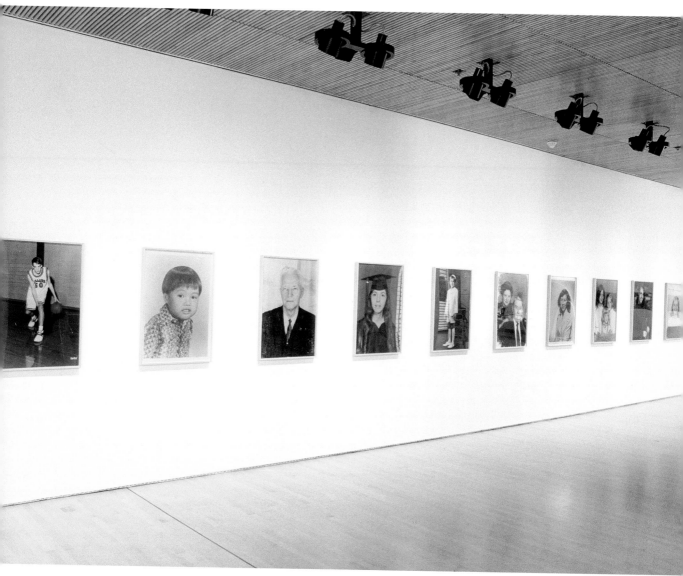

126 **Philippe Parreno** *The Speaking
Stone* 1994 / Installation view at
the Kunstmuseum Luzern, Lucerne,
Switzerland, 1994 / Plastic, wireless
loudspeaker, audiotape, and Walkman /
Courtesy Friedrich Petzel Gallery,
New York

An impromptu circle of people gather
around a stone that addresses itself to the
group as they sketch this object. Parreno's
Speaking Stone re-creates the communal
experience of a drawing class in the gallery
space. The art object speaks to the artists
during the art-making process—a still life
come to life to provide instruction. —*TZ*

125 *Some People from Around Here* 1997 /
Installation view in Fairfield, California, 1997 /
Wood and paint / Courtesy Jon Rubin

Assignment #63
Make an encouraging banner.
Jenner
Milwaukee, Wisconsin USA

127

127–29 **Harrell Fletcher and Miranda July** *Learning to Love You More* 2002–present / Online project (http://www.learningtoloveyoumore.com) / Courtesy the artists

In *Learning to Love You More* the general public responds to creative assignments on a website launched by Fletcher and July in 2002. Participants follow the simple instructions and submit documentation (a photograph, a text, or a video) to be posted online. The artists liken the prescriptive nature of these assignments to "a recipe, meditation practice, or familiar song" that guides people to their own experience. Now numbering more than five thousand from all over the world, the virtual submissions may also be selected for inclusion in physical exhibitions and other public presentations. —*TZ*

Assignment #63
Make an encouraging banner.
Ceress Wiegand
Hutchinson, Kansas USA

128

Assignment #63
Make an encouraging banner.
The Musgrove Family
Pine City, Minnesota USA

129

155

MINERVA CUEVAS

Toward the end of the twentieth century many young artists voiced a critique of the effects of globalization, embracing in their work a political activism that previously had been held to be antiartistic. Appropriation and simulation were two formal strategies used in the service of this political agenda. Cuevas launched *Mejor Vida Corp.,* or *M.V.C.,* in 1998 as a series of public interventions in Mexico City, joining forces with artists and media activists such as Heath Bunting (see pl. 132), whose site irational.org hosts Cuevas's project. Striving to create an international network of people who question capitalism as a system, she addresses these far-flung individuals via *M.V.C.,* whose Spanish name translates literally as "Better Life Corp." *M.V.C.*'s mission statement announces that it "creates, promotes and distributes world wide products and services for free," adding that it does not discriminate according to gender, race, religion, sexual preference, or economic status. With a logo that promises "a human interface," the project ludicrously mimics the structure and vocabulary of a Mexican global corporation. Its website offers a typical roster of links to products, services, campaigns, information on shipping, and contact details.

M.V.C. not only provides its goods for free but also facilitates interventions in social spaces. One exemplary campaign targeted Melate, the national lottery of Mexico. Questioning the lottery's alleged financing of public assistance, Cuevas altered the lottery's identity and installed her revised logo on signs throughout Mexico City, adding statistical data that revealed how the system benefited private stakeholders. Another service offered the assistance of a security agent to help in dealings with the police. Cuevas's approach to social activism extends to products such as fake student ID cards providing complimentary access to museums, free subway tickets, stickers with barcodes that reduce the price of supermarket goods (pl. 130), posters advertising "safety pills" to raise awareness of potential violence on public transportation, prestamped envelopes (pl. 131), and lottery tickets. Until 2003 she occupied an office at the Latinoamerican Tower in Mexico City as a way to reach out to audiences beyond the artistic context. Deeply rooted in everyday life (and the specific social context of Mexico), and partaking in alternative financial systems such as the gift economy, Cuevas's work takes as its arena not the museum or art gallery but rather public spaces open to all individuals. —*RF*

130–31 *Mejor Vida Corp.* 1998–present / Barcode stickers (pl. 130) and shipment (pl. 131) / Online project (http://www.irational.org/mvc) / Courtesy the artist

130

131

157

<div>

132 Olia Lialina and Heath Bunting
Identity Swap Database 1998–present /
Online project (http://www.teleportacia.
org/swap) / Courtesy the artists

Net art and net activism often went hand
in hand in the formative period of the
1990s. Bunting's irational.org is a website
hosting the British artist's own projects
as well as those of friends and other
activists. One such example, *Identity Swap
Database,* produced by the Russian net
artist Lialina in collaboration with Bunting,
takes an ironic approach to the notion of
identity at a time of search engines and
global diaspora. Presented as a "service"
for a global, multilingual community of
migrants, the site's text flashes constantly
in four languages: English, German,
Spanish, and Russian. —RF

</div>

Identity Swap Database

Stiften	Suchen	*Principal*

Einzelheiten der Identität	
Anonyme e-mail Adresse	irisann6996@aol.com
Sex	female
Год рождения	1975
Hautfarbe	white
Цвет волос	brown
Augenfarbe	blue
Weight (in kg)	54.4
Altura (en cm)	134
Kreditgeschichte	Below average rating
Судимости	None
Physical marks & scars	Tattoos on back, arm and left hip
Staatsangehörigkeit	american
Lengua materna	english
Stiften	temporary

FRANCIS ALŸS

"Walk for as long as you can while holding a 9mm Beretta in your right hand." In Mexico City, the Belgian artist Alÿs followed this self-imposed rule until the inevitable dramatic conclusion—his arrest—fifteen minutes later. He then convinced police officers to allow him to repeat the performance, including the arrest, as a staged reenactment for the camera. His double video projection *Re-enactments* (2001; pls. 133–38) presents performance documentation on one screen and the reenactment on the other. In both versions Alÿs is seen buying a pistol and carrying it at his side as he walks swiftly through the city streets. The second performance borrows the stylized language of crime reenactments on television, employing dramatic angles of Alÿs and the gun. In the first footage cinematographer Rafael Ortega focused on trailing the artist's tall, lanky figure; the second version, however, emphasizes the participatory role of passersby as they become aware of the potential threat and alert the authorities. The work belongs to a series of casually executed street actions in which the artist makes use of anomalous props: pushing a block of melting ice, dragging a metal collector, or dripping a can of paint.

Whereas *Re-enactments* provoked the involvement of a few individuals, *When Faith Moves Mountains* (2002; pl. 139) recruited five hundred Peruvian volunteers to move a mountain in Ventanilla, on the outskirts of Lima. On April 11, 2002, Alÿs coordinated efforts to shovel a gigantic sand dune, moving it an almost imperceptible four inches. According to the artist, this irrational project exercised the principle of maximum effort for minimal effect. "The Lima Action wanted to re-socialize Land Art," he says. "It wanted to rehumanize it by turning sculpture into mass experience, while referring to the condition of landless people." —*TZ*

133–38 *Re-enactments* 2001 / Two-channel color video installation with sound, 5:20 min. / Courtesy the artist and David Zwirner Gallery, New York

TCR 00:02:55:18

RE-ENACTMENT

TCR 00:11:14:09

RE-ENACTMENT

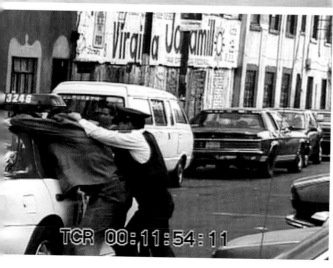
TCR 00:11:54:11

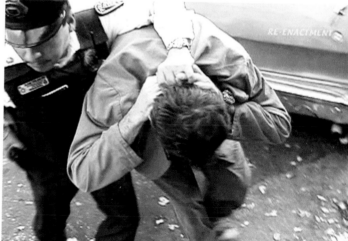
RE-ENACTMENT

133–38

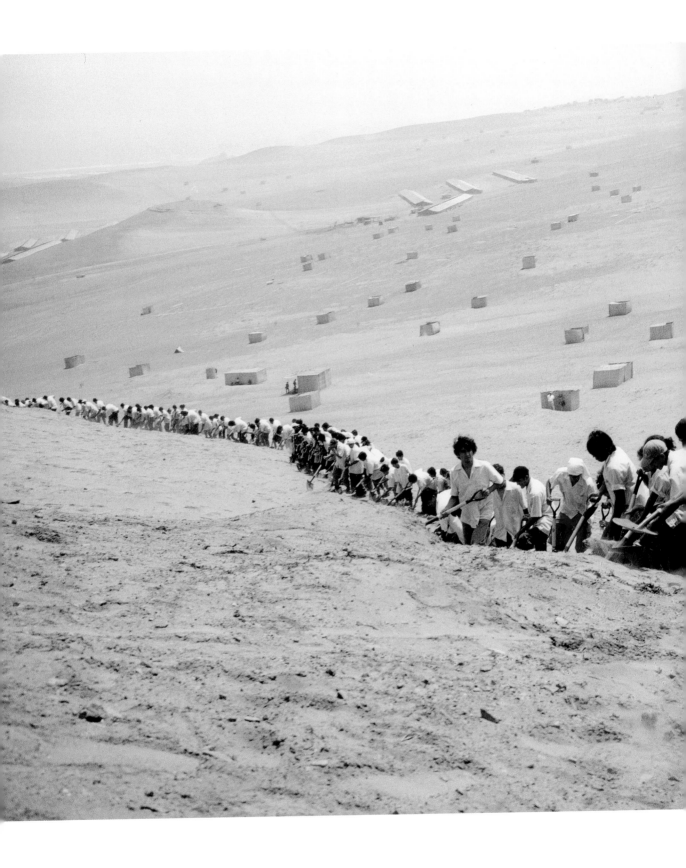

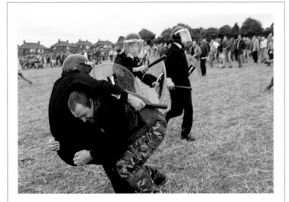

140 **Jeremy Deller** *The Battle of Orgreave* 2001 / Performance in Orgreave, England, 2001 / Coproduction with Artangel, London

On June 18, 1984, in Orgreave, England, a climactic clash occurred between striking miners and riot police. Seventeen years later, on June 17, 2001, the British artist Deller revisited the trauma of this event and its biased coverage in the Thatcher-era news media. He staged a reenactment at the original site in Yorkshire, enlisting a corps of volunteers comprising war reenactment enthusiasts, townspeople, and members of both sides of the conflict. Directed by Mike Figgis, the resulting documentary aired on the BBC in 2002. —TZ

139 *When Faith Moves Mountains*
2002 / 16mm film (color, sound) transferred to two video projections and one video on monitor / Courtesy the artist and David Zwirner, New York

139

ERWIN WURM

"By coincidence I became a sculptor." This statement by Wurm applies to all who follow his often deadpan, absurd instructions and in the act become sculptors, too. When one first encounters his *One Minute Sculptures* (2006; pl. 143), the display of ordinary objects—a fridge, plastic bottles, tennis balls—on a white platform may suggest the idea of sculpture, yet the artist makes it clear that this is not the actual artwork. What is seen is not yet realized, but only a virtual artwork embodied in the instructional drawings and corresponding props needed to perform each sculpture temporarily.

Wurm declares his practice to be a "research of emptiness, virtuality and volume," toward which he typically employs a variety of media, including photography, video, objects, and drawings. The seeming artlessness of his work speaks openly of everyday life, a concern that he inherited from Fluxus, whose artists manifested a similar antiart attitude and playful approach to the poetic. Though he is also aware of the looming tradition of Viennese Actionism, which staged shocking and often violent situations, Wurm chooses to quietly transform the participant's embarrassment into sculpture. Offering no space for utilitarian thought, his artistic language is as accessible and universal as the slapstick comedy of Laurel and Hardy. But faced with *Adorno as Oliver Hardy in the Bohemian Girl (1936), and the burden of desperation* (2006), one of a series of Wurm works addressing philosophers, one perceives that it is less of a joke than an absurd confusion of genres and topics.

The artist is probably always the first witness of his often unforeseen results. He says that experiencing the work takes a "willingness to become confused," and he asks this openness from all who choose to carry out his instructions. Yet the decision to step up and perform—and thus also be temporarily exhibited for others to watch—is typically a small one. It does not take any virtuosity, only curiosity. In turn, each performer is rewarded by the satisfaction of having physically realized a vision of something very specific and also, momentarily, of having become somebody different. In real life it sometimes takes only a few pounds gained involuntarily to have a similar feeling. And at the end of the day, Wurm points out, "art deals with the difficulty of coping with life—be it by means of philosophy or a nutritional diet." —RF

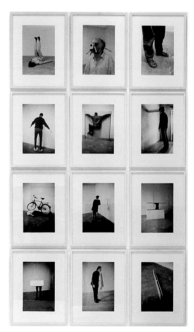

141–42 *One Minute Sculptures* 1997 / Chromogenic prints / Thirty-two prints, each: 26¾ × 20½ in. (framed) / Collection of the artist

141

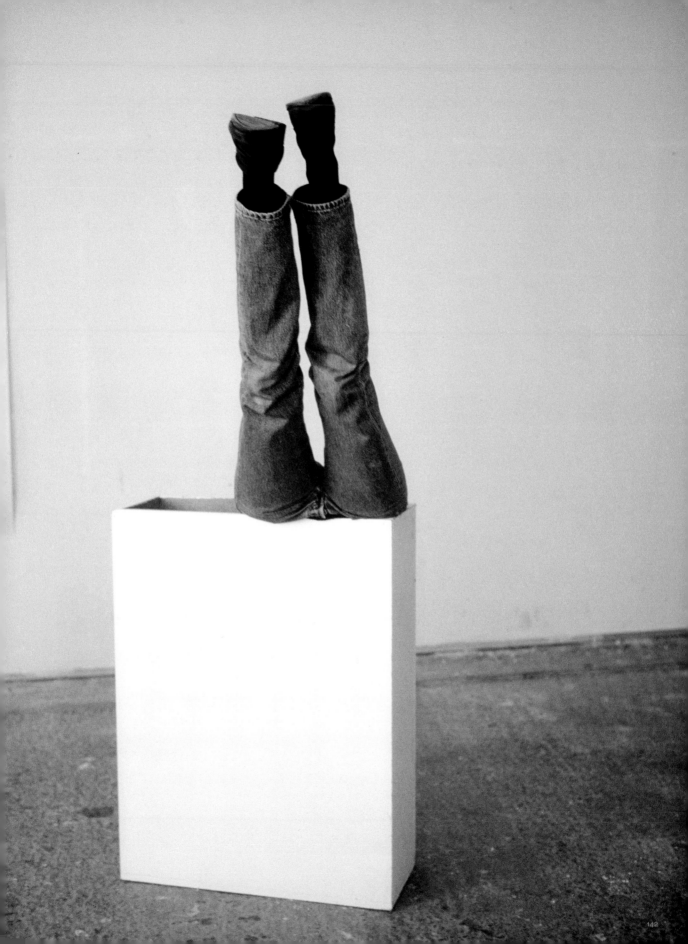

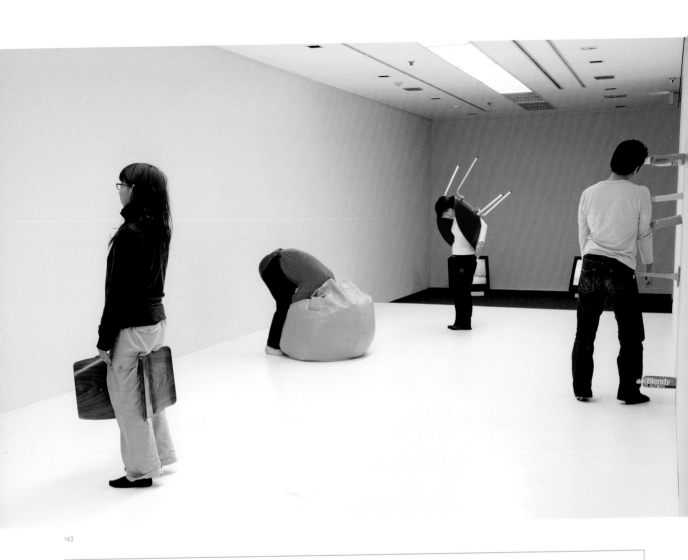

143

145 **Sarkis** *La défilé du siècle en fluo à Darmstadt* 2000–2002 / Workshop and performance at the Hessisches Landesmuseum Darmstadt, Germany, 2002 / Courtesy the Hessisches Landesmuseum Darmstadt

Ten colorful costumes for children, designed by Victor Férès after historic models of the twentieth century, were fabricated in a workshop set up by Sarkis at the Hessisches Landesmuseum Darmstadt, famous for housing Joseph Beuys's *Block Beuys* (1970–86), a multiroom installation of objects collected by the artist. The children dressed up in these clothes in preparation for a tour of the seven galleries that comprise Beuys's installation. Their fluorescent procession through the earthen-colored *Block Beuys* was strongly theatrical, countering the static permanency of the installation with the spirit of live interpretation. —*RF*

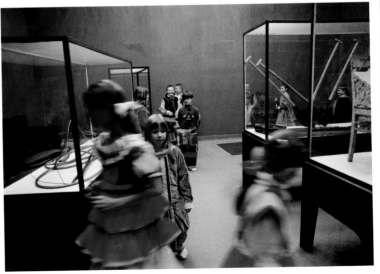

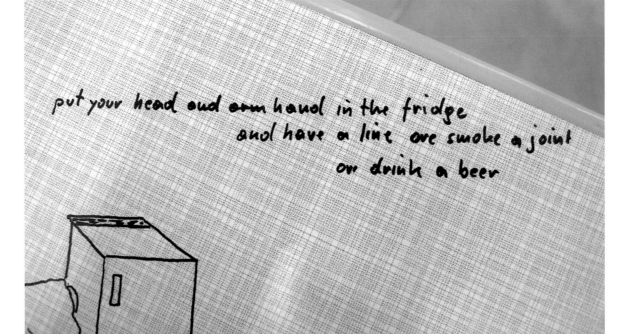

put your head and arm hand in the fridge
and have a line one smoke a joint
on drink a beer

144

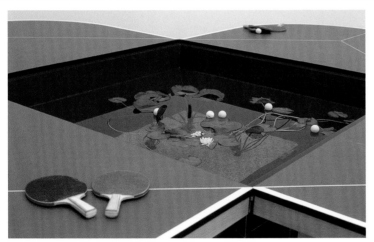

143 *One Minute Sculptures* 2006 / Installation views at the Museum of Modern Art, Saitama, Japan, 2006 / Performative objects and instruction drawings on pedestal / Collection of the artist 144 *Keep a cool head* 2003 / Refrigerator and instruction drawing / 33¼ × 19¾ × 24 in. / Collection of the artist

146 **Gabriel Orozco** *Ping Pond Table* 1998 / Installation view at ARC / Musée d'Art moderne de la Ville de Paris, 1998 / Modified ping-pong tables, water lilies, water, and mixed media / 30 × 167¾ × 167¾ in. / Courtesy Marian Goodman Gallery, New York

Play is crucial to the way we learn to socialize and understand reality. From Marcel Duchamp to Fluxus, many artists have explored an interest in game structures. A more recent artistic interpretation of the universal desire to engage in games, Orozco's *Ping Pond Table* subverts preconceived ideas of play. A typical game is played according to preestablished rules. In this case, however, participants must figure out how to negotiate four sections of a ping-pong table arranged around a lily pond. Orozco's interactive sculptural form is typical of work by artists associated with relational aesthetics in the 1990s. —RF

JOCHEN GERZ

In the 1960s Gerz began to investigate the nature of public space via conceptual gestures and performance; since the 1980s he has focused on site-specific projects that foster public participation and dialogue with the community. He emphasizes the process of production, establishing a context for participation in which he need not be present. In 2000, for example, he initiated the photography project *The Gift* (pls. 147–49) in Tourcoing, France. Local residents were invited to have black-and-white portraits taken by young artists and photography students over the course of one weekend. Each participant received a portrait in return—not his or her own, but that of a stranger—and was asked to display the picture at home. Visitors who might not otherwise collect contemporary art were thus able to display a piece that was part of a larger network of portraits, what the artist calls a "collection" on permanent loan to the public. Gerz partnered with regional newspapers both to make the project known to the community and to publish the resulting photographs (see pl. 150). He realized the project again later that year as part of the *Vision.Ruhr* exhibition in Dortmund, Germany. This time, however, the photography studio and the production process were on full view, with the framed portraits exhibited at the local Museum am Ostwall.

Gerz's project shows the development of an exhibition and an artwork. At first, while portraits are taken, nothing is displayed; gradually, as the photographs are printed and framed, they begin to fill the space. The visitors are important agents: they are part of the production as models, and then, in turn, they own part of the collection. The gift implied is less about the receipt of a portrait, since it depicts a stranger, than about the shared experience and the exchange itself. "What is offered is what is received," notes Gerz, who says that the project represents "a collective memory" and a "self-portrait" of a region. At the San Francisco Museum of Modern Art, the photography studio will be visible alongside the displayed and stored framed portraits. Participants are invited to a closing reception at which each will be given the portrait of another visitor, and thus *The Gift* will be redistributed to its very producers. The artist will ask all subjects to contribute pictures or commentary online to demonstrate how they exhibit their photographs at home. —MP

147–49 **The Gift** 2000 / Installation views at Le Fresnoy, Studio national des arts contemporain, Tourcoing, France, 2000 (pls. 147–48), and at the Schirn Kunsthalle Frankfurt, Germany, 2000 (pl. 149) / Digital photography studio, production lab, digital pigment prints, and newspaper advertisements / Each photograph: 23⅝ × 19¹¹⁄₁₆ in. / Courtesy Gerz Studio
150 **The Gift** 2000 / Newspaper reproduction of installation photographs in *Westfälische Rundschau* (Dortmund, Germany), 2000 / Courtesy Gerz Studio

149

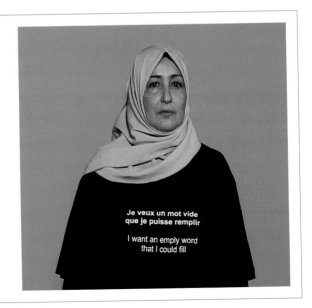

151 **Sylvie Blocher** *Je et Nous* (I and Us) 2003 / Single-channel color video installation with sound, 55 min. / Courtesy the artist

Part of Blocher's ongoing video portrait series *Living Pictures*, *Je et Nous* (I and Us) features a hundred residents of a densely populated Paris suburb who responded to her open call for volunteers. They appear one after another in a studio setting, wearing custom-printed bilingual T-shirts (produced with the help of the artist) that express a range of brief yet intense—and often unexpected—statements. Communication takes place not just through text but also through subtext: facial expression and body language. The work developed out of the artist's long-term collaboration with this impoverished community as a member of the interdisciplinary collective Campement Urbain. —*TZ*

 vision.ruhr KUNST MEDIEN INTERAKTION AUF DER ZECHE ZOLLERN II/IV DORTMUND 14.05.-20.08.2000

Wir laden Sie ein, sich von jungen Künstlern fotografieren zu lassen.
In der Ausstellung entsteht Ihr Porträt. Ein Porträt ist DAS GESCHENK für Sie.
Ein Gemeinschaftsprojekt von vision.ruhr, der Westfälischen Rundschau,
dem Museum am Ostwall und der Fachhochschule Dortmund.

 Westfälisches
Industriemuseum

 Museum
am Ostwall
Dortmund

mit freundlicher
Unterstützung von

CALC
JOHANNES GEES

The idea of shared authorship and collective production took on new meaning in the 1990s, when the internet introduced new opportunities for networking. The pan-European collective c a l c (casqueiro atlantico laboratorio cultural) is a self-styled "cultural laboratory" of multimedia artists and designers formed in 1990. Based in Seville, Spain, c a l c's core membership comprises Teresa Alonso Novo, tOmi Scheiderbauer, Malex Spiegel, Looks Brunner, and Dani Gómez Blasco. In 1999, on the invitation of Swiss *Expo.02,* c a l c, together with collaborating artist Gees, began to develop *communimage* (pl. 153); the project has continued independently to this day. Visitors to the website are invited to upload pictures to a grid system, along with some basic metainformation. Each image, or "patch," may be viewed individually using a navigator tool that can zoom in or out. Contributions are unfettered and unregulated, resulting in widely varied subject matter: from the photorealistic to the animated, from the intimate to the exhibitionist. The multitudinous images together form one collective map, so large that if it were printed out at actual size it would reach a height of nearly forty-six feet. As of late June 2008 it contained more than 25,700 images uploaded by some 2,220 visitors.

Viewed as a whole, *communimage* forms an abstract, polymorphous shape: a true demographic representation of the global internet community. Indeed, the artists' platform for image exchange foreshadowed the current boom of visual postings on sites such as YouTube and Flickr. At the San Francisco Museum of Modern Art, viewers will encounter the project in the gallery as a large-scale print (*communimage—a moment in time VI*), reflecting the site's contents as of September 17, 2008. To display the site in the museum as a static print may seem a contradictory gesture, but it is also a compelling reflection on the status of the image in the public realm. —*MP*

152 *communimage—a moment in time I* 2000 / Installation view at allerArt, Bludenz, Austria, 2000 / Digital pigment print mounted on aluminum / 204¾ × 110⅛ in. / Courtesy the artists 153 *communimage* 1999–present / Online project (http://www. communimage.net) / Courtesy the artists

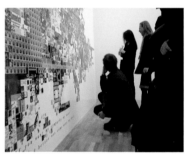

152

153

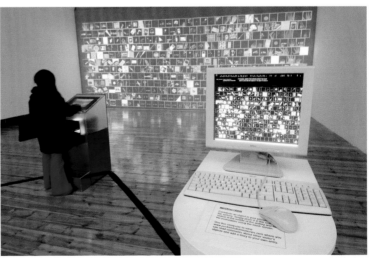

154 **George Legrady** *Pockets Full of Memories* 2001–7 / Installation view at Cornerhouse Gallery, Manchester, England, 2005 / Mixed-media installation, projections, computer terminals, scanning station, and wall stickers / Collection of the artist

Legrady's interactive installation *Pockets Full of Memories* investigates the interstices between systems of classification, memory recall, and semantics. Visitors are invited to scan personal belongings and enter descriptions of them in a database. Using the Kohonen self-organizing map algorithm, the objects are categorized according to their descriptions, with like placed by like and distanced from unlike. The comparisons are made visible as they are projected onscreen in the exhibition space. —MP

WARREN SACK

Text-based conversations were at the core of the internet even prior to its widespread public use in the late 1990s. In 2000 Sack, a digital artist and media theorist, developed *Conversation Map* (pl. 155), a sophisticated example of internet art that addresses public discussion forums for online communities. In response to the phenomenon of many-to-many exchanges on the internet, Sack designed a newsgroup graphical browser that automatically analyzes thousands of messages in what he terms "very large-scale conversation," or VLSC, occurring on listservs and Usenet newsgroups. For Sack, the unprecedented scale of such conversations required a new model of analyses, one that bridged the macro and micro levels of conversation—a computational tool stemming from the field of discourse architecture. Though the resulting website can be used like a typical electronic news or email program, the system is capable of analyzing content and exhibiting the social and semantic relationships between messages, making large-scale conversations comprehensible to the user. Functioning as a kind of thesaurus of a group conversation, the project reveals the themes and terms used among and produced by participants. With its simplified aesthetic, the project gestures toward the look of the early internet while anticipating the use of tag clouds and other current forms of data visualization.

Conversation Map presents three panels of interrelated dimensions: social networks (the interpersonal relationships, or who is corresponding with whom), themes (the textual content, a menu of discussion themes embodied in the messages), and semantic network (equivalent terms under discussion by the group). These three aspects are cross-linked; clicking on one panel highlights terms in the others, and clicking on a theme highlights the part of the social network in which participants have discussed that theme. The maps can also be used to access message archives.

This online work has been used to represent the terms of the debate, including media and collective discussions, regarding political candidates in American presidential elections. The maps it generates function not only as tools, but also, notes Sack, as "a technology of the self"—a means of group self-reflection and discussion that predates the rise of the blogosphere. —*TZ*

155 *Conversation Map* 2000 / Online project (http://people.ucsc.edu/~wsack/ conversationmap) / Courtesy the artist

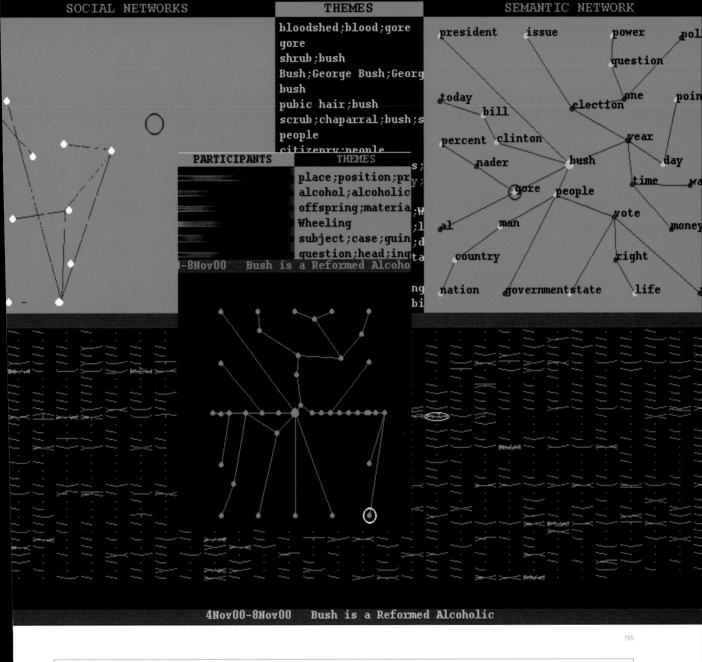

156 **Giselle Beiguelman** *Poétrica* 2003–4 / Installation view at the Kurfürstendamm, Berlin, 2004 / Interactive electronic billboard / Courtesy the artist

Poétrica involves a series of "teleinterventions" into the urban land-scape: visual poems publicly displayed in a variety of ways, including on commercial electronic billboards and as movie trailers. The public composes and submits messages via the internet or SMS; these texts are translated into fonts composed of dingbats and system characters, exploring new boundaries of nonphonetic language. For Beiguelman, *Poétrica* has "a political agenda not only because you hack the adver-tisement structure and use this as part of your public space, but also because [it] question[s] the role of the author and the work of art aura." —TZ

MATTHIAS GOMMEL

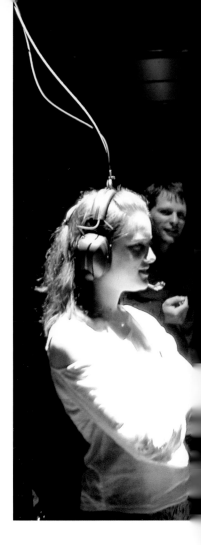

Dangling from the ceiling, two spotlit headsets invite visitors to enter into dialogue. Microphones record the participants' speech and channel it to the headphones. Although the other person is audible, a three-second delay impedes clear communication. Gommel describes the experience of *Delayed* (2002; pl. 157) as the perception of one's own act of speech being detached from its execution.

A founding member of the robotlab collective, the German artist investigates interactivity, communication between man and machine, and the impact of digital processes on physical space. *Delayed* revisits notions of feedback that were introduced by artists in the early 1970s: closed-circuit video installations that not only included the visitor in the picture, in real time, but also explored the very limits of systems of communication. According to cybernetic theory, distortions and delays are fundamental aspects of electronic communication; it is in these delays that perception and awareness are heightened. Building on this history of experimentation with time delay in early media art, *Delayed* also implicates the ubiquity of personal communication technologies today. Despite the continual improvement of cell phone and computer devices, the inevitable delays remind us of technology's failures, a key theme in Gommel's work. Brief glitches and slow responses frustrate our increasing expectation for speed—and ease—in all modes of communication. —*TZ*

157 **Delayed** 2002 / Closed-circuit sound installation / Courtesy the artist

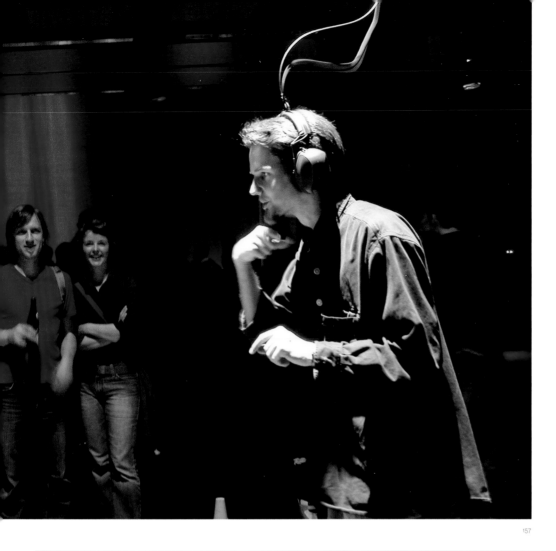

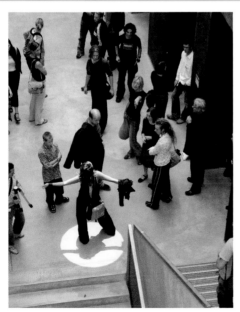

158 **Marie Sester** *ACCESS* 2003 / Installation view at Ars Electronica, Austria, 2003 / Online project (http://www.accessproject.net), custom software and electronics, robotic spotlight and acoustic beam, and cameras / Courtesy the artist

ACCESS is an installation in which visitors to the project website can track individuals in public spaces using a robotic spotlight and acoustic beam system. The spotlight follows the selected individual while the beam projects audio that only he or she can hear. Sester creates "a paradoxical communication loop" between tracker and tracked, both of whom are unaware that they are the only ones triggering or hearing the sound. Instead of choosing to step into the spotlight, the performer appears to be selected by it. Though playful, the installation underscores the omnipresence of surveillance technology in today's society while highlighting our culture's voyeuristic obsession with celebrity. —*TZ*

JANET CARDIFF

Cardiff's audiovisual narrative walking pieces conflate cinematic fiction with the physical immediacy of moving in real time and space. From Central Park to the Carnegie Library, the artist has created unique site-specific tours that propose an alternate reality for each location, revealing an artistic approach to psychogeography.

The Telephone Call (2001; pls. 159–66) is an immersive itinerary through the San Francisco Museum of Modern Art. After checking out a digital camcorder and headphones, visitors synchronize their movement through the museum with the staged journey depicted on the small screen. Cardiff chose these handheld recording devices because of their ease of use. At a moment when many artists working with video chose to approach narrative through projection, Cardiff's singular use of a mobile display format pushed the medium out of the paradigm of the black box installation. Her tours are only fully realized through the active participation of viewers and their navigation of the physical environment.

Cardiff narrates her stories with stream-of-conscious monologues, which could not be further removed from the didactic discussion of artworks that characterizes the typical museum audio tour. Her imagery considers the entire context, from exhibition galleries to public areas to the interstitial spaces that link them and guide the flow of visitor traffic. Cardiff's soundtracks collage various ambient sounds and music, but she always uses her own voice to address the audience, thereby establishing an intimate connection. Against the fixed backdrop of SFMOMA's architecture, *The Telephone Call* exposes the disparity between the real and represented flux of visitors and exhibition activity—a haunting reminder that institutions and their collections long outlive the people who visit or work there. —*TZ*

159–66 *The Telephone Call* 2001 / Installation view at the San Francisco Museum of Modern Art, 2008 (pl. 159) / Audio and video walk through the San Francisco Museum of Modern Art: digital video, mini DV camera, and headphones, 17 min. / San Francisco Museum of Modern Art, purchased through a gift of Pamela and Dick Kramlich and the Accessions Committee Fund

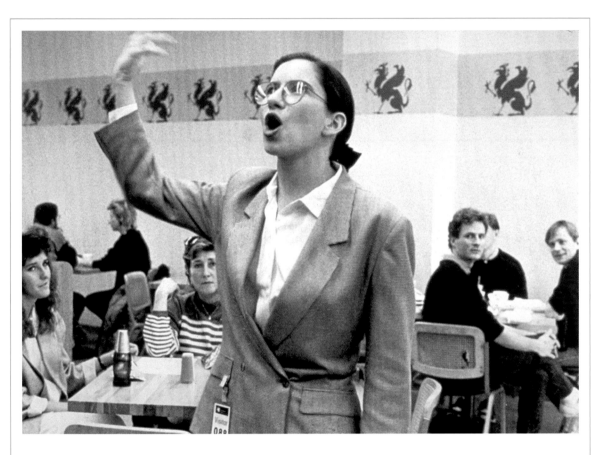

167 **Andrea Fraser** *Museum Highlights: A Gallery Talk*
1989 / Performance at the Philadelphia Museum of Art, 1989 /
Courtesy the artist

In *Museum Highlights: A Gallery Talk,* a famous example of institutional
critique, Fraser posed as a museum docent under the pseudonym
of Jane Castleton and voluntarily led tours offering a verbose run-
ning commentary on everything from the cafeteria to the drinking
fountain. Her script was woven together from a variety of literature,
including a manual on the poorhouse, thereby questioning the
traditional role of the museum as an arbiter of taste. In recent videos
that feature the artist listening to exhibition audio tours, Fraser has
continued to demonstrate how art institutions perform for their audi-
ences, letting the museum speak for (and hang) itself. —*TZ*

LYNN
HERSHMAN
LEESON

Pioneering the presentation of art in alternative spaces has been a characteristic strength of Hershman Leeson's practice for more than three decades, from her early performance and site-specific installations to her recent network activity. Nearly all of her work expresses a desire for public interaction and an interest in the construction of identity (her own or that of fictional others) via photography, diaries, and other forms of documentation. The San Francisco–based artist recently teamed up with the Stanford Humanities Lab to revisit parts of her working archive (1966–2002) that were acquired by the university. Their first project has focused on reconfiguring the artifacts of her historic project *The Dante Hotel* (1973–74) in the multiuser virtual environment of Second Life (see figs. 29–30, pls. 168–70). Entitled *Life²,* this experiential digital archive broadens the audience for Hershman Leeson's work while reflecting on the fragmentary nature of memory. Indeed, the project coincides with increasing public demand for records and archival material to be made accessible on the internet.

The original installation of *The Dante Hotel* proposed that visitors directly experience a fictional world in real time and space. Occupying a rented room in a residential hotel in San Francisco's North Beach district, the project was open twenty-four hours a day for nine months. Viewers checked out a key and entered the room to discover signs of life of the "occupants": sleeping wax figures, recorded sounds, and fictional personal belongings. Mannequins populated the artist's other tableaux from this critical period, appearing in public venues such as New York's Chelsea Hotel and Bonwit Teller store windows. Her use of doll bodies foreshadowed her later work with artificial intelligence agents that attempt to converse with real people. In a related development, Roberta, a female persona that originated with the durational performance work *Roberta Breitmore* (1974–78) and was resurrected as the telerobotic doll *CyberRoberta* (1995–98), has been reborn once more as an avatar host for *Life².*

Second Life also serves as a venue for the artist to reflect on the exhibition of her work; there she will digitally relocate documentation of *Lifeⁿ*, a yearlong exhibition series that is jointly organized by six major Bay Area art institutions and includes the SFMOMA presentation of *Life².* Currently under expansion, with neighboring gallery wings being added to house other past projects, *Life²* offers a dynamic new model for the archive and the museum. —*TZ*

168–70 *Life²* 2006–present / Online
project (http://slurl.com/secondlife/
NEWare/128/128/0) / Collection of the artist
171 *The Dante Hotel* 1973 / Collage with
photographs, ink, and stickers / 13 × 17 in. /
Collection of the artist

171

172–73 **Eva and Franco Mattes aka 0100101110101101.org**
Synthetic Performance 2007 / Second Life reenactments of VALIE
EXPORT's *TAPP- und TASTKINO* (TAP and TOUCH CINEMA, pl. 172)
and Vito Acconci's *Seedbed* (pl. 173) / Courtesy Postmasters Gallery,
New York

The *Synthetic Performance* series translates seminal works such as
VALIE EXPORT's *TAPP- und TASTKINO* (TAP and TOUCH CINEMA,
1968; pls. 49–50), Abramović/Ulay's *Imponderabilia* (1977; pls. 52–55),
Chris Burden's *Shoot* (1971), Vito Acconci's *Seedbed* (1972), and Joseph
Beuys's *7000 Eichen* (7000 Oaks, 1982–87; pl. 78) into the virtual realm
of Second Life. Avatars perform these historic, often bodycentric
actions for an audience of other avatars. The series raises questions
about the meaning of certain performances when recontextualized—
not only by other artists, but also online. Wrested from the specificity
of time, place, and performer, these reenactments reflect a generation
of contemporary new media artists responding to the powerful legacy
of conceptualism. —*TZ*

172

173

DAN PHIFFER
MUSHON ZER-AVIV

Attracted to the idea of creating a platform or environment for online participation, artists have permeated the realm of the internet since its inception. *The Thing* (http://www.the-thing.org, 1992–present) and *Rhizome* (http://rhizome. org, 1996–present) are but two examples in which networking and information are prioritized as artistic strategies. Many such platforms have attempted to act against the tendency of closed and centralized systems to channel user interaction. Today, in the age of social networking, community-oriented software art typically involves artists, designers, and programmers who collaborate to counter the dominant forces of the online market. Among the simplest and most effective recent examples of this approach is the work of Phiffer, a California hacker and activist, and Zer-Aviv, a New York–based artist. Their project *ShiftSpace* (2007–present; pl. 174) proposes an alternative way of processing online information. "By pressing the [shift] + [space] keys, a *ShiftSpace* user can invoke a new meta layer above any web page to browse and create additional interpretations, contextualizations and interventions—which we call Shifts," they write. Users can choose between several authoring tools ("Spaces") that allow them to annotate or modify the content of a page and, through *ShiftSpace,* share that shift with the rest of the web. "Trails" are maps of shifts that create metalayer navigation across websites. A transparent layer allows users to intervene by posting notes or swapping images.

In the spirit of alternative platforms, the tools available on *ShiftSpace* are developed as open-source projects. Inspired by the Wikipedia model of collective authorship, Phiffer and Zer-Aviv also reach out to the larger community of developers and media activists by granting commissions for further development. Repurposing tools and protocols has been a significant artistic strategy for decades, from early video synthesizers to Radical Software Group's appropriation of the FBI's Carnivore surveillance software (see pls. 175–76). In the field of media art, the call for participation often hides a more conceptual gesture that tends simply to change the visual parameters of a given set of data—a strategy that led to the so-called browser art of the 1990s. With *ShiftSpace,* however, there is an actual use value and a collective productivity that cannot be underestimated. —*RF*

174 ***ShiftSpace*** 2007–present / Online project (http://www.shiftspace.org/rhizome) / Courtesy the artists

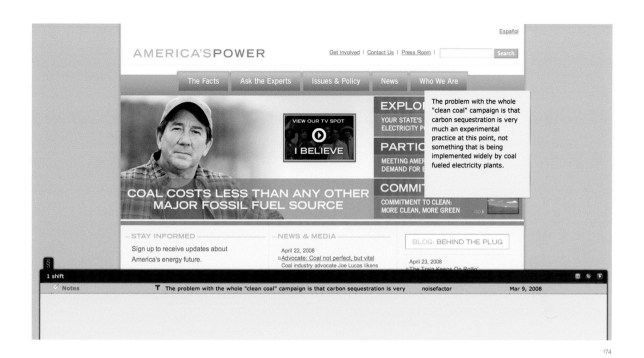

174

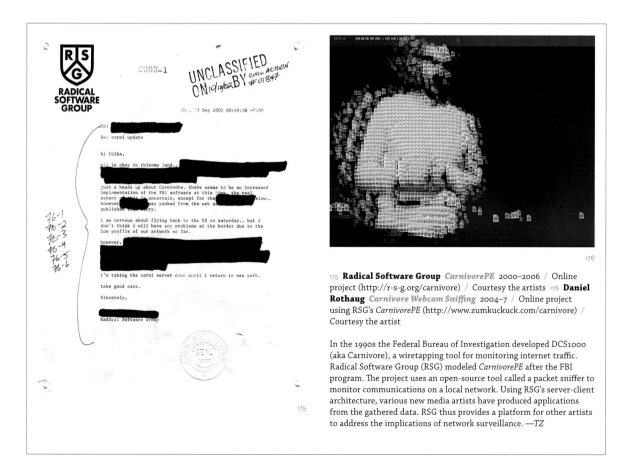

175 **Radical Software Group** *CarnivorePE* 2000–2006 / Online project (http://r-s-g.org/carnivore) / Courtesy the artists 176 **Daniel Rothaug** *Carnivore Webcam Sniffing* 2004–7 / Online project using RSG's *CarnivorePE* (http://www.zumkuckuck.com/carnivore) / Courtesy the artist

In the 1990s the Federal Bureau of Investigation developed DCS1000 (aka Carnivore), a wiretapping tool for monitoring internet traffic. Radical Software Group (RSG) modeled *CarnivorePE* after the FBI program. The project uses an open-source tool called a packet sniffer to monitor communications on a local network. Using RSG's server-client architecture, various new media artists have produced applications from the gathered data. RSG thus provides a platform for other artists to address the implications of network surveillance. —*TZ*

JONAH BRUCKER-COHEN MIKE BENNETT

BumpList [pls. 177–78] *is a mailing list aiming to re-examine the culture and rules of online email lists.* BumpList *only allows for a maximum amount of subscribers so that when a new person subscribes, the first person to subscribe is "bumped," or unsubscribed from the list. Once subscribed, you can only be unsubscribed if someone else subscribes and "bumps" you off.* BumpList *actively encourages people to participate in the list process by requiring them to subscribe repeatedly if they are bumped off.* —Jonah Brucker-Cohen and Mike Bennett

The artists' description of their project is straightforward but not without black humor. In order for the community to sustain itself, its members must operate in silence and exclusivity. Only six members at a time can be part of this elite in-group. If anyone new joins, the listserv automatically eliminates whoever has been on the list the longest—a strictly democratic principle but hardly an appropriate way to advance democratic society. The project does not attempt to resolve this contradiction, but rather thrives on Darwinian selection: those who persist and resubscribe will eventually prevail.

Whereas many net artworks have aged rapidly due to their reliance on specific software, *BumpList: An email community for the determined* has maintained its radical impact. Launched in 2003 as part of the Whitney Museum of American Art's online exhibition *Artport,* it has since garnered several awards. The project reflects the widespread disillusionment caused by the first crash of internet hype around 2000, when the utopian promise of freedom of information was effectively shattered. This led to a scrutiny of the processes by which online communities and mailing lists are formed, and a critique of the gap between their inclusive rhetoric and their actual function of exclusion. Brucker-Cohen and Bennett reacted with an ironic strategy of "deconstructing networks." It should come as no surprise that any open forum is maintained by a dedicated core of active participants, but to forge a true community is and always will be a matter of persistence, stubbornness, and serendipity. —RF

177–78 *BumpList: An email community for the determined* 2003 / Online email list (http://www.bumplist.net) / Courtesy the artists

179 **Aaron Koblin** *The Sheep Market* 2006–present / Online project (http://www.thesheepmarket.com) / Courtesy the artist

Anybody can draw sheep; anybody can participate. When it is so simple, many will actually do it. In 2006 Koblin hired thousands of workers on Amazon's Mechanical Turk service, paying each of them two cents to "draw a sheep facing left." The result is a collection of almost ten thousand sheep, submitted over a period of forty days, that illustrates the collective force of networked capitalist economies. The average wage per hour was sixty-nine cents, and the average time spent on a single sheep was 105 seconds. Today the sheep are available for sale in the form of adhesive stamps: unique sets of twenty sheep retail for twenty dollars. —RF

BUMPLIST

subscribes | bumped | re-subscribes
47961 47957 46644

AN EMAIL COMMUNITY FOR THE DETERMINED

BumpList is a mailing list aiming to re-examine the culture and rules of online email lists. BumpList only allows for a maximum amount of subscribers so that when a new person subscribes, the first person to subscribe is "bumped", or unsubscribed from the list. Once subscribed, you can only be unsubscribed if someone else subscribes and "bumps" you off. BumpList actively encourages people to participate in the list process by requiring them to subscribe repeatedly if they are bumped off. The focus of the project is to determine if by attaching simple rules to communication mediums, the method and manner of correspondences that occur as well as behaviors of connection will change over time.

>>> SUBSCRIBE HERE >>>>>>>

[subscribe field] [Subscribe!]

Date/Time of Post	Duration of time on BumpList	Subject of Message
Sun, Oct 19 16:58:47 2003	42 days, 07 hours, 50 minutes	[BumpList] I WONDER WHAT sTEVE DID BEFORE THE LIST?
Sun, Oct 19 16:55:52 2003	42 days, 07 hours, 50 minutes	[BumpList] STEVE COME FROM A LARGE FAMILY
Sun, Oct 19 16:53:13 2003	42 days, 07 hours, 50 minutes	[BumpList] A GREAT STEVE RECYCLE
Sun, Oct 19 16:50:57 2003	42 days, 07 hours, 50 minutes	[BumpList] STEVE RECYCLED
Sun, Oct 19 16:47:52 2003	44 days, 06 hours, 08 minutes	[BumpList] make it a grope effort and I'm in!!!!!
Sun, Oct 19 16:46:26 2003	42 days, 07 hours, 50 minutes	[BumpList] FRM STEVE AND ANNETTE

BUMPLIST ACTIVITY

STATS Check out BumpList Stats including: Who's On, Hall of Fame, Personal Stats, and more soon!

FAQ Frequently Asked Questions: Everything you wanted to know about BumpList and more!

BUMPMANIA! BumpList in the press, blogs, related links, store and more coming soon!

CREDITS Design/Concept - Jonah Brucker-Cohen | Technical/Concept - Mike Bennett | Copyright 2003
JBC/HC/MLE/TCD - For more info see: http://www.coin-operated.com/projects

177

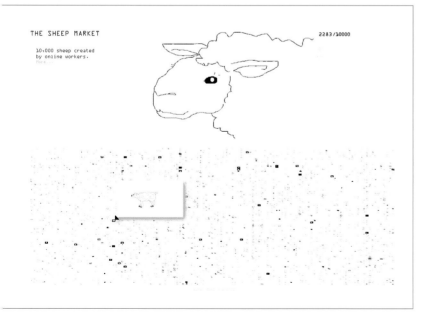

THE SHEEP MARKET

10,000 sheep created
by online workers.
More

2283/10000

WHO'S ON?

Subscriber	Duration of time on BumpList	Posts	Subscribes	Bumps	Resubscribes
Michael714	59 days, 04 hours, 43 minutes	931	4075	4074	4074
blanco	59 days, 00 hours, 44 minutes	498	4112	4111	4111
AHRFLL	42 days, 07 hours, 51 minutes	3205	3531	3531	3531
mikko	28 days, 13 hours, 17 minutes	67	1932	1931	1931
narlis	19 days, 09 hours, 51 minutes	204	1607	1606	1606
j.kuns	7 days, 14 hours, 47 minutes	0	390	389	389

HALL OF FAME

TIME

Subscriber	Duration of time on BumpList	Description:
Michael714	59 days, 04 hours, 43 minutes	Time is a measure of the total duration a person has spent subscribed to BumpList. Everytime they subscribe, their current time is added to their total time spent on the list.
blanco	59 days, 00 hours, 44 minutes	
xraymilavich	44 days, 06 hours, 08 minutes	
AHRFLL	42 days, 07 hours, 51 minutes	
steve.shaffer	41 days, 16 hours, 39 minutes	
Jonah	38 days, 04 hours, 06 minutes	
CrisisOntr	34 days, 07 hours, 43 minutes	
mikko	28 days, 13 hours, 17 minutes	

POSTS

Subscriber	Total Number of Posts	Description:
AHRFLL	3205	Posts are the total number of posts a person has sent to BumpList, of course any posts sent when they were bumped off were rejected and aren't counted.
Steve Shaffer	2644	
jim_klediner	1671	
xraymilavich	1389	
CrisisOntr	1415	
Michael714	931	
burper	877	
mark	763	

BUMPS

Subscriber	Bumps	Description:
steve.shaffer	4497	Bumps are the number of times each person was bumped off the mailing list by someone else signing up.
blanco	4111	
Michael714	4074	
AHRFLL	3531	
CrisisOntr	3195	
jim_klediner	2153	
mikko	1931	
narlis	1606	

178

187

RAQS MEDIA COLLECTIVE

In 1992 the Delhi-based documentary filmmakers Jeebesh Bagchi, Monica Narula, and Shuddhabrata Sengupta formed Raqs Media Collective, a cooperative whose work ranges from media art and installations to cultural criticism and curatorial activities. Their name is derived from the Persian, Arabic, and Urdu words for "dance" and the Sufi ritual of whirling; they also like to point out that in English it is an acronym for "rarely asked questions." Fundamental to their practice are the ideas behind the Sarai in Delhi, cofounded in 2000 (with the Centre for the Study of Developing Societies) as a communal space for media production and independent research that is open to the public. *Sarai* is a Mughal Empire term denoting a refuge for travelers—a place where pilgrims engaged in discussion, dance, theater, music, and other restorative divertissements. Raqs has reinterpreted the concept for the twenty-first century, proposing it as a resting place for new media nomads, with an emphasis on hospitality. In 2003 the artists collaborated with the Tokyo-based architecture firm Atelier Bow-Wow on the installation *Temporary Autonomous Sarai* (pl. 180). To encourage cultural exchange among visitors, they used office supplies and other inexpensive, portable materials to build temporary structures, which housed media equipment and computers displaying online works by various international artists. Participants could reconfigure the spatial arrangement and use the supplies as they wished.

Central to Raqs' ethos is the facilitation of minority access to resources such as the internet and computer applications. Their support of the free software culture, or the idea of a "digital commons," is evident on their site Opus (http://www.opuscommons.net). Users can upload media as "source code" to be manipulated by others. Both the original material and the new hybrid work are then accessible. There is similar evidence of remix or mashup in the installation *Please do not touch the work of art* (2006; pl. 181). The common gallery prohibition is cut up, its fragments repositioned several times. The resulting text is self-referential, like a computer program that relies on generating permutations. Raqs claims that "every culture is a 'remix' culture.... There is a tendency to think of 'culture' in a somewhat precious manner, but this overlooks the fact that in another sense, the growth of moulds, fungi and bacteria are also known as cultures. We like to think of culture in its contagious sense." —MP

180 *Temporary Autonomous Sarai* 2003 / Installation view at the Walker Art Center, Minneapolis, 2003 / Packing crates, projectors, paper, wire, fencing material, metal, paint, Post-its, and sound / Courtesy the artists 181 *Please do not touch the work of art* 2006 / Adhesive vinyl and offset lithography / Courtesy the artists

180

PLEASE. DO NOT TOUCH THE WORK OF ART
TOUCH. DO NOT PLEASE THE WORK OF ART
WORK. DO NOT PLEASE THE ART OF TOUCH
PLEASE THE ART OF TOUCH. DO NOT WORK
TOUCH THE ART OF WORK. DO NOT PLEASE
PLEASE WORK NOT. DO TOUCH OF THE ART
DO THE ART OF TOUCH PLEASE. WORK NOT
DO NOT TOUCH THE ART OF WORK. PLEASE
PLEASE DO WORK. TOUCH NOT OF THE ART

182 **Futurefarmers** *The Reverse Ark: The Flotsam & the Jetsam*
2008 / Event at the Pasadena City College Art Gallery, California,
2008 / Courtesy Amy Franceschini

The art and design collaborative Futurefarmers proposes alterna-
tive systems of production, taking a multidisciplinary approach to
environmental and community engagement. Their public projects
often use the workshop or laboratory—a hybrid artistic, educational,
and curatorial model—as an open-source system for playful group
activities centered on creative investigation. *The Reverse Ark: The
Flotsam & the Jetsam* evolved over the course of a four-day residency
at the Pasadena City College Art Gallery, where Futurefarmers worked
with students to assemble an archive of recycled materials. The artists'
concept of building an ark touched on notions of limited resources,
mass transportation, and global warming. —*TZ*

BLANK & JERON
GERRIT GOHLKE

Since 1996 the collaborative internet projects of Joachim Blank and Karl Heinz Jeron have reflected on art's relation to the economy and an increasingly mediated society. Their 1999 project *re-m@il,* for example, was an ironic groupware solution that involved the artists anonymously answering unwanted emails forwarded by online participants. In collaboration with Gohlke, the German artistic duo is now updating the 2001 project *1st Public White Cube* (pls. 183–92) as an online and onsite project for the San Francisco Museum of Modern Art. On a weekly basis, Blank & Jeron will hold an eBay auction of their gallery real estate. "What will be up for bid...won't be ownership of the customary art objects," they note, "but rather the right to alter them." The auctions initiate a series of interventions into existing artworks and the space itself, welcoming destruction as well as creativity.

The group has invited two guest artists—10lb Ape and Ledia Carroll—to separately create art installations for one of the exhibition galleries. Gustavo Herrera and Matt Wardell, on behalf of the Los Angeles–based collective 10lb Ape (see pls. 193–94), will create *Your Mother Was Beautiful Once, Part Drei,* a temporary structure to be altered over the course of four auctions during the first half of the exhibition. Introduced with a performance by the artists, the shack will incorporate detritus and pamphlets found around Los Angeles. The winning bidders cannot remove anything; instead the space will reveal traces of their cumulative changes. The sequence of auctioned changes repeats with Carroll, who will further her topographical investigations of San Francisco with *Sand Dune* (pl. 195), a sand sculpture referencing the region's public beaches. Visitors can track the status of the eight auctions on eBay or the artists' website (http://www. publicwhitecube.com). —*TZ*

183–92 *1st Public White Cube* 2001 / Installation views at Galerie M. Kampl, Berlin, 2001 / Online project (http://www. publicwhitecube.com), eBay auctions, and winning bidders' interventions into mixed-media installations by guest artists Adib Fricke, Peter Friedl, and Torsten Hattenkerl / Courtesy the artists

183

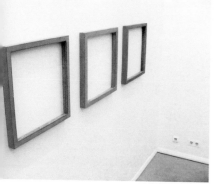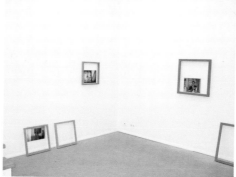

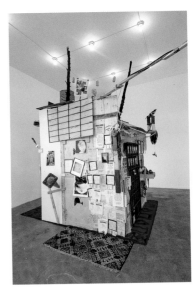

193–94 **10lb Ape** *Your Mother Was Beautiful Once, Part Deux* 2008 / Installation view at Black Dragon Society, Los Angeles, 2008 / Mixed media / Courtesy the artists 195 **Ledia Carroll** *Sand Dune* 2008 / Sand / Courtesy the artist

195

196 **UBERMORGEN.COM** *[V]ote-Auction* 2000/2004 / Online project (http://www.vote-auction.net) / Courtesy the artist and Fabio Paris Art Gallery, Brescia, Italy

The controversial *[V]ote-Auction* project by the Austrians Hans Bernhard and lizvlk allegedly offered Americans the opportunity to auction off their votes in the 2000 presidential election. The online platform was modeled after the server-side technologies and design of online auction services such as eBay. Although the auction website proved to be fictional, it prompted 450 million users to execute several hundred auctions. Not surprisingly, it provoked overwhelming backlash from the mass media and the government, although the resulting legal injunctions were later dropped. With the slogan "Bringing Capital and Democracy Together," this exemplar of digital activism problematized the ways in which big-business campaign contributions undermine state and federal laws against the individual selling of votes. —*TZ*

Step 1:
Please select an option to help us finish the title of this art work...

Automatic For The People

(Good Album by R.E.M or Bad Performance by MTAA)
(Good Album by R.E.M or Bad Performance by MTAA)
(The Manuel For Interaction In Institutions)
(Democracy Live)
(Let Us Now Praise Famous Crowds)
(Vote Early, Vote Often, Vote Undead)
(People For The Automatic)
(Idol Americans)
(Do You Remember Rock and Roll Radio?)
(Generic Performance x 100)
(I Still Blame Bush)

Submit Selection

197

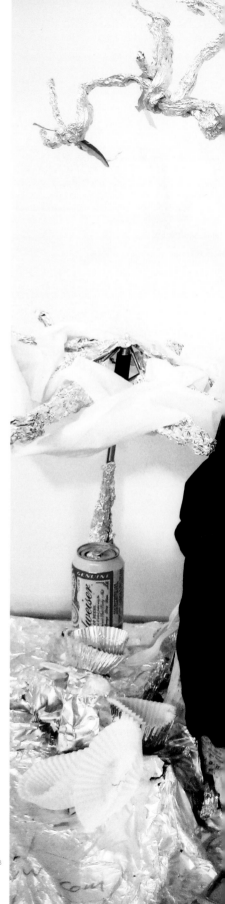

198

MTAA

For more than a decade the Brooklyn-based duo M.River & T.Whid Art Associates (Michael Sarff and Tim Whidden) has created participatory projects that bring performance strategies into the realm of online art, reflecting on the digitization of formerly analog techniques. Their *Updates* series (2001–4), for example, remixes historic durational pieces such as On Kawara's *Today Series* (1966–present) and Tehching Hsieh's *One Year Performance* (1980–81). Software automates and thereby fakes the process, shifting the onus of labor from the artists to the viewers by proposing that they visit the website over the course of a year.

The artists' strategy of looking at how online communities affect the production and distribution of art also extends to the gallery or museum context. *Automatic for the People: ()* (2008; pl. 197) allows online and onsite visitors to participate in the creation of a performance at the San Francisco Museum of Modern Art by voting on ten components, including the artwork's location, props, themes, and subtitle. How MTAA articulates the variables in the poll is as much a part of the piece as the final outcome. Kicked off with a performance lecture, the project culminates with the artists' execution of the "viewers' choice" at the end of the exhibition. "As a system for art production, democracy could be a path to open experimentation or a road to preordained failure," they note. "It's all up to the vote." In a previous piece embracing failure, *10 Pre-Rejected, Pre-Approved Performances* (2005), MTAA presented online a list of performance-based artworks that had been rejected by curators at various venues. The piece chosen by voters involved purchasing a hundred dollars' worth of miscellaneous beer cans, foil, mousetraps, and cupcake wrappers at the nearest deli at midnight. These materials resulted in the ungainly sculpture *Midnight in the Deli* (pl. 198), which was exhibited at Artists Space, New York, with accompanying video documentation. The artists' characteristic sense of humor is at play throughout the SFMOMA poll, which nods to the stereotypes surrounding performance art by offering wardrobe options such as "Definitely not naked" and cultural references like "Marcel Duchamp, chat rooms, ukuleles, and takeout food." *Automatic for the People: ()* encourages us to look at the codes of performance conceptualization rather than just watch the script play out. —TZ

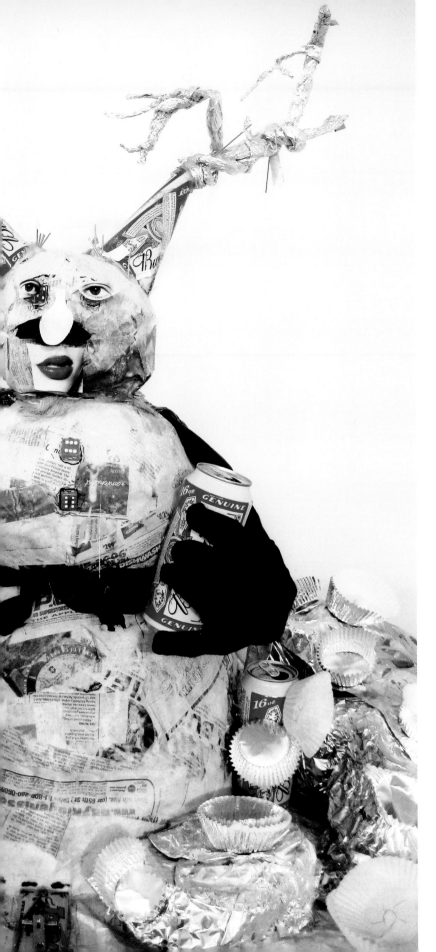

197 *Automatic for the People: ()* 2008 /
Online project (http://mtaa.net/vote)
and performance / Courtesy the artists,
commissioned by the San Francisco Museum
of Modern Art 198 *10 Pre-Rejected, Pre-
Approved Performances: Midnight in the
Deli* 2005 / Installation view at Artists Space,
New York, 2005 / Online poll, video, and
mixed media / Courtesy the artists

199

200

199 **Komar & Melamid** *America's
Most Wanted* 1994 / Oil and acrylic
on canvas / 24 × 32 in. / Private
collection, Moscow, courtesy Ronald
Feldman Fine Arts, New York 200
Komar & Melamid *America's Most
Unwanted* 1994 / Tempera and oil
on canvas / 5½ × 8½ in. / Private
collection, Moscow, courtesy Ronald
Feldman Fine Arts, New York

Vitaly Komar and Alex Melamid devel-
oped their 1994 *Most Wanted* and *Most
Unwanted* paintings by taking a statisti-
cal approach to national aesthetics. They
conducted telephone opinion polls,
posing questions about key qualities of
popular paintings: "Outdoor or indoor
scenes? Realistic or different looking?
Sharp angles or soft curves?" The survey
presented conclusive evidence that the
avant-garde is no match for status quo
aesthetic ideals. Perhaps unsurpris-
ingly, American popular taste gravitated
toward traditional realist genre painting
and the landscape tropes of Sunday
painters; abstraction generally proved
undesirable. —TZ

TOROLAB

The border town of Tijuana, Mexico, is the home of Torolab, an art, architecture, and design group directed and founded by Raúl Cárdenas Osuna. This location, a site between developing and developed nations, is a key inspiration for the collective. Its members often create work that responds to the particular, complex urban environment of the border zone. Cárdenas Osuna, who refers to the group as a "workshop-laboratory," is committed to researching social phenomena that might enhance the quality of life for Tijuana residents. The collective is known for a clothing label, ToroVestimienta, whose line includes multipocketed cargo pants that allow the wearer to hide documents or credit cards when crossing the border. Torolab also creates "emergency architecture," shelters made out of necessity from recycled materials. Another focus of the collective is the facilitation of better community relations.

Since 2001 Torolab has been developing a series of *Work Rooms* at cultural institutions in various locations. The first iterations took place at the Museum of Contemporary Art, San Diego (2001), the Laboratorio Arte Alameda, Mexico City (2003–4; pl. 201), and the Museum of Craft and Folk Art, San Francisco (2007). Cárdenas Osuna and his collaborators worked with security guards stationed in the galleries, creating different roles for them within the museum environment. Torolab provided them with training in DJing, video recording, and video editing and designed an exhibition space where the guards could display their work. The projects turned the institutional space inside out: those guarding it now contributed to what was exhibited. For *Work Room 4* (2008; pl. 202) at the San Francisco Museum of Modern Art, a published Bay Area author will hold a workshop for museum guards and frontline staff. During the course of the exhibition, these volunteers will be invited to contribute writing to a specially designed blog. Torolab gives voice to the observations of those who work behind the scenes, making visible that which is normally unseen. —MP

201 ***Work Room 2*** 2003 / Collaborative project at Laboratorio Arte Alameda, Mexico City, 2003 / Courtesy the artist 202 ***Work Room 4*** 2008 / Collaborative writing project and weblog (http://www.work-room.net) / Courtesy the artist, commissioned by the San Francisco Museum of Modern Art

201

WORKROOM 4.0

SF MOMA <<<<<<<<<<<
SECURITY GUARD NO.9

203 **Surasi Kusolwong** *One Pound Turbo Market (You'll have a good time)* 2006 / Performance and market event at the Tate Modern, London, 2006 / Courtesy the artist

Evoking the economic strategy of floating Asian markets, the Thai artist Kusolwong brings the product to the consumer. Since the mid-1990s (most notably at the 1998 Sydney Biennale), he has installed variations on itinerant markets at a number of international venues. On May 26, 2006, as part of the Long Weekend live arts festival at the Tate Modern, London, Kusolwong presented the performance installation *One Pound Turbo Market (You'll have a good time)*. He filled the museum's vast Turbine Hall with thousands of colorful, mass-produced toys and household goods from Thailand, accompanied by a soundtrack of Thai pop. Flea market and art market converged as visitors bought the imported items for one pound each. —*MP*

RAFAEL LOZANO-HEMMER

The forms of interaction that defined most media art of the 1990s produced many installations that were technically challenging yet lacked the qualities necessary to move and engage viewers on a deeper level. The Mexican media artist Lozano-Hemmer first became known in that decade for staging large-scale interactive installations, works that were not only technologically advanced, but also accessible, poetic, and open to the contribution of the public. Since 1997 his *Relational Architecture* series has addressed such interaction via the bodily presence of passersby (in *re:positioning fear* [1997], for example, which tracked and projected the shadows of visitors and incorporated real-time chats related to the topic of fear), databases (the textual tags projected onto visitors in *Subtitled Public* [2005]), and radio broadcast (as in *Frequency and Volume* [2003], which enabled viewers to use their bodies as surfaces and transmitters of information).

The spoken word, however, has a much stronger physical presence than any projected image or text. Nothing speaks louder than a person who steps up to a microphone onstage under a spotlight. The microphone is the embodiment of public speech, and Lozano-Hemmer's *Microphones* (2008; pls. 204–5) enacts the idea of an invisible stage. In this interactive installation vintage 1939 Shure microphones are placed on stands at different heights; each microphone has been modified so that its head contains a tiny loudspeaker and a circuit board connected to a network of hidden computers. When someone speaks into a microphone, it records his or her voice and immediately plays back a recording of a previous participant, as an echo of the past and a memory of all recordings made during the exhibition. The microphone "talks back," creating a situation in which participants can overcome the urge to sound test the equipment and instead productively engage with the installation, leaving an acoustic trace or joining others in the aural equivalent of a surrealist game of "exquisite corpse." All content is generated entirely by the participation of the public and is stored as a memento of a specific period in time. The gallery in turn becomes a stage, a recording studio, a listening device, a platform for interaction. —*RF*

204–5 *Microphones* 2008 / Interactive installation with modified microphones, computers, electronics, and custom software / Courtesy the artist

204

205

206 **Scott Snibbe** *Blow Up* 2005 / Installation view at Yerba
Buena Center for the Arts, San Francisco, 2005 / Aluminum, steel,
commercial fan parts, motors, impellers, custom electronics, and
software / Courtesy the artist

One of the San Francisco Bay Area's most active media artists, Snibbe
has produced a series of interactive installations that visualize
relationships between participants. *Blow Up* invites the viewer to blow
into a set of twelve small impellers, which "record," amplify, and play
back his or her exhalation on a wall of twelve large fans. The fans con-
tinue to play back the last breathing pattern until someone inspires a
new one. What starts as the minimal movement of breathing is trans-
lated into a powerful wind, physically challenging other visitors. —RF

Notes to Plate Entries

Page 82 *didn't tell people what to do* Conversation between John Cage and Alan Gillmor (1976), quoted in *Conversing with Cage,* ed. Richard Kostelanetz (New York: Limelight, 1988), 74.

82 *divine influences* Cage appears to have picked up this idea from an Indian student in the 1940s. See Larry J. Solomon, "The Sounds of Silence: John Cage and 4′33″," http://solomonsmusic.net/4min33se.htm (accessed June 24, 2008).

82 *mirrors of the air* John Cage, *I–VI,* Charles Eliot Norton Lectures, 1988–89 (Cambridge, MA: Harvard University Press, 1990), 26.

82 *video documentation of Cage performing* See also footage of David Tudor, http://www.youtube.com/watch?v=HypmW4Yd7SY&feature=related, and Lawrence Foster conducting the BBC Symphony Orchestra in 2004, http://www.ubu.com/film/cage_433.html and http://www.youtube.com/watch?v=3fYvfEM UJl8&feature=related (accessed May 25, 2008).

84 *two colors at once* Robert Rauschenberg, in *Rauschenberg: An Interview with Robert Rauschenberg,* by Barbara Rose (New York: Vintage, 1987), 23, quoted in Peter Gena, "Cage and Rauschenberg: Purposeful Purposelessness Meets Found Order," in *John Cage: Scores from the Early 1950s* (Chicago: Museum of Contemporary Art, 1992), available online at http://www.petergena.com/cageMCA.html.

86 *a painting made by chance* George Brecht, in "An Interview with George Brecht by Irmeline Lebeer," *Art Vivant* (Paris), May 1973, quoted in *An Introduction to George Brecht's Book of the Tumbler on Fire,* by Henry Martin (Milan: Multhipla, 1978), 83.

86 *how I interact with them* Brecht, interview with Henry Martin in *Art International* (Lugano), November 1967, quoted in Martin, *An Introduction,* 38.

89 *the first proto-happenings* Allan Kaprow, interview with John Held Jr. (1988), http://www.mailartist.com/johnheldjr/InterviewWithAlanKaprow.html (accessed June 25, 2008).

89 *happening* Allan Kaprow, "The Legacy of Jackson Pollock," *ARTnews* 57, no. 6 (October 1958): 57.

90 *mine or somebody else's* Andy Warhol, quoted in David Bourdon, *Warhol* (New York: Abrams, 1989), 100.

91 *without being either one* Dan Graham, "Other Observations" (1969), in *Dan Graham, Works 1965–2000* (Düsseldorf, Germany: Richter Verlag, 2001), 97.

94 *each other's work and personality* Brecht, in Martin, *An Introduction,* 86.

98 *Robot K-456* Playing audiotaped speeches by John F. Kennedy and defecating beans as it walked along a Manhattan sidewalk, Nam June Paik's robot was featured in the first performance of the artist's *Robot Opera* (1964) at the Avant Garde Festival that year. It also interacted with the public during *24-Stunden* (24 Hours), a happening at Galerie Parnass, Wuppertal, Germany, in 1965 (see pls. 14, 26). See John G. Hanhardt, *The Worlds of Nam June Paik* (New York: Guggenheim Museum, 2000), 37.

101 *a sound dialogue* Max Neuhaus, "Rundfunkarbeiten und Audium," in *Transit* (Vienna: Zeitgleich, 1994), 21–23, quoted by Golo Föllmer, http://www.medienkunstnetz.de/works/public-supply-i/ (accessed June 17, 2008).

102 *WGBH* This Boston public television station, an early supporter of video art, frequently commissioned and aired experimental videotapes. The artists-in-residence program, WGBH New Television Workshop, started in 1967 but was not formally named until 1974. It began with *The Medium Is the Medium* and later supported artists such as Stan VanDerBeek, Peter Campus, and William Wegman. See http://www.experimentaltvcenter.org/history/groups/gtext.php3?id=99 (accessed June 10, 2008).

102 *remote locations* See Gene Youngblood, "Closed-Circuit Television and Teledynamic Environments," *Expanded Cinema* (New York: Dutton, 1970), 343.

102 *goodbye to himself* Allan Kaprow, "Hello Plan and Execution," *Art-Rite,* no. 7 (1974): 17.

103 *Minucode* For one journalist's description, see Gerald Jonas, "The Talk of the Town: Environment," *The New Yorker,* June 22, 1968, 22.

104 *enter the painting* Lygia Clark (1986), quoted in *Lygia Clark* (Barcelona: Fundació Antoni Tàpies, 1997), 22.

104 *two living organisms* Lygia Clark, from "Bichos," in *Livro-obra* (Rio de Janeiro, 1983), quoted in *Lygia Clark,* 121.

104 *meaning of our routine gestures* Lygia Clark, in "L'Art: C'est le corps," *Preuves* (Paris), no. 1 (1973): 140–43, quoted in *Lygia Clark,* 188.

108 *quiet and beautiful movements* Yoko Ono, from a 1990 interview quoted in Barbara Haskell and John G. Hanhardt, *Yoko Ono: Arias and Objects* (Salt Lake City: Peregrine Smith, 1991), 91.

110 *VALIE EXPORT* In 1967 the artist changed her name from Waltraud Lehner Höllinger, rejecting both her father's name (Lehner) and her former husband's (Höllinger) for a pseudonym declared in all capitals, thereby choosing her own identity. She chose VALIE for feminity and EXPORT for its marketing connotations (Smart Export was a popular Austrian brand of cigarettes).

110 *the entrance to the movie house* VALIE EXPORT, http://www.thegalleriesatmoore.org/publications/valie/valietour3.shtml (accessed April 2, 2008).

110 *TAPP- und TASTKINO* The artwork's title and capitalization vary in the artist's documentation of the performance and in later scholarship on the work. The chronology recounted in this catalogue is based on information in *Valie Export* (Vienna: Folio Verlag, 2007), 352, and the virtual tour of *TAPP- und TASTKINO* at http://www.thegalleriesatmoore.org/publications/valie/valietour3.shtml.

110 *the physical experience of the body* In her statement on *TAPP– und TASTKINO,* EXPORT articulated her political stance against the limited public expression of real female sexuality and the images of women produced in a patriarchal culture: "Attributes of women, which our culture turns into objects for the sexuality of men, have been directly abolished and taken out into the streets in a form that breaks the rules of society. The state allows the tactile and visual experience of sexuality only in the privacy of family and home.... This process of liberation is woman's first step from object to subject. She is free to dispose of her bosom, and no longer obeys social precepts. Since everything takes place on the street, and the consumer can be anybody, man or woman, this is an undisguised raid on the taboo of homosexuality. Since a bosom is no longer a male chattel, since woman now disposes of it independently, the morality of state precepts (state, family, ownership) is undermined." Quoted at http://www.thegalleriesatmoore.org/publications/valie/valietour3.shtml. (accessed April 2, 2008)

110 *Stachus square in Munich* EXPORT performed the work here as part of the First European Meeting of the World's Independent Filmmakers, organized by the Independent Film Center at Munich's Künstlerhaus.

110 *remaining performances* In 1977–78 EXPORT's second cinema box was lost after touring with the exhibition *Film als Film—1910 bis heute* at the Kölnische Kunstverein, Cologne (November 1977–January 1978); the Akademie der Künste, Berlin (February–March 1978); the Museum Folkwang, Essen (April–May 1978); the Württembergischer Kunstverein, Stuttgart (June–July 1978); and the Institute of Contemporary Art, London (May–June 1979). Reconstructions of the first and second versions were created for *Out of Actions: Between Performance and the Object, 1949–1979,* at the Museum of Contemporary Art, Los Angeles (August 2–October 5, 1998); these replicas were acquired in 1999 by the Generali Foundation, Vienna.

112 *which one of us to face* Ulay/Abramović: Performances, 1976–1988 (Eindhoven, Netherlands: Stedelijk Van Abbemuseum, 1997), 350.

112 *determining human contact* Ibid., 13.

116 *Following Piece* Vito Acconci performed this activity in various Manhattan locations under the auspices of *Streetworks IV,* sponsored by the Architectural League of New York (October 3–25, 1969). See *Vito Acconci: Diary of a Body, 1969–1973* (Milan: Charta, 2006), 76–83.

116 *Seedbed* Acconci's action was performed twice per week, eight hours each day, at the Sonnabend Gallery, New York (January 15–29, 1972). See ibid., 286.

116 *apartment to a gallery* Titled *Room Piece (Room Situation: A Situation Using Room),* Acconci's activity/installation took place at varying times each day over three weekends at Gain Ground Gallery, New York (January 1970). See ibid., 146–57.

116 *guarded as art objects* Acconci's *Service Area,* an activity performed on various days at irregular times, was featured in the landmark exhibition *Information,* organized by Kynaston McShine for the Museum of Modern Art, New York (July 2–September 20, 1970). See ibid., 188–89.

119 *Catalysis* See Lucy Lippard, "Catalysis: An Interview with Adrian Piper," *The Drama Review: TDR* 16, no. 1 (March 1972): 76–78.

120 *could replace the painting* John Baldessari, quoted in Jan Debbaut, *John Baldessari* (Eindhoven, Netherlands: Van Abbemuseum; Essen, Germany: Museum Folkwang, 1981), 6.

121 *in process* Douglas Huebler, quoted in *Douglas Huebler: Variable, Etc.* (Limoges, France: Fonds régional d'art contemporain Limousin, 1993), 181.

122 *the device of time delay* Dan Graham's closed-circuit video installations frequently make use of five- to eight-second delays, a duration that the artist believes corresponds to the limit of short-term memory.

125 *natural and pedestrian movement* Joan Jonas was taking an experimental dance workshop with Trisha Brown when she staged *Mirror Piece I* (1969) at the Loeb Student Center at New York University. Brown was a member of the pioneering Judson Dance Theater, which included Steve Paxton, Deborah Hay, and Simone Forti. Jonas's performance work also draws from the task-oriented performance of happenings and integrates elements from Japanese Noh and Kabuki theater.

126 *News* When first exhibited in 1969 and 1970, Hans Haacke's installation was presented in two versions, one using a single teletype printer and the other multiple printers. After its Düsseldorf debut, it appeared at New York's Howard Wise Gallery in November 1969, and in 1970 it was part of the exhibition *Software: Information Technology; Its New Meaning for Art,* organized by Jack Burnham for the Jewish Museum, New York (September 10–November 8, 1970).

126 *MOMA-Poll* This Haacke work was presented as part of the 1970 exhibition *Information* at the Museum of Modern Art, New York.

128 *environmental fact* Stephen Willats, "The Random Event" (1961), quoted in Tom Morton, "Networking," *Frieze,* no. 106 (April 2007): 126, available online at http://www.frieze.com/issue/print_article/networking/ (accessed June 10, 2008).

128 *the making of society* Stephen Willats, quoted in Jane Kelly, "Stephen Willats: Art, Ethnography and Social Change," *Variant* 2, no. 4 (Autumn 1997): 20–21, available online at http://www.variant.randomstate.org/issue4.html (accessed May 26, 2008).

130 *art as social sculpture* "The concept of sculpting," wrote Joseph Beuys, "can be extended to the invisible materials used by everyone." Caroline Tisdall, *Joseph Beuys* (New York: Solomon R. Guggenheim Museum, 1979), 72.

130 *the whole work of humanity* Joseph Beuys, *Documenta 6 Satellite Telecast* (1977), quoted at http://www.mediaartnet.org/works/rede-in-der (accessed May 7, 2008).

130 *7000 Eichen* For a full description of Beuys's project, see http://www.diaart.org/ltproj/7000 (accessed May 7, 2008).

134 *The Act of Drinking Beer with Friends* For more on the origins of Tom Marioni's beer salon, see *Tom Marioni: Beer, Art, and Philosophy (The Exhibition) 1968–2006* (Cincinnati: Contemporary Arts Center, 2006), 10.

134 *Action rather than Object as art* Tom Marioni, *Beer, Art, and Philosophy: A Memoir* (San Francisco: Crown Point Press, 2003), 93.

136 *monument to the machine: the automobile* Chip Lord, *Automerica: A Trip Down U.S. Highways from World War II to the Future; A Book by Ant Farm* (New York: E. P. Dutton & Co., 1976), 65.

136 *nomadic truckitecture* Chip Lord, Doug Michels, and Curtis Schreier, "Ant Farm Timeline," in *Ant Farm: 1968–1978,* by Constance M. Lewallen and Steve Seid (Berkeley: University of California Press, 2004), n.p.

136 *important in the fifties* Ibid.

140 *media-based performance* The late 1970s witnessed a number of satellite and telecommunication projects—by figures such as Douglas Davis, Robert Adrian X (see pl. 113), Willoughby Sharp, Keith Sonnier, and Liza Bear, among others—that either featured artists as a part of an event or used recordings of the public to examine the art exhibition context. At the time, video conferencing had not yet reached the masses and satellite was the only viable means of transmitting television-quality video overseas. Since they did not rely on video technology, which was relatively affordable, ambitious satellite projects required considerable coordination with large companies and foundations for support.

140 *a day of rest* Kit Galloway and Sherrie Rabinowitz deliberately inserted an off day during the event, partly as an attempt to sustain an aspect of discovery for unsuspecting participants and partly to thwart art-world insiders.

140 *over twenty years* http://www.ecafe.com/getty/HIS/index.html (accessed April 15, 2008).

143 *The World in 24 Hours* The cities involved in Robert Adrian X's project were Vienna, Frankfurt, Amsterdam, Bath, Wellfleet, Pittsburgh, Toronto, San Francisco, Vancouver, Honolulu, Tokyo, Sydney, Istanbul, and Athens. Each location was called from Linz at 12 p.m. local time; the project thus began at noon (Central European Time) on September 27 and, following the midday sun around the world, ended at noon on September 28. See http://alien.mur.at/rax/BIO/telecom.html (accessed May 7, 2008).

144 *The File Room* This project was initiated by Antoni Muntadas and produced by Randolph Street Gallery in collaboration with the School of Art and Design, University of Illinois at Chicago, and the Department of Cultural Affairs—City of Chicago. The site is maintained by the National Coalition Against Censorship.

144 *National Endowment for the Arts* For a chronology of events related to the censorship of artists, notably Robert Mapplethorpe, Andres Serrano, David Wojnarowicz, and Annie Sprinkle, see Margaret Quigley, "The Mapplethorpe Censorship Controversy," http://www.publiceye.org/theocrat/Mapplethorpe_Chrono.html (accessed June 11, 2008).

144 *TVE: Primer Intento* See the *File Room* case submitted by Muntadas at http://www.thefileroom.org/documents/dyn/DisplayCase.cfm/id/386 (accessed May 26, 2008).

144 *They rule* Josh On, http://www.theyrule.net (accessed May 7, 2008).

148 *the uniqueness of the art object* Many of Felix Gonzalez-Torres's artworks are purely conceptual objects; they exist only in the form of certificates of authenticity and instructions for reproducing endless copies.

148 *eventual disappearance* In conversations with Tim Rollins on April 16 and June 12, 1993, Gonzalez-Torres commented: "In a way this 'letting go' of the work, this refusal to make a static form, a monolithic sculpture, in favor of a disappearing, changing, unstable, and fragile form was an attempt on my part to rehearse the fears of having Ross disappear day by day in front of my eyes." *Felix Gonzalez-Torres* (Los Angeles: A.R.T. Press, 1993), 13.

156 *products and services for free* http://www.irational.org/mvc/corpora.html (accessed May 26, 2008).

158 *the condition of landless people* Francis Alÿs, quoted in Saul Anton, "A Thousand Words: Francis Alÿs Talks About *When Faith Moves Mountains,*" *Artforum* 40 (Summer 2002): 147.

161 *The Battle of Orgreave* In 1984 the National Union of Mineworkers went on strike, a bitter dispute that lasted for more than a year. *The Battle of Orgreave* is a reenactment of one of the strike's most violent confrontations, which occurred at the Orgreave coking plant (it began in a field near the plant and culminated in a cavalry charge through the village). Jeremy Deller's project was orchestrated by Howard Giles, a historical reenactment expert and the former director of English Heritage's event program; was filmed under the direction of Mike Figgis for Artangel Media and Channel 4; and aired by the BBC on October 20, 2002. See http://www.artangel.org.uk/pages/past/01/01_deller.htm (accessed May 26, 2008).

162 *by coincidence I became a sculptor* This and all quotes by Erwin Wurm are from *Erwin Wurm: The Artist Who Swallowed the World* (Ostfildern, Germany: Hatje Cantz, 2006).

166 *a collective memory . . . [a] self-portrait* Jochen Gerz, unpublished exhibition notes compiled by Le Fresnoy, Studio national des arts contemporain, Tourcoing, France, ca. 2000 (author's translation).

168 *Je et Nous* For more on Sylvie Blocher's work (including stills showing other volunteers' T-shirts), see Rudolf Frieling, *New Work: Sylvie Blocher*, exhibition brochure (San Francisco: San Francisco Museum of Modern Art, 2007).

168 *Campement Urbain* The interdisciplinary collective was founded in 1997 by Blocher and the urban planner François Daune. See http://www.campementurbain.org (accessed June 27, 2008).

172 *Usenet newsgroups* Usenet is a computer network communications system established in 1980. It is still in widespread use, though its cultural significance has diminished with the rise of internet forums, weblogs, and mailing lists.

172 *discourse architecture* Warren Sack's project furthers ideas from the social sciences by using methods from art and design; he devises networked environments that support conversation, discussion, and exchange between individuals. See Sack, "Discourse Architecture and Very Large-Scale Conversations," in *Digital Formations: IT and New Architectures in the Global Realm*, ed. Robert Latham and Saskia Sassen (Princeton, NJ: Princeton University Press / Social Science Research Council, 2005), available online at http://hybrid.ucsc.edu/SocialComputingLab/publications.htm (accessed May 24, 2008; see in particular page 30).

172 *email program* *Conversation Map* is used like conventional programs such as Eudora and Netscape Messenger. The software arrived after the emergence of Mosaic and other graphical browsers, which altered how users could comprehend what was happening on the internet.

172 *a technology of the self* Sack, 30.

173 *Poétrica* Giselle Beiguelman's artwork was presented in São Paulo in 2003 and in Berlin in 2004. See http://www.poetrica.net.

173 *the work of art aura* Giselle Beiguelman, in Kanarinka, "Interview with Giselle Beiguelman," http://rhizome.org/discuss/view/11431 (accessed May 7, 2008).

175 *a paradoxical communication loop* Marie Sester, http://www.accessproject.net/concept.html (accessed May 26, 2008).

176 *The Telephone Call* Janet Cardiff's video walk was originally commissioned for the exhibition *010101: Art in Technological Times* at the San Francisco Museum of Modern Art (March 3–July 8, 2001).

179 *Museum Highlights: A Gallery Talk* See Andrea Fraser, *Museum Highlights: The Writings of Andrea Fraser*, ed. Alexander Alberro (Cambridge: MIT Press, 2005), 95–114.

179 *speak for (and hang) itself* In *Little Frank and His Carp* (2001), Fraser humorously takes the Guggenheim Museum Bilbao up on its offer, via the audio tour, to touch the sensuous curves of Frank Gehry's architectural attraction. See ibid., 233–60.

180 *The Dante Hotel* Lynn Hershman Leeson's installation of mixed-media objects, wax figures, and audio was housed in a room at a low-rent hotel in San Francisco from November 30, 1973, through August 31, 1974. She rented room 47; room 43 was taken by her friend Eleanor Coppola, who hired another friend, Tony Dingman, to live in the space and be watched. Nine months after Hershman Leeson's room opened to the public, a 3 a.m. visitor mistook the wax bodies to be corpses and phoned the police, who seized the room's contents and took them to central headquarters. The documentation of the project is now housed in the Department of Special Collections at Stanford University. When *Life²* is exhibited as an installation, the artist presents selected documentation from this archive in vitrines, along with computers offering online access to the project.

180 *Life²* Hershman Leeson's digital archive (2006–present), also known as *Life Squared*, is part of "The Presence Project" and is associated with the Metamedia Lab at the Stanford Archaeology Center, part of the Stanford Humanities Lab. Funding for the *Life²* project is provided by the Daniel Langlois Foundation and the Stanford Humanities Lab. See http://presence.stanford.edu:3455/LynnHershman/261 (accessed May 29, 2008).

180 *store windows* Hershman Leeson's *Forming a Sculpture/Drama in Manhattan* was sited at the YWCA, the Chelsea Hotel, and the Plaza Hotel, New York, in 1974. Another New York installation, *25 Windows: A Portrait of Bonwit Teller*, appeared in the department store's display windows from October 28 through November 2, 1976.

184 *which we call Shifts* http://www.shiftspace.org/rhizome (accessed May 26, 2008).

186 *if they are bumped off* http://www.bumplist.net (accessed May 26, 2008).

188 *digital commons* See Mike Caloud's interview with Raqs Media Collective, posted April 18, 2002, http://rhizome.org/discuss/view/30122/#3465 (accessed June 23, 2008).

188 *culture in its contagious sense* Raqs, interview with Johan Pijnappel, in *Icon: India Contemporary* (New York: Bose Pacia, 2005), 51.

189 *Futurefarmers* Founded in 1995 by the San Francisco–based new media artist Amy Franceschini, Futurefarmers has a variable composition of collaborators for different projects. Franceschini and two core Futurefarmers associates, Michael Swaine and Stijn Schiffeleers, organized *The Reverse Ark: The Flotsam & the Jetsam* during their 2008 residency at Pasadena City College, California. For more on the project, see http://www.futurefarmers.com/reverseark (accessed June 20, 2008).

190 *1st Public White Cube* The first iteration of this project was part of a 2001 solo exhibition at Galerie M. Kampl, Berlin, featuring installations by guest artists Adib Fricke, Peter Friedl, and Torsten Hattenkerl.

190 *the right to alter them* Blank & Jeron, http://www.publicwhitecube.com (accessed May 26, 2008).

193 *[V]ote-Auction* After the Chicago Board of Elections Commissioners filed a lawsuit against the creators of the project—then known as [V]ote-auction.com—on October 8, 2000, the Circuit Court of Cook County, Illinois, issued an injunction against the website, naming the company that registered the domain as a codefendant. The domain company promptly shut it down. A week later the project reappeared as Vote-auction.com, a URL that was cancelled by the Swiss domain name registrar. Today the project, including an archive of legal documents and media coverage, can be found at http://www.vote-auction.net.

194 *Updates* For more on this MTAA work, see http://www.mteww.com/update/ (accessed May 26, 2008).

194 *It's all up to the vote* MTAA, proposal for the exhibition *The Art of Participation* at the San Francisco Museum of Modern Art, February 1, 2008.

194 *10 Pre-Rejected, Pre-Approved Performances* MTAA's project was included in *ARTISTS SPACE: Empty Space with Exciting Events Performance*, presented at Artists Space, New York, in conjunction with *Performa '05* (December 13–17, 2005).

195 *Sharp angles or soft curves?* For a full description of Komar & Melamid's survey and its methodology, see *Painting by Numbers: Komar and Melamid's Scientific Guide to Art*, ed. JoAnn Wypijewski (New York: Farrar Straus Giroux, 1997). The online version of the project, *The Most Wanted Paintings on the Web* (1995), further demonstrated societal faith in numbers; see http://www.diacenter.org/km/ (accessed May 7, 2008).

Catalogue of the Exhibition

The below catalogue represents the best available information at the time of publication. In the case of art collectives, whose composition may change over time, every effort has been made to identify the founding and/or current members contributing to each project. URLs cited herein may change or become invalid after the close of the exhibition.

Abramović/Ulay
Serbian, b. 1946; German, b. 1943

Imponderabilia [compilation version], 1977 (pls. 52–55) / Single-channel black-and-white video with sound, 9:50 min. / Courtesy the artist and Sean Kelly Gallery, New York

Vito Acconci
American, b. 1940

Proximity Piece, 1970, printed 2008 (pls. 58–59) / Digital pigment prints mounted on board / 68 × 22 in. (172.7 × 55.9 cm) / Courtesy Acconci Studio

Francis Alÿs
Belgian, b. 1959
(in collaboration with Rafael Ortega)

Re-enactments, 2001 (pls. 133–38) / Two-channel color video installation with sound, 5:20 min. / Dimensions variable / Courtesy the artist and David Zwirner Gallery, New York

John Baldessari
American, b. 1931

Terms Most Useful in Describing Creative Works of Art, 1966–68 (pl. 62) / Acrylic on canvas / 113¾ × 96 in. (288.9 × 243.8 cm) / Museum of Contemporary Art, San Diego, gift of John Oldenkamp

Joseph Beuys
German, 1921–1986

Intuition, 1968 (pl. 17) / Wood, graphite, and metal staples / 11¾ × 8¼ × 1⅞ in. (29.7 × 21 × 5 cm) / Collection of Dare and Themistocles Michos, San Francisco

La rivoluzione siamo noi (We Are the Revolution), 1972 (pl. 77) / Screen print on polyester with handwritten text, ed. 149/180 / 75³⁄₁₆ × 40⅛ in. (191 × 102 cm) / Collection of Pamela and Richard Kramlich, San Francisco

Excerpt from *Documenta 6 Satellite Telecast*, 1977 (pl. 76) / Single-channel color video with sound, approx. 9 min. / Courtesy Electronic Arts Intermix, New York

Joseph Beuys, Bazon Brock, Rolf Jährling, Ute Klophaus, Charlotte Moorman, Nam June Paik, Eckart Rahn, Tomas Schmit, and Wolf Vostell
German, 1921–1986; German, b. 1936; German, 1913–1991; German, b. 1940; American, 1933–1991; American, b. South Korea, 1932–2006; German, b. 1944; German, 1943–2006; German, 1932–1998

24-Stunden (24 Hours), 1965 (pl. 14) / Offset lithography, plastic, and flour (catalogue of a happening at Galerie Parnass, Wuppertal, Germany, June 5, 1965) / 4¼ × 3 × 2 in. (10.8 × 7.6 × 5.1 cm) / Special Collections, San Francisco Museum of Modern Art Research Library

Blank & Jeron and Gerrit Gohlke
Joachim Blank: German, b. 1963; Karl Heinz Jeron: German, b. 1962; Gerrit Gohlke: German, b. 1968

1st Public White Cube, 2001/2008 (pls. 183–92) / Online project (http://www.publicwhitecube.com), eBay auctions, and winning bidders' interventions into mixed-media installations by guest artists / Dimensions variable / Support provided by the Institut für Auslandsbeziehungen (Institute for Foreign Cultural Relations), Stuttgart, Germany / Courtesy the artists

> Guest artist installations by 10lb Ape (Gustavo Herrera: American, b. 1975; Matt Wardell: American, b. 1976), *Your Mother Was Beautiful Once, Part Drei,* 2008; Ledia Carroll (American, b. 1974, Guatemala), *Sand Dune,* 2008

George Brecht
American, b. 1926

Toward Events, 1959 (pl. 6) / Offset lithography on paper bag (announcement for an exhibition at Reuben Gallery, New York, October 16–November 5, 1959) / 9¹⁵⁄₁₆ × 6¼ in. (25.3 × 15.8 cm) / Archiv Sohm, Staatsgalerie Stuttgart, Germany

Direction: A Fluxgame, 1963/1969 / Fluxus edition: plastic box and offset lithography / 4¾ × 3¹¹⁄₁₆ × ¹¹⁄₁₆ in. (12 × 9.3 × 1.7 cm) / Label designed by George Maciunas / The Gilbert and Lila Silverman Fluxus Collection, Detroit

Water Yam, 1963 (pl. 8) / Fluxus edition: cardboard box and offset lithography (sixty-nine cards) / 9⅝ × 8⅞ × 1⅝ in. (24.4 × 22.5 × 4.8 cm) / Label designed by George Maciunas / The Gilbert and Lila Silverman Fluxus Collection, Detroit

Universal Machine, 1965 (pl. 7) / MAT MOT edition: cloth-covered box, offset lithography, glass, buttons, stainless-steel ball bearing, balsa wood, wood toothpicks, glass beads, metal hook and eye, brass washer, and iron snap clasp, ed. 73/100 / 11 × 11 × 1⁹⁄₁₆ in. (28 × 28 × 4 cm) / The Gilbert and Lila Silverman Fluxus Collection, Detroit

Deck: A Fluxgame, 1966 (pl. 5) / Fluxus edition: plastic box and offset lithography (sixty-four laminated cards) / 2⅝ × 3¹¹⁄₁₆ × ⅞ in. (6.7 × 9.3 × 2.3 cm) / Label designed by George Maciunas / The Gilbert and Lila Silverman Fluxus Collection, Detroit

Jonah Brucker-Cohen and Mike Bennett
American, b. 1975; Irish, b. 1977

BumpList: An email community for the determined, 2003 (pls. 177–78) / Online email list (http://www.bumplist.net) / Courtesy the artists

John Cage
American, 1912–1992

4'33", 1952 (pl. 1) / Musical score with handwritten notes by David Tudor / 12½ × 9½ in. (31.8 × 24.1 cm) / Courtesy the Getty Research Institute, Los Angeles

4'33", excerpt from *A Tribute to John Cage* by Nam June Paik, 1973/1976 (pl. 3) / Single-channel color video with sound, 3:55 min. / San Francisco Museum of Modern Art, Camille W. and William S. Broadbent Fund

c a l c and Johannes Gees
Teresa Alonso Novo: Spanish, b. 1963; tOmi Scheiderbauer: Austrian, b. 1961; Malex Spiegel: Austrian, b. 1970; Looks Brunner: Swiss, b. 1959; Dani Gómez Blasco: Spanish, b. 1976; Johannes Gees: Swiss, b. 1960

communimage, 1999–present (pl. 153) / Online project (http://www.communimage.net) / Original website development supported by Swiss National Exposition *Expo.02*. Additional support for 2008 website redesign from Empresa Pública de Gestión de Programas Culturales, Junta de Andalucia, Consejería de Cultura, Seville, Spain, and Amt der Vorarlberger Landesregierung, Bregenz, Austria / Courtesy the artists

communimage—a moment in time VI, 2008 / Digital pigment print on Sintra / Approx. 204 × 257⅟₁₆ in. (518.2 × 653 cm) / Courtesy the artists

Janet Cardiff
Canadian, b. 1957

The Telephone Call, 2001 (pls. 159–60) / Audio and video walk through the San Francisco Museum of Modern Art: digital video, mini DV camera, and headphones, 17 min. / Dimensions variable / San Francisco Museum of Modern Art, purchased through a gift of Pamela and Dick Kramlich and the Accessions Committee Fund: gift of Jean and James E. Douglas Jr., Carla Emil and Rich Silverstein, Patricia and Raoul Kennedy, Phyllis and Stuart G. Moldaw, Lenore Pereira-Niles and Richard Niles, and Judy and John Webb

Lygia Clark
Brazilian, 1920–1988

Diálogo de mãos (Hand Dialogue), 1966/2008 (pl. 42) / Elastic / 6⅝ × ¾ in. (16.8 × 1.9 cm) / Clark Family Collection, Rio de Janeiro

Máscaras sensoriais (Sensorial Masks), 1967 (pl. 40) / Cloth masks with ear devices and goggles, fabric, metal, seeds, plastic, polyethylene, mirrors, glass, shells, steel wool, sponge, and tissue / Six masks, each: approx. 25⅝ × 19¾ × 2⅜ in. (65 × 50 × 6 cm) / Clark Family Collection, Rio de Janeiro

Diálogo: Óculos (Dialogue: Goggles), 1968/2008 (pl. 41) / Modified diving goggles, metal, and mirror / 3 × 7 × 11 in. (7.5 × 18 × 29 cm) / Clark Family Collection, Rio de Janeiro

Rede de elástico (Elastic Net), 1973/2008 (pls. 36–39) / Rubber / Dimensions variable / Clark Family Collection, Rio de Janeiro

The World of Lygia Clark, 1973 (pls. 37–38, 42) / Black-and-white video with sound, 27 min. / Directed by Eduardo Clark / Clark Family Collection, Rio de Janeiro

Minerva Cuevas
Mexican, b. 1975

Mejor Vida Corp., 1998–present (pls. 130–31) / Online project (http://www.irational.org/mvc) / Courtesy the artist

Maria Eichhorn
German, b. 1962

Prohibited Imports, 2003 (pl. 117) / Offset lithography (twenty-five books and three magazines), glass, and wood / 30¼ × 18⅝ × 15 in. (76.7 × 47.2 × 38.2 cm) / Collection of the artist

VALIE EXPORT
Austrian, b. 1940

Selected documentation of *TAPP- und TASTKINO* (TAP and TOUCH CINEMA), 1968–69 (pls. 49–50) / Generali Foundation, Vienna

 Konzept VALIE EXPORT, Der Busen als Leinwand (Concept VALIE EXPORT, The Breasts as Screen), 1968, printed 2008 / Digital pigment print / 9⁷⁄₁₆ × 7ⁱ⁄₁₆ in. (24 × 18 cm)

 Zweites TAPP- und TASTKINO (Second TAP and TOUCH CINEMA), 1968/1998 / Aluminum and foam / 23⅝ × 13⅞ × 20¾ in. (59.9 × 35.1 × 52.5 cm) / Fabricated by Wolfgang Ernst

 TAPP- und TASTKINO (TAP and TOUCH CINEMA), 1969 / Single-channel black-and-white video with sound, 1:20 min. / Performed by VALIE EXPORT; narrated by Peter Weibel; edited by Wolfgang Hajek and Helmut Dimko; produced by ORF/ZDF for Apropos Film

Harrell Fletcher and Jon Rubin
American, b. 1967; American, b. 1963

Pictures Collected from Museum Visitors' Wallets, 1998 (pls. 123–24) / Chromogenic prints / Ten prints, each: 40 × 30 in. (101.6 × 76.2 cm) / San Francisco Museum of Modern Art, purchased through a gift of the Wallace Alexander Gerbode Foundation

Fluxus Collective
Active 1960s–late 1970s

Fluxkit, 1965–66 (pls. 15–16) / Fluxus edition: vinyl attaché case, metal hinges, and silkscreen (contains various Fluxus objects) / 12⅝ × 16¹⁵⁄₁₆ × 4¹⁵⁄₁₆ in. (32 × 43 × 12.5 cm) / Assembled by George Maciunas / The Gilbert and Lila Silverman Fluxus Collection, Detroit

Kit Galloway and Sherrie Rabinowitz
American, b. 1948; American, b. 1950

Hole-in-Space, 1980/2008 (pls. 90–91) / Two-channel black-and-white video projection with sound, approx. 360 min. (re-creation using original footage from a live two-way telecommunication event at Lincoln Center for the Performing Arts, New York, and Century City Shopping Center, Los Angeles, November 11, 13, and 14, 1980) / Dimensions variable / Courtesy the artists

Jochen Gerz
German, b. 1940

The Gift, 2000/2008 (pls. 147–49) / Digital photography studio, production lab, digital pigment prints, and newspaper advertisements / Each photograph: 23⅝ × 19¹¹⁄₁₆ in. (60 × 50 cm); overall dimensions variable / Courtesy Gerz Studio

Matthias Gommel
German, b. 1970

Delayed, 2002 (pl. 157) / Closed-circuit sound installation / Dimensions variable / Courtesy the artist

Felix Gonzalez-Torres
Cuban, 1957–1996

"Untitled," 1992/1993 (pl. 119) / Offset lithography (endless copies) / 8 × 44½ × 33½ in. (20.3 × 113 × 85.1 cm) / San Francisco Museum of Modern Art, Accessions Committee Fund: gift of Ann S. Bowers, Frances and John Bowes, Collectors Forum, Elaine McKeon, Byron R. Meyer, and Norah and Norman Stone

Dan Graham
American, b. 1942

Poem, n.d. / Ink on paper / 9 × 6 in. (22.9 × 15.2 cm) / The Museum of Modern Art Archives, New York

Schema for a Set of Pages, 1966 / Offset lithography / 8½ × 5½ in. (21.6 × 14 cm) / The Museum of Modern Art Archives, New York

Performer/Audience/Mirror, 1977 (pl. 64) / Single-channel black-and-white video with sound, 22:52 min. / San Francisco Museum of Modern Art, Camille W. and William S. Broadbent Fund

Double Cylinder (The Kiss), 1994 (pl. 65) / Two-way mirror, glass, and steel / Each cylinder: 96 × 96 × 96 in. (243.8 × 243.8 × 243.8 cm) / San Francisco Museum of Modern Art, Accessions Committee Fund: gift of Frances and John Bowes, Emily L. Carroll, Collectors Forum, Jean and Jim Douglas, Susan and Robert Green, Jerome S. Markowitz and Maria Monet Markowitz, Elaine McKeon, and Norah and Norman Stone

Hans Haacke
German, b. 1936

News, 1969/2008 (pl. 70) / RSS newsfeed, paper, and printer / Dimensions variable / Collection of the artist

Lynn Hershman Leeson
American, b. 1941

Selected documentation of *The Dante Hotel,* 1973–74 (pl. 171) / Gelatin silver prints, chromogenic prints, newspaper clippings, and ink on paper / Each document: approx. 8 × 10 in. (20 × 25 cm) / Department of Special Collections, Stanford University, California

Life², 2006–present (figs. 29–30, pls. 168–70) / Online project (http://slurl.com/secondlife/NEWare/128/128/0) / Project management and development by Henrik Bennetsen with Jeff Aldrich and Henry Segerman; principal research by Henry Lowood and Michael Shanks, Stanford Humanities Lab; additional support by Roberto Trujillo and Peter Blank, Special Collections, Stanford University Libraries / Collection of the artist

Allan Kaprow
American, 1927–2006

Hello, excerpt from *The Medium Is the Medium,* 1969 (pls. 29–34) / Single-channel black-and-white video with sound, 4:85 min. / Produced by WGBH, Boston / Courtesy Electronic Arts Intermix, New York

Henning Lohner and Van Carlson
American, b. Germany, 1961; American, b. 1950

4'33" in Berlin (with John Cage), raw material video pictures cat. # 001, 1990 / Single-channel color video with sound, 4:33 min. / San Francisco Museum of Modern Art, gift of the artists and Galerie Springer & Winckler, Berlin

Chip Lord, Curtis Schreier, and Bruce Tomb
American, b. 1944; American, b. 1944; American, b. 1958

Ant Farm Media Van v.08 (Time Capsule), 2008 (pl. 87) / Customized 1972 Chevy C10 van, mixed media, video, computer, custom electronics, and custom software / 84 × 79 × 192 in. (213.4 × 200.7 × 487.7 cm) / Support provided by Headlands Center for the Arts, Marin, California / Courtesy the artists, commissioned by the San Francisco Museum of Modern Art

Rafael Lozano-Hemmer
Mexican, b. 1967

Microphones, 2008 (pls. 204–5) / Interactive installation with modified microphones, computers, electronics, and custom software / Dimensions variable / Programming by Gideon May / Courtesy the artist

Tom Marioni
American, b. 1937

FREE BEER (The Act of Drinking Beer with Friends Is the Highest Form of Art), 1970–79 / Refrigerator, framed print, shelf, beer bottles, and lightbulb / 114 × 114 × 60 in. (289.6 × 289.6 × 152.4 cm) / San Francisco Museum of Modern Art, anonymous gift

The Act of Drinking Beer with Friends Is the Highest Form of Art, 1970–2008 (pl. 82) / Site-specific installation with functioning bar / Dimensions variable / Courtesy the artist

MTAA (M.River & T.Whid Art Associates)
Michael Sarff: American, b. 1967; Tim Whidden: American, b. 1969

Automatic for the People: (), 2008 (pl. 197) / Online project (http://mtaa.net/vote) and performance at the San Francisco Museum of Modern Art / Dimensions variable / Courtesy the artists, commissioned by the San Francisco Museum of Modern Art

Antoni Muntadas
Spanish, b. 1942

The File Room, 1994–present / Online project (http://www.thefileroom.org) / Courtesy the artist

Yoko Ono
Japanese, b. 1933

Cut Piece, 1965 (pl. 45) / 16mm black-and-white film transferred to video, 9 min. / Courtesy the artist

Cut Piece, 2003 (pl. 46) / Single-channel color video with sound, 16 min. / Courtesy the artist

Nam June Paik
American, b. South Korea, 1932–2006

Participation TV, 1963/1998 / Manipulated television, signal amplifiers, and microphone / Dimensions variable / Nam June Paik Art Center, Korea

Dan Phiffer and Mushon Zer-Aviv
American, b. 1980; Israeli, b. 1976

ShiftSpace, 2007–present (pl. 174) / Online project (http://www.shiftspace.org/rhizome) / Courtesy the artists

Raqs Media Collective
Jeebesh Bagchi: Indian, b. 1965; Monica Narula: Indian, b. 1969; Shuddhabrata Sengupta: Indian, b. 1968

Please do not touch the work of art, 2006 (pl. 181) / Adhesive vinyl and offset lithography / Each card: 4 × 6 in. (10.2 × 15.2 cm); overall dimensions variable / Courtesy the artists

Robert Rauschenberg
American, 1925–2008

White Painting (Three Panel), 1951 (pl. 4) / Oil on canvas / 72 × 108 in. (182.9 × 274.3 cm) / San Francisco Museum of Modern Art, purchased through a gift of Phyllis Wattis

Warren Sack
American, b. 1962

Conversation Map, 2000 (pl. 155) / Online project (http://people. ucsc.edu/~wsack/conversationmap) / Courtesy the artist

Mieko Shiomi
Japanese, b. 1938

Spatial Poem No. 1, 1965 (pl. 20) / Fluxus edition: stenciled map on painted composition board, masking tape, pins, and offset lithography (sixty-nine cards) / 11¹⁵⁄₁₆ × 18 × ⅞ in. (30.3 × 45.7 × 2.3 cm) / Assembled by George Maciunas / The Gilbert and Lila Silverman Fluxus Collection, Detroit

Torolab
Raúl Cárdenas Osuna: Mexican, b. 1969

Work Room 4, 2008 (pl. 202) / Collaborative writing project and weblog (http://www.work-room.net) / Courtesy the artist, commissioned by the San Francisco Museum of Modern Art

Wolf Vostell
German, 1932–1998

Petit Ceinture (Small Loop), 1962 / Offset lithography (invitation to a happening in Paris, July 3, 1962) / 5¹⁄₁₆ × 9⁷⁄₁₆ in. (14.5 × 24 cm) / Archiv Sohm, Staatsgalerie Stuttgart, Germany

Do it yourself, 1963
Offset lithography and glass (invitation to a happening at Smolin Gallery, New York, May 22, 1963) / 4³⁄₁₆ × ⅝ × ⅝ in. (10.7 × 1.6 × 1.6 cm) / Archiv Sohm, Staatsgalerie Stuttgart, Germany

9 Decollagen, 1963
Typed invitation and score (documentation of a happening at Galerie Parnass, Wuppertal, Germany, September 14, 1963) / Invitation: 4¹⁵⁄₁₆ × 8 in. (12.6 × 20.3 cm); score: 11¹¹⁄₁₆ × 8¼ in. (29.7 × 21 cm) / Archiv Sohm, Staatsgalerie Stuttgart, Germany

You—A Decollage Happening, 1964 (pl. 13) / Typed score, ink, gouache, and spray paint on cardboard (documentation of a happening in Great Neck, New York, April 19, 1964) / Score: 11 × 8⁷⁄₁₆ in. (28 × 21.5 cm); "psychogram": 19¹¹⁄₁₆ × 23⅝ in. (50 × 60 cm) / Archiv Sohm, Staatsgalerie Stuttgart, Germany

Andy Warhol
American, 1928–1987

Do It Yourself, 1962 (pl. 10) / Colored crayon on paper / 25 × 18 in. (63.5 × 45.72 cm) / Princeton University Art Museum, courtesy Sonnabend Collection

Stephen Willats
British, b. 1943

A Moment of Action, 1974 (pls. 72–74) / Gelatin silver prints, gouache, ink, and Letraset mounted on card stock with questionnaire and clipboard / Six panels, each: 25 × 16 in. (63.5 × 40.6 cm); overall dimensions variable / Courtesy Victoria Miro Gallery

Erwin Wurm
Austrian, b. 1954

One Minute Sculptures, 1997 (pls. 141–42) / Chromogenic prints / Thirty-two prints, each: 26¾ × 20½ in. (68 × 52 cm) (framed) / Collection of the artist

Keep a cool head, 2003 (pl. 144) / Refrigerator and instruction drawing / 33¼ × 19¾ × 24 in. (85 × 50 × 61 cm) / Collection of the artist

One Minute Sculptures, 2007/2008 / Performative objects and instruction drawings on pedestal / Dimensions variable / Collection of the artist

The trap of the truth, 2007/2008 / Performative objects on shelf and instruction drawing / Dimensions variable / Collection of the artist

Photography Credits

Unless otherwise indicated below, all illustrations were provided by the owner of the work named in the image caption or in the catalogue of the exhibition (pages 204–7).

Endsheets / **front** © 2008 Estate of Wolf Vostell / Artists Rights Society, New York / VG Bild-Kunst, Bonn; Kuzuyuki Matsumoto, © 2008 Artists Rights Society (ARS), New York / VBK, Vienna; **back** Ben Blackwell, courtesy San Francisco Museum of Modern Art, © The Felix Gonzalez-Torres Foundation, © 2008 Artist Rights Society (ARS) New York / VG Bild-Kunst Bonn.

Frontispieces / **pp. 2–3** Paul Hoffman, courtesy Tom Marioni; **pp. 6–7** Eduardo Clark, courtesy "The World of Lygia Clark" Cultural Association.

Figures / **2** courtesy Archivi Gerardo Dottori, Perugia (http://www.gerardodottori.net); **3** Courtesy Mart, Museo di arte moderna e contemporanea di Trento e Rovereto, Archivio del '900, fondo Depero; **6** Stephen Shore, courtesy 303 Gallery, New York, © 2008 Andy Warhol Foundation for the Visual Arts / ARS, New York; **7** Amy C. Elliott, courtesy Public Art Fund; **8, 19** Ben Blackwell, courtesy San Francisco Museum of Modern Art; **9** © 2008 Artists Rights Society (ARS), New York / VG Bild-Kunst, Bonn, digital image © The Museum of Modern Art / Licensed by SCALA / Art Resource, New York; **10** © 2008 Artists Rights Society (ARS), New York / VG Bild-Kunst, Bonn; **11** © 2008 Robert Morris / Artists Rights Society (ARS), New York, digital image © Tate, London 2008; **15** Viktor Kolibal, courtesy Galerie Krinzinger, Vienna; **16** © 2008 Artists Rights Society (ARS), New York / ADAGP, Paris; **18** Elizabeth Sisco; **21** © 2008 Judy Chicago / Artists Rights Society (ARS) New York, digital image © Through the Flower Archive; **22** Philip Gagliani, courtesy San Francisco Museum of Modern Art Archives, © 2008 Judy Chicago / Artists Rights Society (ARS) New York; **23–24** © The NAMES Project Foundation; **25** © Thomas McGovern; **26** Jan Christensen; © 2008 Artists Rights Society (ARS), New York / VEGAP, Madrid; **27** © 2008 Artists Rights Society (ARS), New York / VEGAP, Madrid.

Plates / **1** courtesy Research Library, The Getty Research Institute, Los Angeles, California (980039); **2** © 1960, renewed 1988, by Henmar Press Inc., C. F. Peters Corporation, Sole Selling Agent. Used by permission. All rights reserved; **4** Ben Blackwell, courtesy San Francisco Museum of Modern Art, art © Rauschenberg Estate / Licensed by VAGA, New York; **5, 7** R. H. Hensleigh, courtesy the Gilbert and Lila Silverman Fluxus Collection, Detroit; **8, 15–16, 19–20** Brad Iverson, courtesy the Gilbert and Lila Silverman Fluxus Collection, Detroit; **9** photo © Robert R. McElroy / Licensed by VAGA, New York, courtesy Research Library, The Getty Research Institute, Los Angeles (980063); **10** Bruce M. White, photo © Trustees of Princeton University, © 2008 Andy Warhol Foundation for the Visual Arts / ARS, New York; **12** photo by Peter Moore © Estate of Peter Moore / Licensed by VAGA, New York, © 2008 Estate of Wolf Vostell / Artists Rights Society, New York / VG Bild-Kunst, Bonn; **13** © 2008 Estate of Wolf Vostell / Artists Rights Society, New York / VG Bild-Kunst, Bonn; **14, 65–66, 88** Ben Blackwell, courtesy San Francisco Museum of Modern Art; **17–18, 69–70, 76–77, 147–50** © 2008 Artists Rights Society (ARS), New York / VG Bild-Kunst, Bonn; **21** courtesy the Estate of Ray Johnson at Richard L. Feigen & Co.; **22** © Estate of Nam June Paik; **23** Anne Niemetz, courtesy Bermant Foundation, © Estate of Nam June Paik; **24** Dieter Daniels, © Estate of Nam June Paik; **25–26** Manfred Montwé, © Estate of Nam June Paik; **28** Paul Berg for the *St. Louis Post-Dispatch,* courtesy Research Library, The Getty Research Institute, Los Angeles (980063); **35** The Museum of Modern Art / Licensed by SCALA / Art Resource, NY; **36, 39** Hubert Josse, courtesy "The World of Lygia Clark" Cultural Association; **37–38, 41–42** Eduardo Clark, courtesy "The World of Lygia Clark" Cultural Association; **40** Sérgio Zalis, courtesy "The World of Lygia Clark" Cultural Association; **44** Ronald Cultone, courtesy Projeto Hélio Oiticica; **45** Ken McKay, © Yoko Ono; **46** Minoru Niizuma, © Yoko Ono; **47** © Yoko Ono, courtesy Lenono Photo Archive; **48** © Chris Burden, courtesy Gagosian Gallery; **49** Hans Peter Kochenrath, © Generali Foundation Collection, Vienna, © 2008 Artists Rights Society (ARS), New York / VBK, Vienna; **50** Werner Schulz, © Generali Foundation Collection, Vienna, © 2008 Artists Rights Society (ARS), New York / VBK, Vienna; **51** © Hans Hammarskiöld, © 2008 Artists Rights Society (ARS), New York / ADAGP, Paris [Niki de Saint-Phalle, Jean Tinguely], © 2008 Artists Rights Society (ARS), New York / BUS, Stockholm [Per Olof Ultvedt]; **52–55** Giovanna dal Magro, © Marina Abramović, © 2008 Artists Rights Society (ARS), New York / VG Bild-Kunst, Bonn; **56** © Marina Abramović, © 2008 Artists Rights Society (ARS), New York / VG Bild-Kunst, Bonn; **57** © 2008 Artists Rights Society (ARS), New York / VISCOPY, Australia; **61** © Adrian Piper Research Archive; **62** Philipp Scholz Rittermann, courtesy Museum of Contemporary Art, San Diego, © 1966–68 John Baldessari; **63** © 2008 Douglas Huebler, digital image © Tate, London, 2008, courtesy Darcy Huebler / Artists Rights Society (ARS), New York; **67** photo by Peter Moore, © Estate of Peter Moore / VAGA, New York; **71** digital image © The Museum of Modern Art / Licensed by SCALA / Art Resource, NY; **75** Victor Lerma, courtesy Mónica Mayer; **78** Dieter Schwerdtle, Kassel, Germany; **79** © 2008 Artists Rights Society (ARS), New York / VG Bild-Kunst, Bonn, courtesy Stiftung Museum Schloss Moyland, Joseph Beuys Archiv des Landes Nordrhein-Westfalen, Bedburg-Hau; **82** Paul Hoffman, courtesy Tom Marioni; **83** Richard Landry with alteration by Gordon Matta-Clark, courtesy David Zwirner, New York, © 2008 Estate of Gordon Matta-Clark / Artists Rights Society (ARS), New York; **84** © 2008 Estate of Gordon Matta-Clark / Artists Rights Society (ARS), New York; © 2008 Estate of Juan Downey / Artists Rights Society (ARS), New York; **85** Chip Lord; **86** Doug Michels; **112** Dorcas Müller; **113** © Robert Adrian; **114, 204–5** © 2008 Artists Rights Society (ARS), New York / VEGAP, Madrid; **116–17** Jens Ziehe, courtesy Galerie Barbara Weiss, Berlin, © 2008 Artists Rights Society (ARS), New York / VG Bild-Kunst, Bonn; **118** Eliane Laubschne, © Artists Rights Society (ARS), New York / COPY-DAN, Copenhagen; **119** Ben Blackwell, courtesy San Francisco Museum of Modern Art, © The Felix Gonzalez-Torres Foundation; **120** Sue Tallon, courtesy Andrea Rosen Gallery, New York, © The Felix Gonzalez-Torres Foundation; **121** Luigi Constantini, AP / Wide World Photos; **122** © Emmanuel Nguyen Ngoc (http://enn2004.free.fr/); **123–24** Ian Reeves, courtesy San Francisco Museum of Modern Art; **140** Martin Jenkinson; **141** Watanabe Osamu, Tokyo, © 2008 Artists Rights Society (ARS), New York / VBK, Vienna; **142–43** Kuzuyuki Matsumoto, Saitama, © 2008 Artists Rights Society (ARS), New York / VBK, Vienna; **144** © 2008 Artists Rights Society (ARS), New York / VBK, Vienna; **145** Wolfgang Fuhrmannek, © 2008 Artists Rights Society (ARS), New York / ADAGP, Paris [Sarkis], © 2008 Artists Rights Society (ARS), New York / VG Bild-Kunst, Bonn [Joseph Beuys]; **151** © 2008 Artists Rights Society (ARS), New York / ADAGP, Paris; **154** Joel Fides; **156** Helga Stein; **158** © Marie Sester; **168–70** image capture by Jeff Aldrich; **184–91** KH Jeron, © 2008 Artists Rights Society (ARS), New York / VG Bild-Kunst, Bonn [Blank & Jeron]; **192** Gerrit Gohlke, © 2008 Artists Rights Society (ARS), New York / VG Bild-Kunst, Bonn [Blank & Jeron]; **193–94** courtesy Black Dragon Society; **199–200** © Komar & Melamid, courtesy Ronald Feldman Fine Arts, New York.